MEMORIES *of*
WORLD WAR II

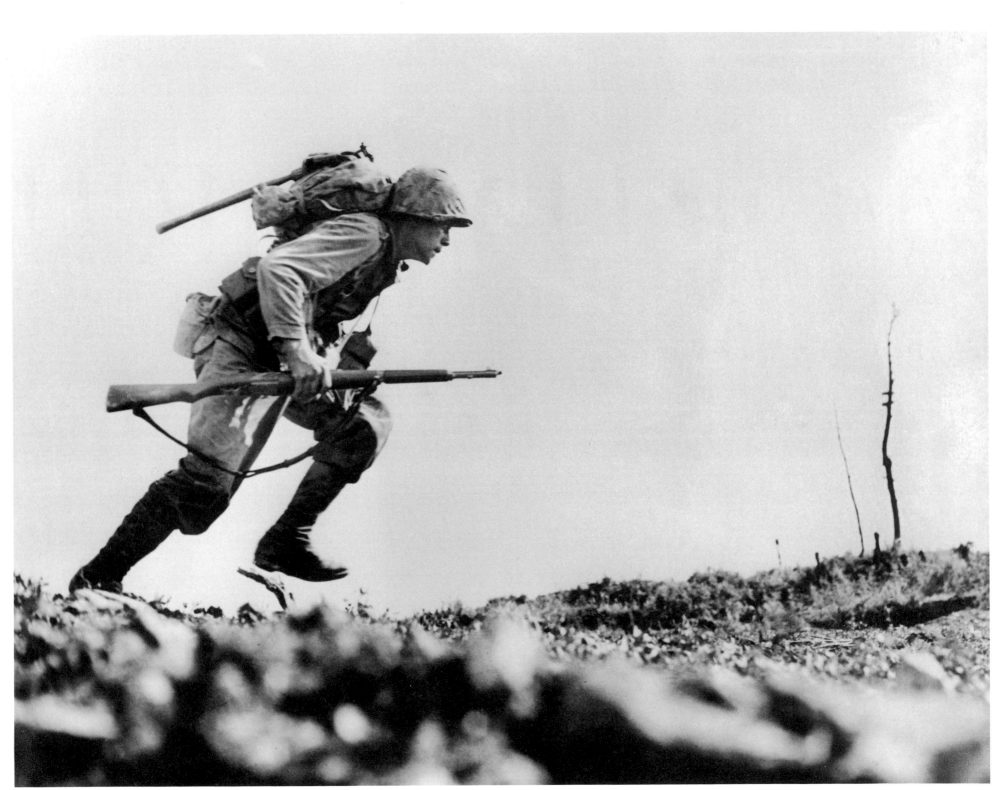

MEMORIES *of*

WORLD WAR II

PHOTOGRAPHS FROM THE ARCHIVES OF **THE ASSOCIATED PRESS**

FOREWORD **BOB DOLE** INTRODUCTION **WALTER CRONKITE**

EDITED BY **KELLY SMITH TUNNEY, ANN G. BERTINI, CHUCK ZOELLER,** AND **ERIC HIMMEL**

HARRY N. ABRAMS, INC. PUBLISHERS

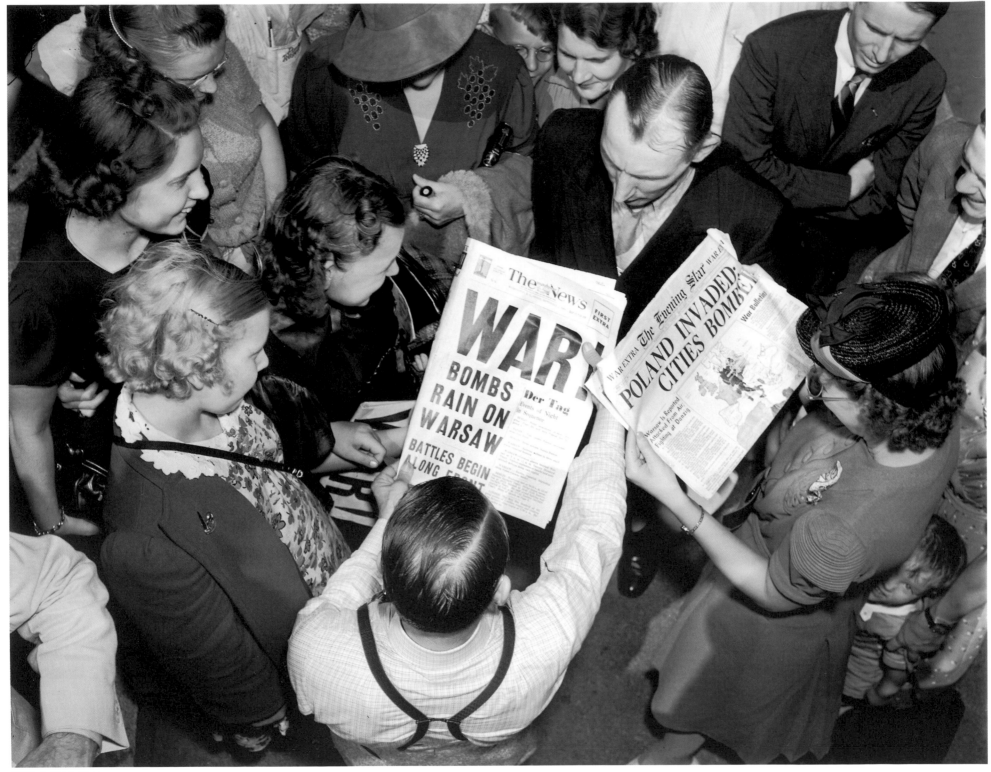

CONTENTS

(frontispiece) OKINAWA, JAPAN, MAY 10, 1945
Pfc. Paul Ison from the Sixth Marine Division charges forward through Japanese machine-gun fire on a
barren piece of land the Marines called "Death Valley." Leathernecks lost 125 men in eight hours of sustained fighting on Okinawa.

(opposite) WASHINGTON, D.C., SEPTEMBER 1, 1939
A crowd gathers outside the U.S. State Department building as news of the German invasion of Poland spreads.
Two days later, on September 3, Britain, France, Australia, and New Zealand declared war on Germany: World War II had begun.

THE IMAGES that make up this book are stark, recording the harsh history of The War, the impact perhaps greater for the black and white of another era. For the causes and objectives of the United States and our Allies in World War II were just that—black and white, good against evil. In conflicts since, America's role and aims have been debated and often disputed at home. But the war against Nazi Germany and the expansionist militarism of Japan was the cause of Americans united—it had to be waged and it had to be won.

Nearly sixty years after the last shots echoed in Europe and the Pacific, the generations that experienced World War II and the men and women who fought it are passing. As we dedicate the National World War II Memorial on the Mall in Washington, D.C., fewer than 4 million of the 16 million Americans who served are alive to see their service commemorated.

The conflict changed the life of every American, not only those who braved the battlefield. From 1941 until 1945 it shaped the daily lives of those who held the home front, building the ships, the aircraft, the tanks, the guns and ammunition that armed fighting men in Europe and the Pacific theater. Even children collected scrap metal and old newspapers as their contribution to the war effort.

It changed my life forever. On April 14, 1945, as a 21-year-old second lieutenant, I was hit by a German shell as we assaulted a machine-gun nest in the Po Valley of Italy. Germany surrendered within the month, but my war lasted for three more years of treatments, rehabilitation, and learning to live with a useless right arm and complication from a spinal injury that cost me a kidney and permanently limited the function of my left arm and hand. I was tested, as were nearly 700,000 of my fellow servicemen who suffered the wounds of the greatest war mankind has known, and came back, as I did, to play our roles in postwar America.

Those of us who remain proudly bear witness for those who went before. As we pass through the ceremonial entrance to the National World War II Memorial on the Mall between the Washington Monument and the Lincoln Memorial, we read these words:

Here in the presence of Washington and Lincoln, one the Eighteenth Century father and the other the Nineteenth Century preserver of our nation, we honor those Twentieth Century Americans who took up the struggle during the Second World War and made the sacrifices to perpetuate the gift our forefathers entrusted to us: A nation conceived in liberty and justice.

In the pages that follow are photographs that record the struggle and the sacrifices. They testify to the dedication and bravery of the men and women who waged the war—and no less, to the commitment of the photographers who took them, armed not with guns but with cameras.

Some are familiar images to us all, none more so than Joe Rosenthal's Pulitzer Prize-winning photograph of Marines raising the American flag atop Mount Suribachi on Iwo Jima, on February 23, 1945. Look closely and you will see an earlier, less heralded Rosenthal photo, taken from the beach at Iwo Jima on February 19, 1945, as Marines storm ashore to do battle for the Japanese-held island.

Look closely, too, at Pete Carroll's photo of servicemen praying aboard their landing craft on the way to the beach at Normandy, on D-Day, as Allied forces prepared to fight their way ashore in France. There is a note on the original—military censors ordered the unit patches of the soldiers edited out before the picture was transmitted, lest the Nazis learn something useful about the invaders.

The faces and the suffering of civilians caught up in war are recorded here as well: a Frenchman weeping at the sight of his nation's regimental flags leaving Marseilles; nurses in the ruins of a London hospital bombed by the Germans in 1941; British clergymen

Pfc. Harvey White, of Minneapolis, Minnesota, gives blood plasma to Private Roy Humphrey, of Toledo,
Ohio, wounded by shrapnel in Sicily during the early days of the Italian campaign.

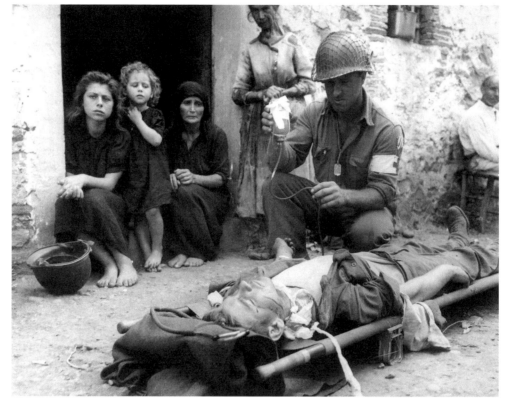

John Steven Wever, U.S. Army/AP Archives

in white vestments in the shell of bombed Coventry Cathedral in 1943.

Then, in 1944, American soldiers marching on the Champs-Elysées in liberated Paris; in 1945, U.S. tanks amid the utter ruins of Nuremberg, Germany; and two weeks later, New York's Times Square jammed with crowds celebrating V-E—Victory in Europe—Day.

The Japanese fought on, surrendering only after atomic bombs destroyed Hiroshima and Nagasaki. The devastation of the A-bomb is part of this record. The only use of those ultimate weapons is debated now. But there would have been no debate among the men who were waiting on troop ships or ports of embarkation for the invasion of the Japanese home islands, an operation that would have cost hundreds of thousands of casualties on both sides had it been waged.

For those of us who fought World War II, and for millions more who remember it as part of their lives, these photographs are personal history relived. For many millions more, the postwar

generations, who know the war only as distant history, these images will serve as the record of a shared and shaping era in our nation's history.

History unfolds with every headline from today's battlefields, where a new generation of citizen soldiers is distinguishing itself for courage, character, and sacrifice in a noble cause. Their heroism reminds us that every generation has what FDR called a rendezvous with destiny. Consequently, ours is a never-ending story, superbly illustrated here by the photographs from the archives of The Associated Press.

I hope that you will keep our current combatants in your thoughts and prayers as you look at these historical photographs, and as you experience the National World War II Memorial.

BOB DOLE

Former United States Senator

Chairman, National World War II Memorial

INTRODUCTION

IT WAS HELL 26,000 feet above the earth, a hell of burning tracer bullets and bursting flak, of crippled B-17 Flying Fortresses and flaming German fighter planes. For two hours, I sat through a vicious gun duel with twisting and turning Focke-Wulf 190 fighters and held tight while we dodged savage antiaircraft fire. I had to scrape the frost from the windows in the plastic nose of the plane in order to see. The fighters came toward us with guns spitting, but we couldn't hear them because of the noise of our own engine. For me, that was February 26, 1943.

When Pearl Harbor was attacked, I was working for United Press in New York and I knew right away, I wanted—no, more than that, I felt I HAD—to get into the war as a correspondent. I never thought of being a soldier. I just believed I could do far more as a correspondent than as an infantryman. People in a democratic nation have a special right to know how wars are fought in their behalf and what their young people are doing in their name. I wanted to make a contribution by writing about what the battlefields of this war were like for young Americans who were getting shot at and killed far away from home.

Indeed, if there were no correspondents or photographers who went to war, what would the folks at home know? What would the mothers and fathers and sisters and brothers and wives know of the heroism, the suffering, the brave deeds, the crippling challenges if we didn't tell them and make images of those moments? What would future generations know? The dramatic, sobering, and often inspiring photographs in this book are evidence enough that times of war need to be recorded and remembered. But newsgathering during war comes at a high price because reporters, who are not armed or trained as soldiers, often are put into life-threatening experiences and perilous circumstances.

AP's Pulitzer Prize-winning correspondent Larry Allen had eight warships sunk beneath him by the enemy and was rescued each time. Joe Rosenthal, who clambered up Iwo Jima's Mount Suribachi to take the flag-raising photo that became the emblem of American victory, nearly died hours before he shot the famous picture. George Bede Irvin was killed in 1944 as he tried to rescue his camera during an aerial bombardment that signaled the start of the Allied drive out of Normandy.

The AP's Joe Morton was executed by the Nazis. Joe had covered Liberia, the invasions of Sicily and Italy, and rode in on the first American bombing of Rome. In 1945, he was chased by Nazi soldiers for two months through bitter cold and snow in Slovakia after covering a failed revolt against the pro-Nazi government. He and others on the mission were captured and later shot.

In all, there were sixty-eight reporters and photographers killed while covering World War II, and many more were gravely wounded. Others were taken prisoner. Some of these men and women were my friends. All of us knew and generally accepted danger as the price for delivering news to the home front, even though as individuals we sometimes wrestled with decisions as to whether to join a particularly hazardous mission. Risking our lives or our health was the price we paid for being journalists, for doing a job that no others could do.

We correspondents were volunteers, and we went out with guys in the foxholes, in the airplanes, in the parachute jump groups, in the gliders, on ships by choice. Soldiers frequently asked, "What the hell are you doing here?" They thought we were heroes for being where we didn't have to be, and we thought they were heroes for being there at all.

We were with the soldiers, airmen, or seamen virtually all the time, and unlike in later wars, had no problem whatsoever with access. We talked to G.I.'s and officers alike, and they talked to us. The military made no attempt to monitor our interviews. In the evening, usually back at a press camp, we wrote our stories and filed

CHARLEROI, BELGIUM, APRIL 18, 1944

Martin B-26 Marauder bombers of the U.S. Ninth Air Force return to England from a mission over Charleroi.
Their targets were a railway yard and power station. Allied bombing missions against communication and transportation targets in northern
Europe were important to the success of the Normandy invasion in June. By February 1945, more than 8,000 aircraft
were pounding Germany's transportation system, putting it nearly out of commission in March.

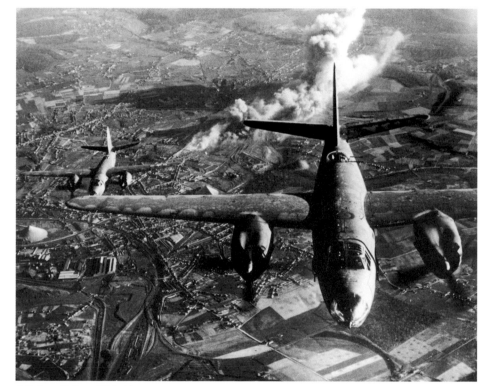

U.S. Army Air Force/AP Archives

them with the unit intelligence officer, and sometimes there were deletions or changes. The copy was returned and we saw the changes. Sometimes we argued and won. Sometimes copy was held up in London. Censorship rules varied from unit to unit. We journalists were deeply concerned that an ill-timed report might endanger even a single American life, yet we recognized the distinction between censorship that protected American lives and censorship that served the public relations interest of the government.

Unlike the rancorous Vietnam era, the forties would be recalled by many as a time when patriotism and support for the war overcame the inevitable and enduring tensions between reporters and their military subjects.

As a correspondent, I was lucky enough to be involved in, and survive, many of the events in western Europe. I was one of the first six correspondents to fly with the U.S. Eighth Air Force, on a raid on the Wilhelmshaven naval base in northwestern Germany in February,

1943. There were supposed to have been eight of us, but one became ill and one plane had to turn back because of technical difficulties. One of our number, the *New York Times*'s Bob Post, lost his life when his B-24 Liberator bomber was shot down over the target. The youngest correspondent was my friend Andy Rooney, who later became a well-known CBS commentator. Also with us was Gladwin Hill of The Associated Press.

We had all been specially trained by the Army for the assignment. And, though we were not supposed to man a gun, the military forced us to attend gunnery school, in case we were needed in the air. We were issued parachutes and heavy flak jackets.

Andy said later: "I thought to myself, 'Why am I doing this? I'm scared to death. I don't have to risk my life—except that I felt so bad for all the men who did have to risk their lives all those times that it just seemed like it was the honest thing to do.'"

My story notes from that flight sixty years ago still stir memories. We were skirting the Frisian Islands and still an hour from the target

when our tail gunner sighted the first of the enemy fighters. Over the intercommunication system, he said: "Six o'clock," which in aerial parlance meant directly behind the plane. It didn't take the fighters long to close in on us, and they came toward us with guns spitting.

Our tail gunner was the first to open up. We could feel the vibrations set up by his rattling gun. Then the waist gunners took over, followed by the ball turret on the belly of the plane, then the top turret.

The enemy planes swept by, and the bombardier and navigator in the nose of the Fortress began firing their guns. Clips of empty cartridges flew around the tiny compartment and the stench of burning powder filtered through our oxygen masks. The antiaircraft fire began as we started the bombing run into Wilhelmshaven.

Through broken clouds at 26,000 feet, we saw the toy village of Wilhelmshaven. The planes ahead were the first to drop their bombs. The "eggs" were plenty hideous-looking as they began what appeared a slow descent to earth. Then the bombardier in my plane, a 26-year-old first lieutenant, put his left hand on the switch panel alongside him and almost imperceptibly touched the button.

"Bombs away!" he said calmly over the intercommunication system. That was it: our mission had been accomplished. I couldn't see our own bombs falling, and even our ball turret gunner was unable to see them hit the ground because of our extreme altitude. I did see some bombs hurtling down from almost directly above us. These came from another formation, and they fell so close to our wings that I could read the inscriptions on them.

Luck was with us, and our Fortress came through the torrent without damage. Other formations caught the brunt of the fighter blows and we saw Fortresses and Liberators plucked from the flights around us. Seven planes were later missing. Andy's bomber was hit, but returned safely. As we swept back over the North Sea we saw great pillars of smoke pluming from the target area. It was a relief to be back home in England.

For the months preceding the Normandy invasion, I was in charge of our coverage of the air war. From experiences like the one I've just described, I knew what our crews were facing as they penetrated deeper and deeper into Germany on their mission to crush the Nazi war machine. They were taking heavy losses. None of us ever will forget what became known in 1944 as The Big Week: the most concentrated seven days of our bombardment of Germany—February 19-25. Those were days we waited at English air bases for the Fortresses and the Liberators to return from the deepest and most dangerous penetrations of Germany to date.

When they began appearing over the Channel coast, fears mounted and fears were confirmed. On the ground, we watched their return, counting the number of planes left in the formations. Many fired off red rockets as they landed, signaling wounded aboard. Two hundred and forty-four bombers were lost that week . . . more than 2,000 airmen.

In the spring of 1944, the Ninth Air Force, the tactical force in charge of medium bombardment and the fighters escorting the Eighth's bombers, offered me an opportunity to go on a special mission.

"It will be dangerous, and we won't even be able to tell you after you have been there what we have bombed, and we don't know whether you'll even be able to write the story" was the way they phrased the invitation. It didn't sound particularly promising, but the mystery made it irresistible and I accepted.

In a B-25 Mitchell medium bomber, at low level against a lot of flak that bounced us around a bit, we bombed something I could not identify . . . a sort of L-shaped concrete structure that looked like a ramp of some kind. Our crew claimed that even they didn't know what it was. Only after the German unmanned V-1 missiles begin hitting London did I realize that what I had seen was a V-1 launching pad.

In a way, I had revenge for the fact that one of the first of the V-1s bombed me out of my flat on Buckingham Gate Road in London. That bomb may have been aimed for nearby Buckingham Palace, but instead it hit the Guards' Chapel just as Sunday services began with a large number of high British and American officers inside. The toll was terrible.

The Air Force assignment also got me a balcony seat for the Normandy invasion when I thought I had been cut out of that day in history. I was assigned to stay in London and help write the lead story when the invasion came, but the night before, I was awakened by the Air Force with an offer of another assignment. The Eighth Air Force had been asked to provide heavy bombardment on some recently discovered big guns just behind the beach, and the unit with which I had flown before, the 303rd B-17 group, had been given the job—a low-level attack for which they had no training.

We made two passes at our target, but the visibility was so bad we couldn't drop our bombs. On the flight back, I got a great view of that incredible armada and the troops as they assaulted the beaches of Normandy. A short while later, I would go ashore, too, only to be called back to England to train with the 101st Airborne Division for what was a planned drop on Rambouillet Forest outside Paris. We were to be with the troops who liberated the French capital.

It was a choice assignment, but it was not to be. Our ground forces moved so rapidly that the air drop was abandoned. Not too long afterward, following several other false starts with the Airborne

because of the speedy advance of the ground troops, I found myself with other correspondents on the way to Holland.

This time I was assigned to a glider. After seeing what happened to the gliders in the Normandy invasion, I had little heart for the experience, and a crash landing in the fields north of Eindhoven confirmed for me that this is a poor way to go to war. But we made it, and the 101st secured the area it was assigned, holding a route open for Field Marshal Montgomery's British forces that were supposed to crash through from Belgium and sweep across the Rhine on bridges at Arnhem.

Not only was this thrust turned back, but during the battle the British First Airborne Division landed right on top of a German armored division that wasn't supposed to be anywhere near Arnhem and, as valiant as the British troops were, they were all but wiped out. With the unsatisfactory conclusion of that operation, I was deployed to Brussels to cover Montgomery's headquarters. The U.S. First Army was spread out along the Luxembourg, Belgian, and Dutch frontiers with Germany when Von Rundstedt launched his famous attack.

I was asleep in my Brussels apartment when I was awakened by a colleague, United Press's First Army correspondent Jack Fleisher. He was dirty, unshaven, obviously sleepless, and considerably shaken. He had reached Brussels after being caught in a maelstrom of American men and vehicles fleeing the front in a disorganized retreat.

Fleisher wrote a dispatch for me to try to get through the censors and, despite his exhaustion, remounted his jeep to try to get back to the front. I filed the dispatch (it never went through) and filed another advisory to our Paris headquarters that I, too, was on the way to action. Jack would die later, when a stray bomb hit near the First Army press camp. I was luckier. I joined the Third Army press corps after first checking into a hotel in Luxembourg. Several of us who were fast enough to get into the hotel commuted to the Battle of the Bulge each day, suffered the snowstorms and the terrible cold that were bedeviling our troops, but returned each night to a bottle of Champagne, a hot bath, and warm bed.

For us who were fortunate, hotel living was a brief, though welcome, respite. Many of our colleagues were living in mud-crusted fox-holes and snow, sleeping on cots in drafty tents or in sleeping bags, traveling by mule, jeep, or on foot.

I made it my principle assignment to write about my old mates, the 101st, who were surrounded in Bastogne. The world followed the dramatic fight as they held that important road junction, so vital to Von Rundstedt's progress. It was there, of course, that General Tony McAuliffe answered a German demand to surrender with the single-word response that always will be indicative of the 101st spirit. He said to the German courier's demand: "Nuts!"

The 101st and other Airborne colleagues remained somewhat amused by the world's concern at their being surrounded at Bastonge. As one told me: "What was all the excitement? We were where we are trained to be—behind enemy lines. We are supposed to be surrounded!"

And I was lucky enough to be at the Ninth Air Force forward control point the day the weather finally cleared and the pilots' frustrating helplessness ended. The P-47 Thunderbolts were up above the clouds, the battleground shrouded somewhere below them, and we were listening to the occasional radio chatter between them when there came the electrifying words from the flight leader. I'll never forget it.

"Hey," he said. "There's a hole over there. Good God, there's the whole damned German army down there. Look at 'em! Okay, boys, follow me." In their own words, they "pranged the Germans good." The smoke of burning tanks and trucks and guns that they left behind was the funeral pyre of Von Rundstedt's army and Hitler's dreams.

Our war, and my role in covering it, didn't end until May 1945.

"There is only one way to get the feel, smell, the taste, and the terror of war, and that is to experience it with the troops," wrote AP reporter Don Whitehead, who would later win two Pulitzer Prizes. "You cannot describe the desert unless you have the hot winds blowing sand in your eyes, picture an amphibious assault unless you have waded ashore with the troops and seen them fall around you, write of fear unless you have felt it gripping your soul."

Today we have stories and photographs of World War II because we had correspondents brave and courageous and dedicated enough to put their lives on the line beside our soldiers, to report accurately, fearlessly, and honestly the events they saw as they saw them and the people they met along the way. World War II changed all our lives, and left us a legacy of words and pictures unmatched for its speed and impact.

In 1964, on the twentieth-anniversary of D-Day, I interviewed former President Eisenhower on Omaha Beach, and he still seemed overwhelmed by what his men had accomplished there. "It just shows what free men will do rather than be slaves," he said. The photographs in this book are dedicated to all the brave souls who took part in the world war that defined the twentieth century, and to future generations so that they may know the price of freedom.

WALTER CRONKITE

Former anchor and managing editor, CBS Evening News

PHOTOGRAPHS FROM THE ARCHIVES OF **THE ASSOCIATED PRESS**

EDITOR'S NOTE: *All of the photographs in this book were selected from the archives of The Associated Press. Many were taken by AP staff photographers. Others were taken by photographers in the U.S. armed forces and disseminated to the American press. Still others were acquired from news organizations in other countries. No matter what their original source was, they were provided by the AP to its member newspapers during or shortly after the war and seen by American readers in their local newspapers. The photographs are arranged in chronological order, but photographs relating to one event or sequence of events are kept together. Most of the photographs in the archives are dated, but often the dates are misleading. Every effort has been made to give the correct date, but where that is not possible, a month or months and year are provided. Some of the photographs have areas scratched out by military censors to guard the identities and locations of U.S. troops in combat.*

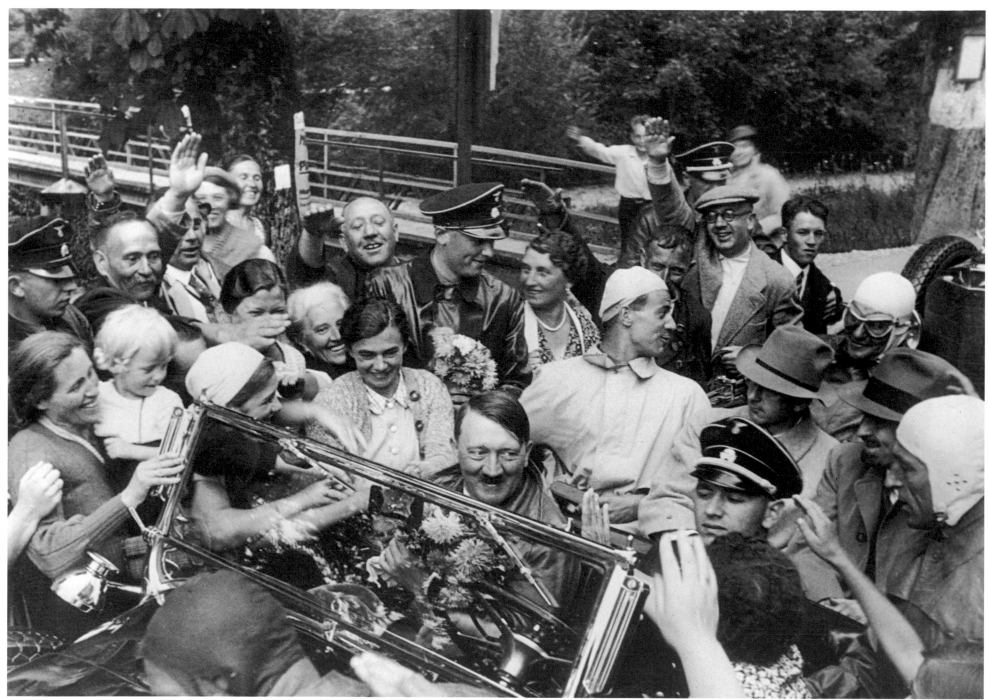

BERCHTESGADEN, GERMANY, SEPTEMBER 9, 1934

Adolf Hitler came to power in Germany in January 1933, when the aging president Field Marshal Paul von Hindenburg let him form the new government. The Reichstag granted Hitler dictatorial powers on March 23, 1934. When Hindenburg died on April 2, Hitler combined the offices of Reich Chancellor and President, declaring himself Führer and Reichsführer. Here, he is mobbed by well-wishers as he travels between his residence in Berchtesgaden and the sixth Nazi Party Congress in Nuremberg, an event both staged for and memorialized in Leni Riefenstahl's film *Triumph of the Will*.

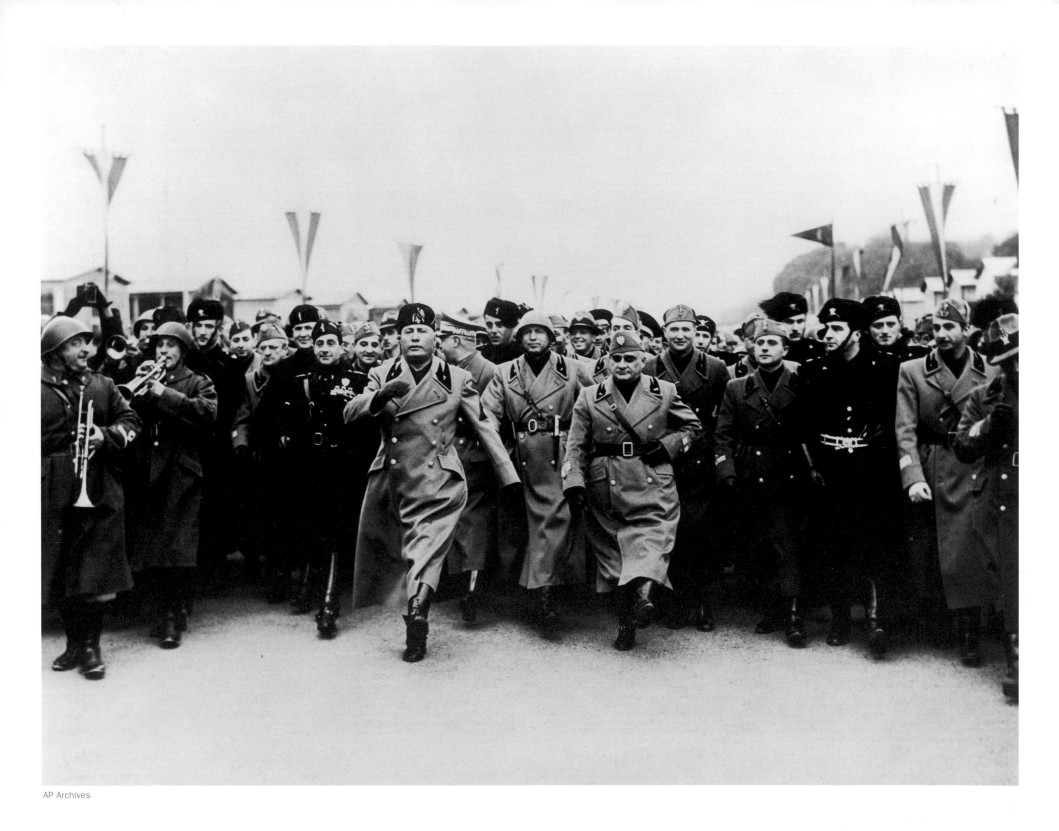

ROME, JANUARY 27, 1938

By 1938, Italian Prime Minister Benito Mussolini had possessed dictatorial powers for more than a decade and was moving toward an alliance with Nazi Germany that was to be cemented by the Pact of Steel in May 1939. Here, he leads a rehearsal for a military parade in honor of Hitler's planned visit to Rome later in the year. The marchers are practicing the goose step, the stiff-legged marching style that was the signature of Hitler's armies. A year later, the Axis powers of Germany and Italy signed a pact with Japan in Berlin.

NUREMBERG, GERMANY, SEPTEMBER 11, 1938

Nazi storm troopers march through Nuremberg during the 10th Nazi Party Congress. In his speech to the congress the next day, Hitler warned the Czechoslovak government of his concerns over the treatment of the German-speaking majority living in the Sudetenland region. Less than three weeks later, on September 29, the Munich pact granted Hitler the Sudetenland, and he agreed to respect the sovereignty of the remainder of Czechoslovakia. This appeasement of Hitler by other European powers led to a false sense that war could be avoided.

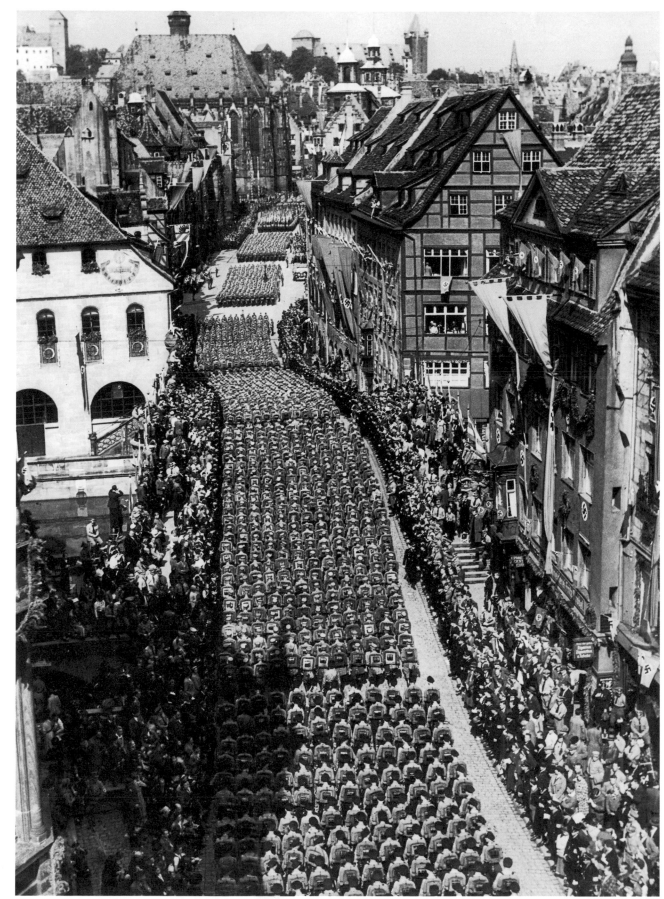

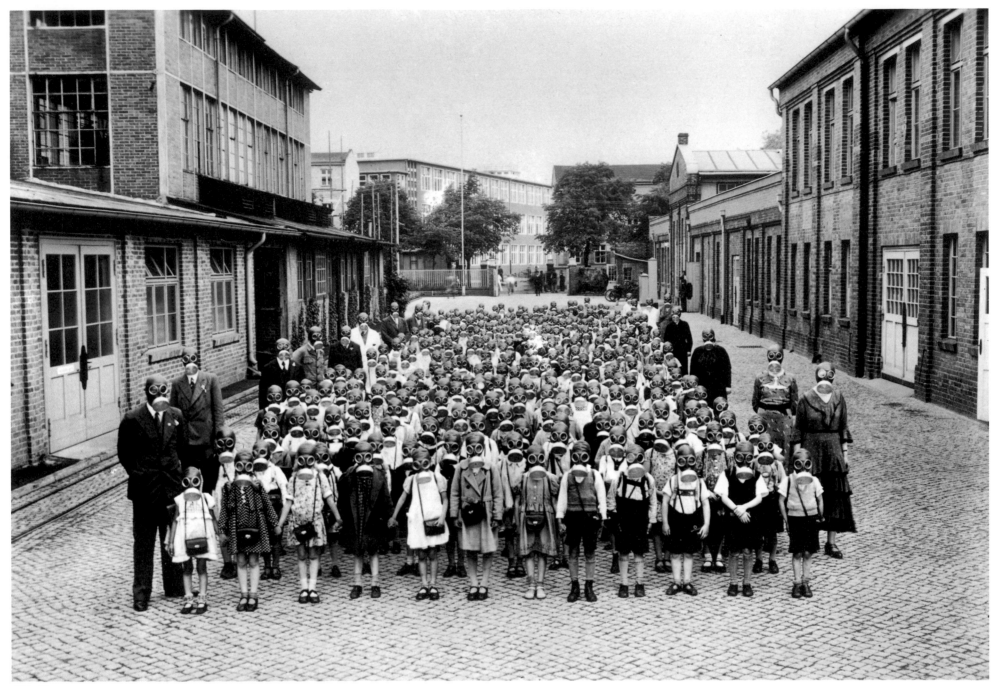

BERLIN, LATE AUGUST 1939

In March 1939, Germany completed the occupation of Czechoslovakia, Hitler's promise at Munich lost in the dust of his invading forces. Britain then drew another line, guaranteeing the sovereignty of Poland and Romania, and Hitler crossed it. On August 23, he signed a pact with the Soviet Union secretly agreeing to partition Poland between the two nations. When the German army invaded Poland on September 1, wider war was inevitable. The first Allies, Britain, France, Australia, and New Zealand, declared war on Germany two days later. Here, schoolchildren drill in gas masks as Germans prepare for war to come to their soil.

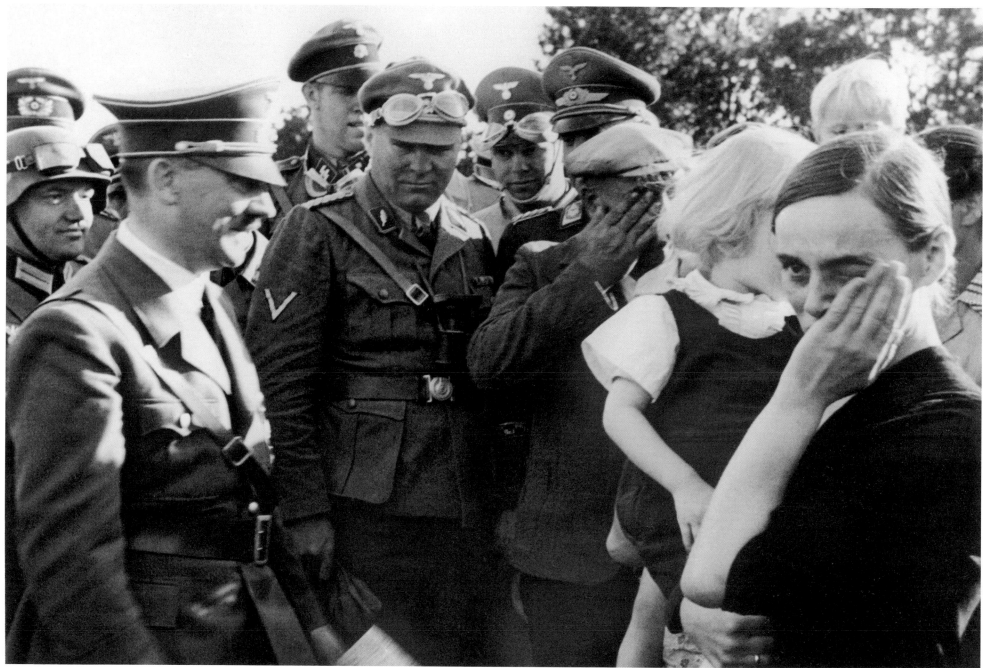

POLAND, SEPTEMBER 1939
Surrounded by his military officers, Hitler talks to a group of Polish-Germans in the
aftermath of the invasion of Poland. As in the case of Czechoslovakia, Hitler claimed that the
invasion of Poland was provoked by the treatment of German nationals living there.

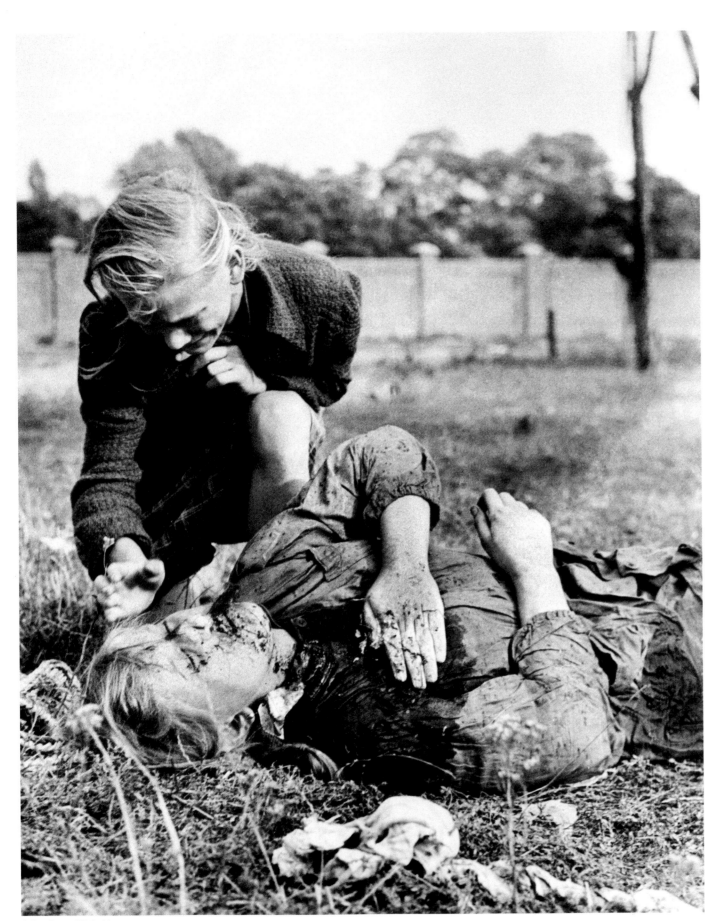

WARSAW, POLAND,
SEPTEMBER 1939
A woman mourns her sister,
killed by German machine-gun fire
while she was picking potatoes
in a field outside Warsaw.

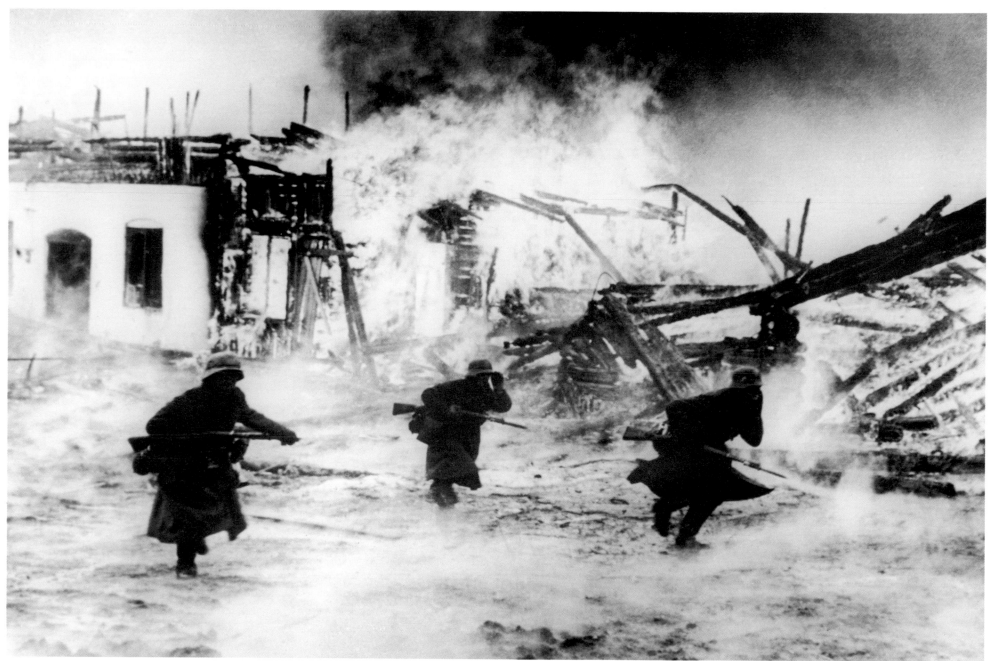

AP Archives

NORWAY, APRIL 1940

The Germans invaded Denmark and Norway on April 9.
Denmark surrendered after resisting for two hours, and obtained a degree of
internal autonomy from the Nazis. Norway gave in two months later, on June 10.
Here, German soldiers move through a burning Norwegian village.

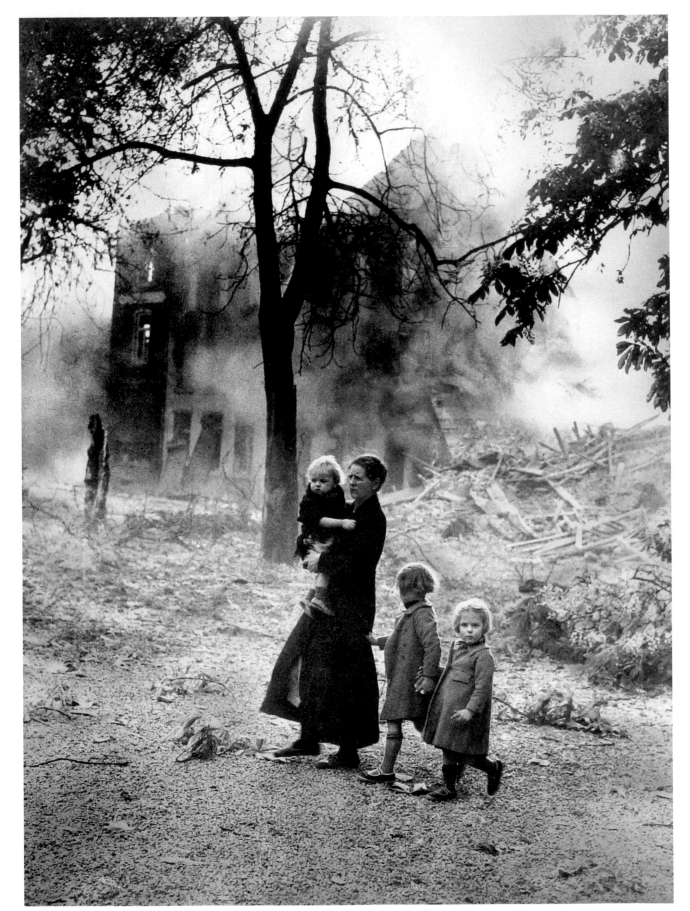

BELGIUM, MAY 1940
Germany invaded France, Belgium,
Luxembourg, and the Netherlands on
May 10. Using tanks, aircraft, and airborne
troops to overcome opponents with larger
forces, the Germans essentially conquered
Western Europe in ten days, although it took
about five weeks for the drama to play out.
This family was left homeless in the chaos.

PARIS, JUNE 14, 1940

The main German force reached Paris at noon on June 14. Here the army is seen marching into the city along the Champs-Elysées. Reporters noted that the capital seemed unusually silent. French president Paul Renaud resigned, and Henri-Philippe Petain formed a new government that shortly thereafter set itself up in the town of Vichy. Petain signed an armistice with the Nazis on June 22, which amounted to surrender. Hitler was in Paris the following day.

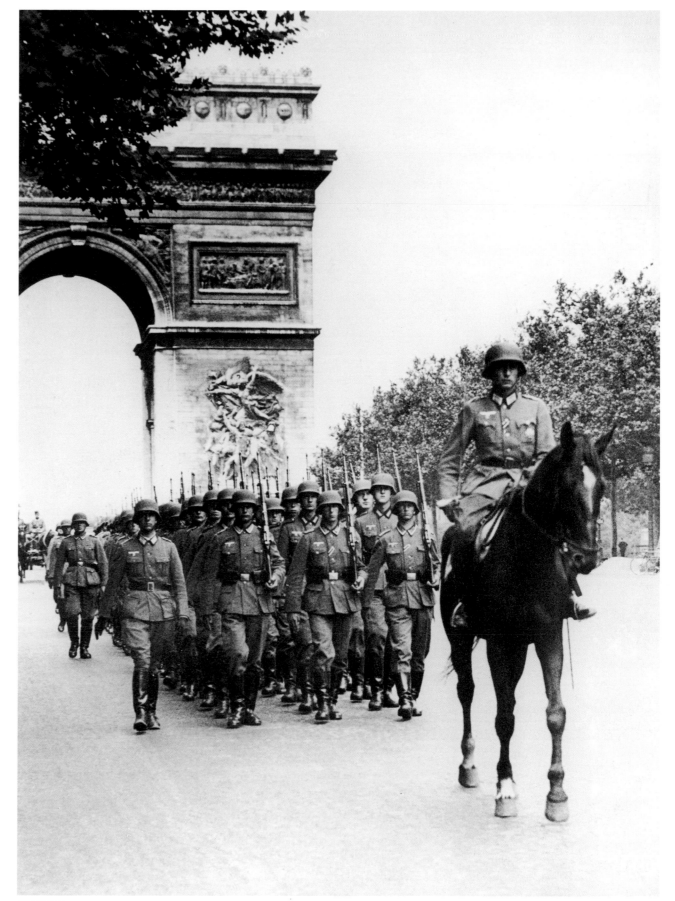

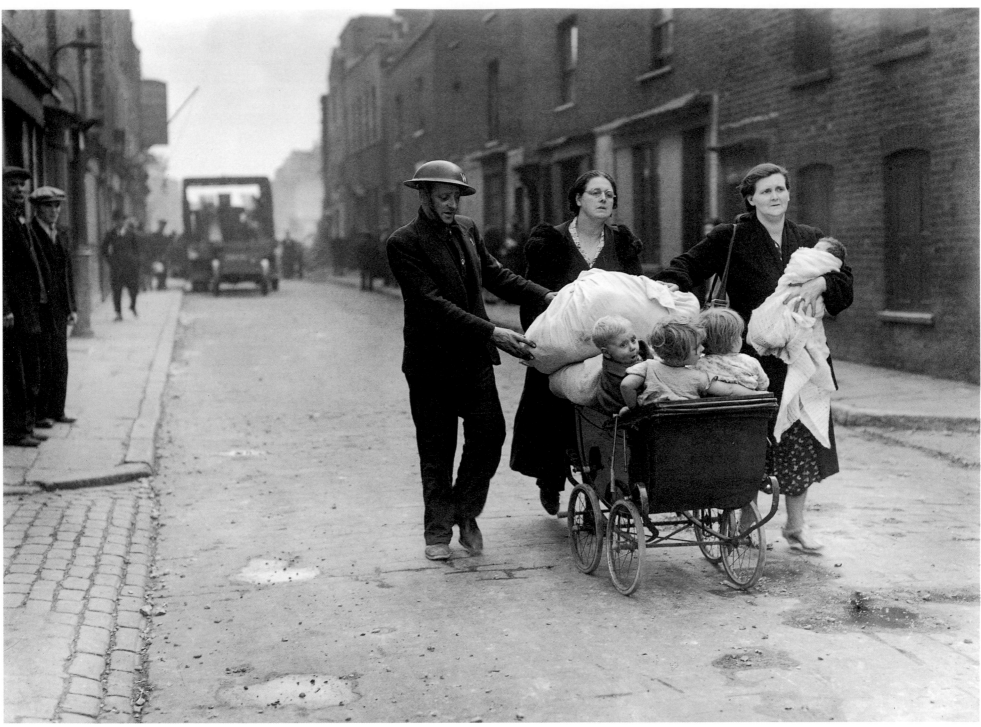

LONDON, SEPTEMBER 8, 1940

An East London family moves to safer quarters after losing their home on the opening night of the Blitz. The first
German air raid on central London took place on the night of August 23, and the British retaliated with an attack on Berlin
two days later. The Blitz—Hitler's attempt to demoralize the English people through concentrated bombing of population centers,
particularly London, and industrial facilities—began on the night of September 7, 1940, and lasted until May 11 the next year.

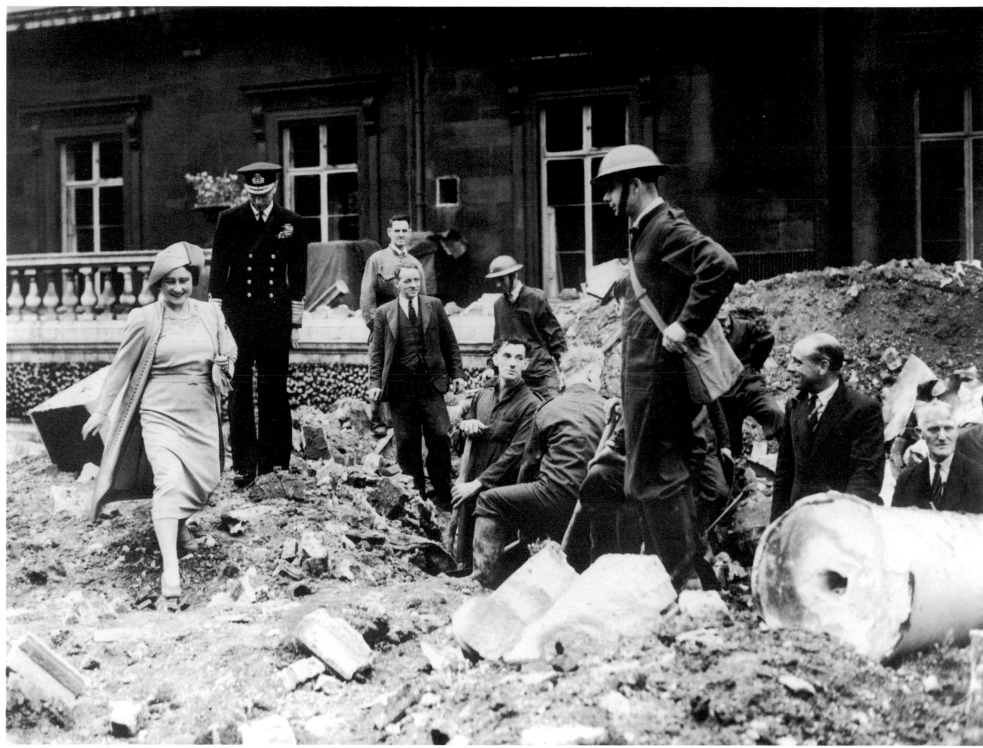

LONDON, SEPTEMBER 1940
Britain's Queen Elizabeth and King George VI, standing behind her in uniform,
inspect damage to Buckingham Palace inflicted by German air raids on September 10.

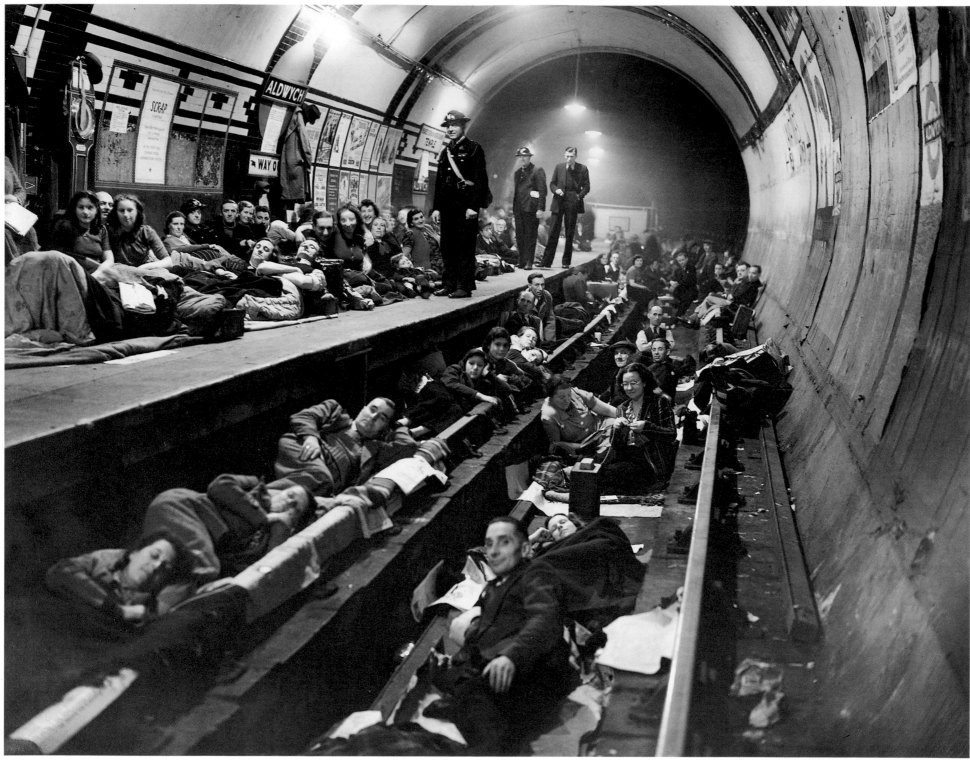

LONDON, OCTOBER 21, 1940
London was fortunate to have a deep subway system, whose underground stations made effective
air-raid shelters. Here, Londoners seek shelter for the night from heavy German bombing raids.

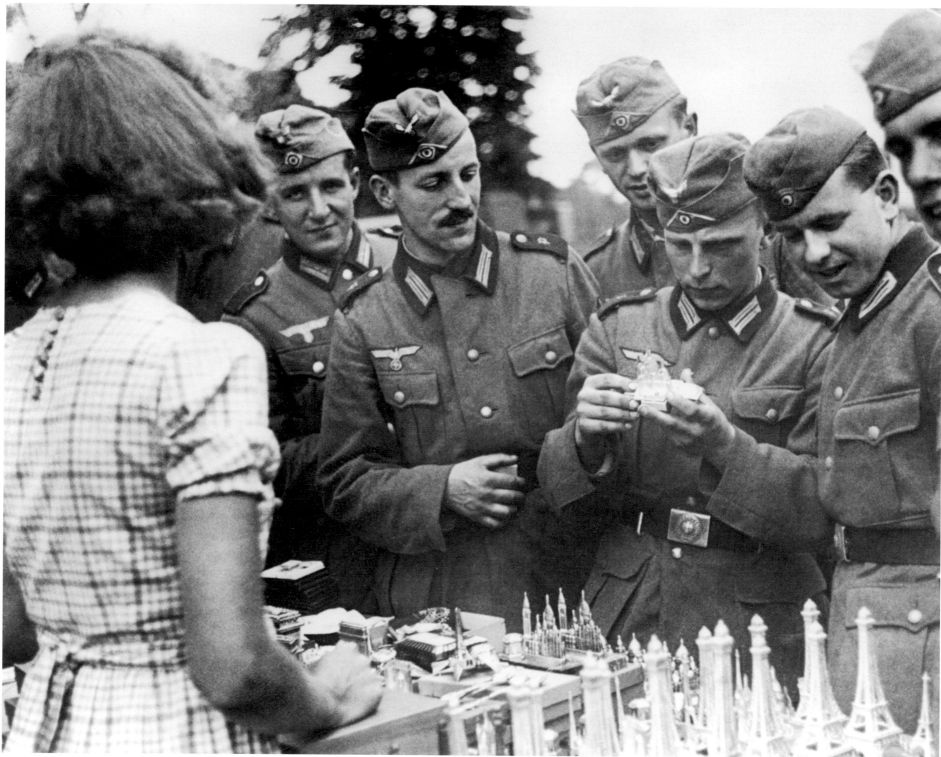

AP Archives

PARIS, OCTOBER 1940

In Paris, occupying German troops shop for familiar tourist
souvenirs. The German occupation of Paris, which lasted until 1944, was
relatively peaceful, and the city escaped the war more or less unscathed.
French police actually outnumbered German troops in the city.

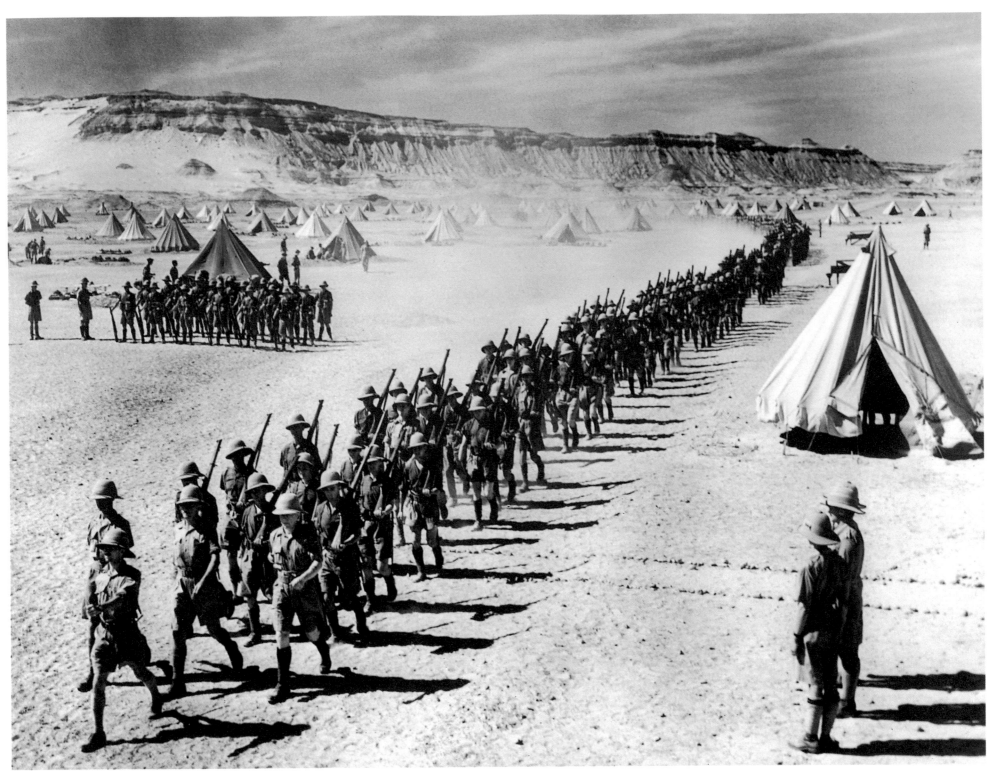

EGYPT, DECEMBER 1940

Italy invaded Egypt from Libya on September 13, and in early December, Britain launched
an offensive against the Italians in North Africa. Here, newly arrived British troops leave their camp to
train for desert warfare. The outnumbered British won a series of dramatic battles and might have driven
Axis forces from North Africa completely had the Cabinet not diverted forces to Greece in February 1941.

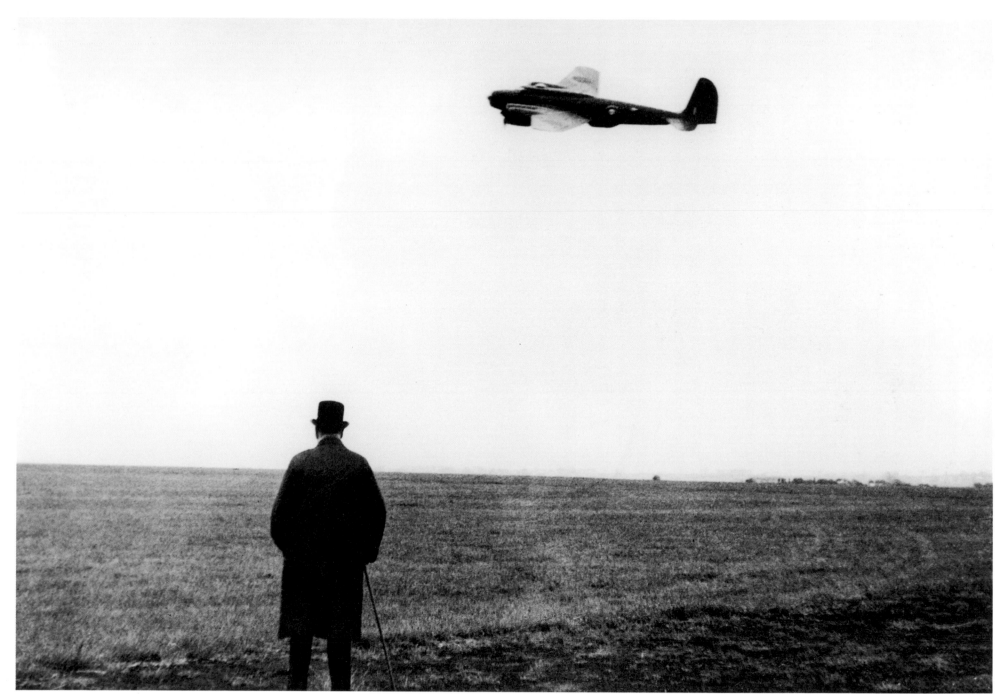

AP Archives

UNDISCLOSED LOCATION, ENGLAND, JANUARY 16, 1941
Winston Churchill became prime minister of England on May 10, 1940, and was
instrumental in organizing the air defense for the Battle of Britain in summer and early fall 1940,
an achievement that preserved his nation's independence and prevented Germany from seizing a
swift victory in the war. He is seen here with a fighter plane undergoing a flight test overhead.

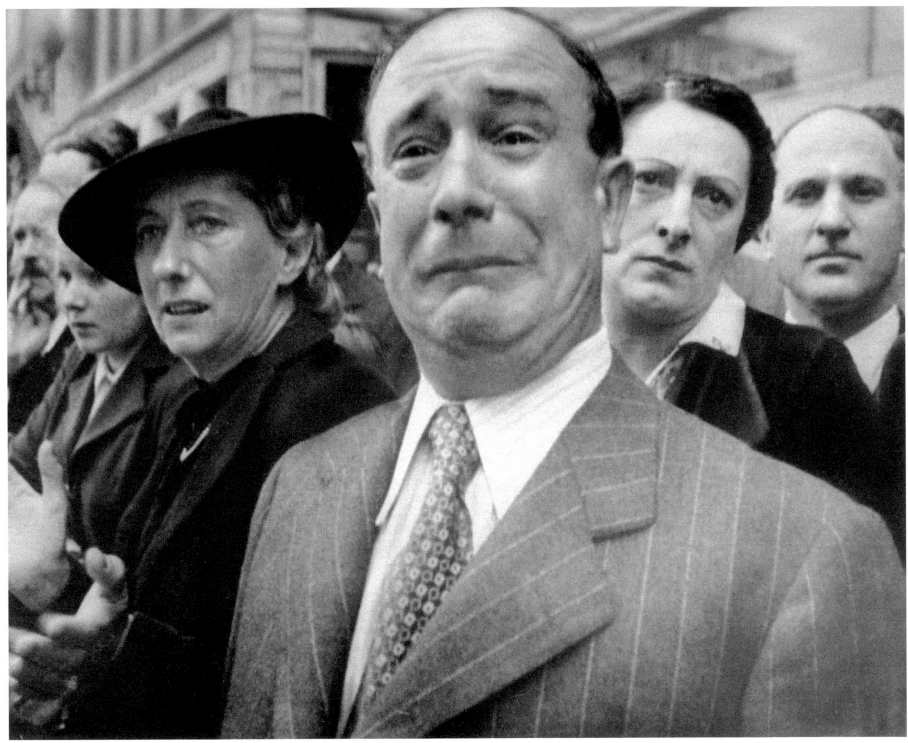

MARSEILLE, FRANCE, FEBURARY 19, 1941

A Frenchman weeps as he watches his nation's historic regimental flags being carried through the streets of Marseille on their
way to Algeria for safekeeping. The armistice with Germany required France to disband its army, except for 100,000 men kept in uniform
to maintain domestic order, in an arrangement mirroring Germany's obligations under the Versailles Peace Treaty ending World War I.
One and a half million French POWs remained in German concentration camps for the duration of the war.

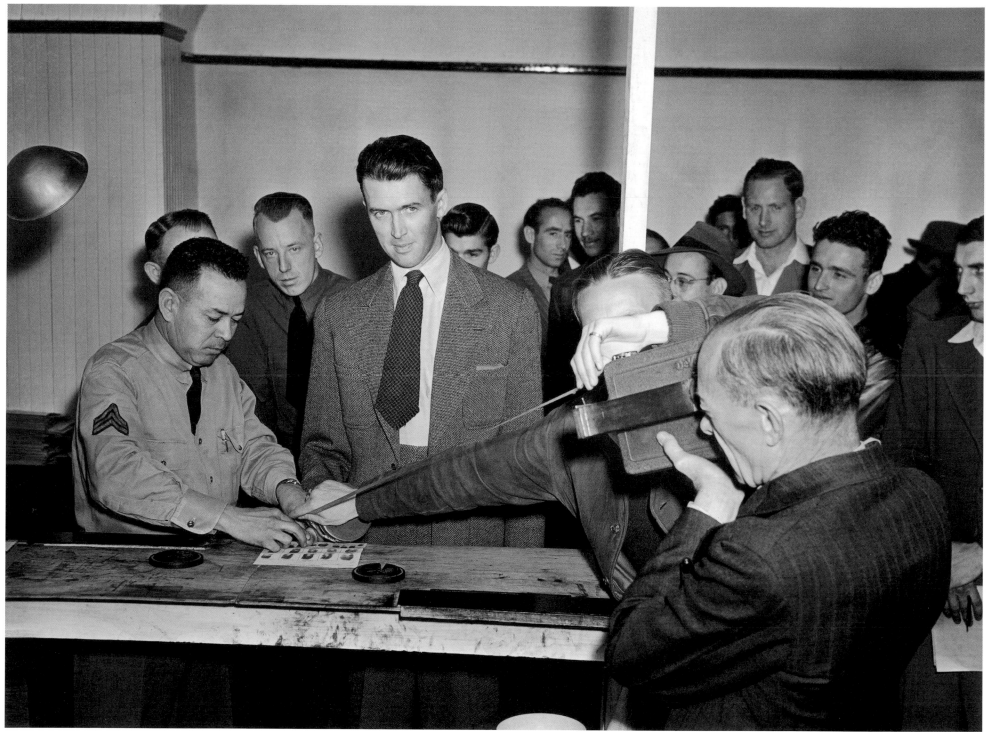

LOS ANGELES, MARCH 22, 1941
Many Americans, aware that war might be imminent, were eager to
serve. Actor Jimmy Stewart, seen here being fingerprinted at his induction,
barely made the weight requirement for service in the Army Air Corps. Still, he became
a combat pilot and eventually a brigadier general in the Air Force Reserve.

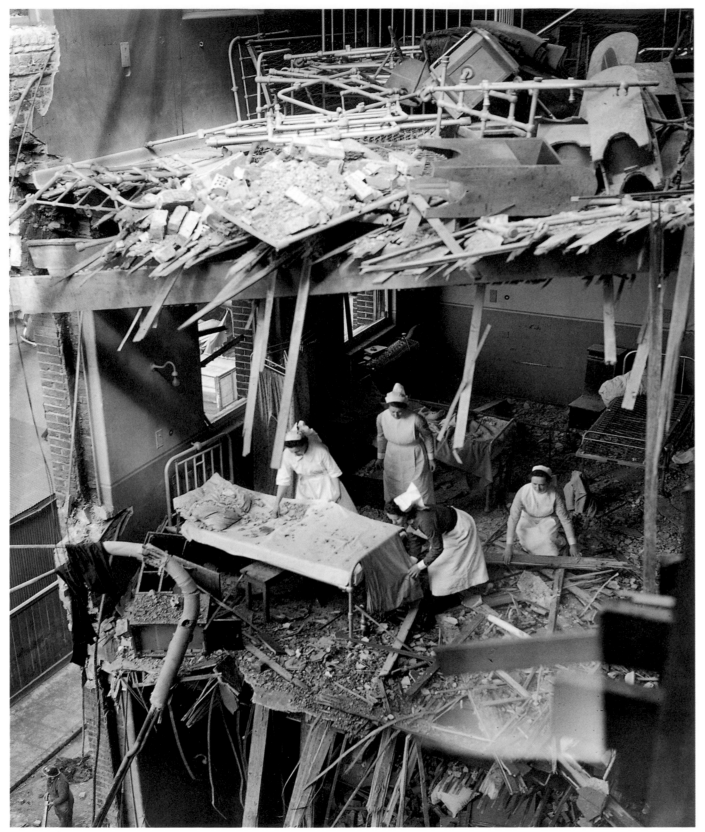

LONDON, APRIL 20, 1941
Nurses make a futile effort to clear
debris from one of the wards in St.
Peter's Hospital, East London—one of
four hospitals damaged in German
air raids the night before.

LONDON, MAY 11, 1941
Winston Churchill inspects damage to
the House of Commons after what was
probably the worst raid on London
during the Blitz. Nearly 1,500 people
were killed and about 1,800 seriously
injured that night. Over the course of
the war, approximately 60,500 English
civilians were killed, and another
86,000 seriously injured, virtually all
in air raids and missile attacks.

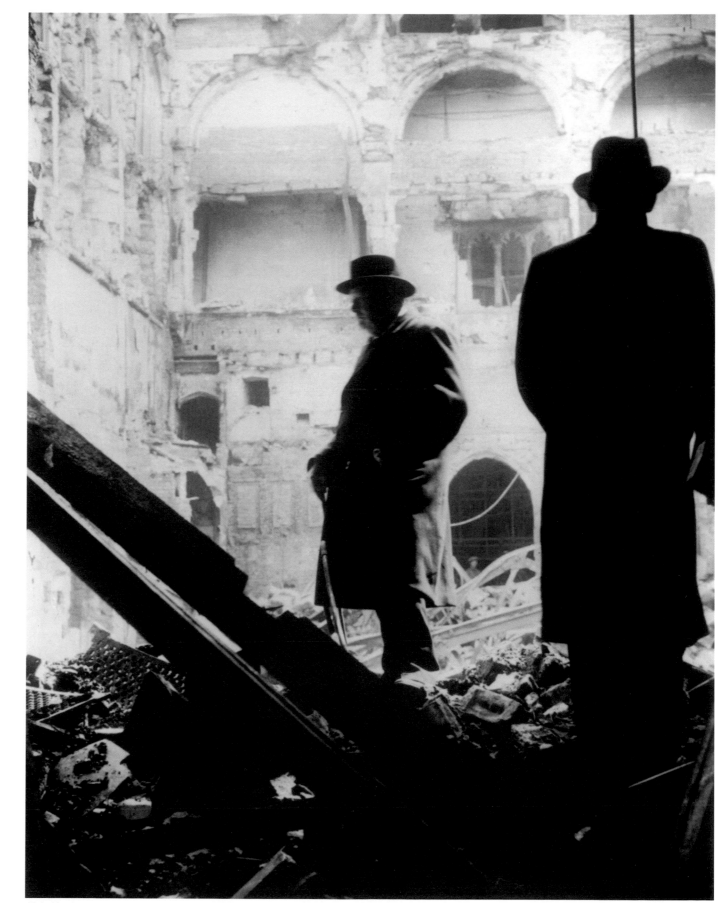

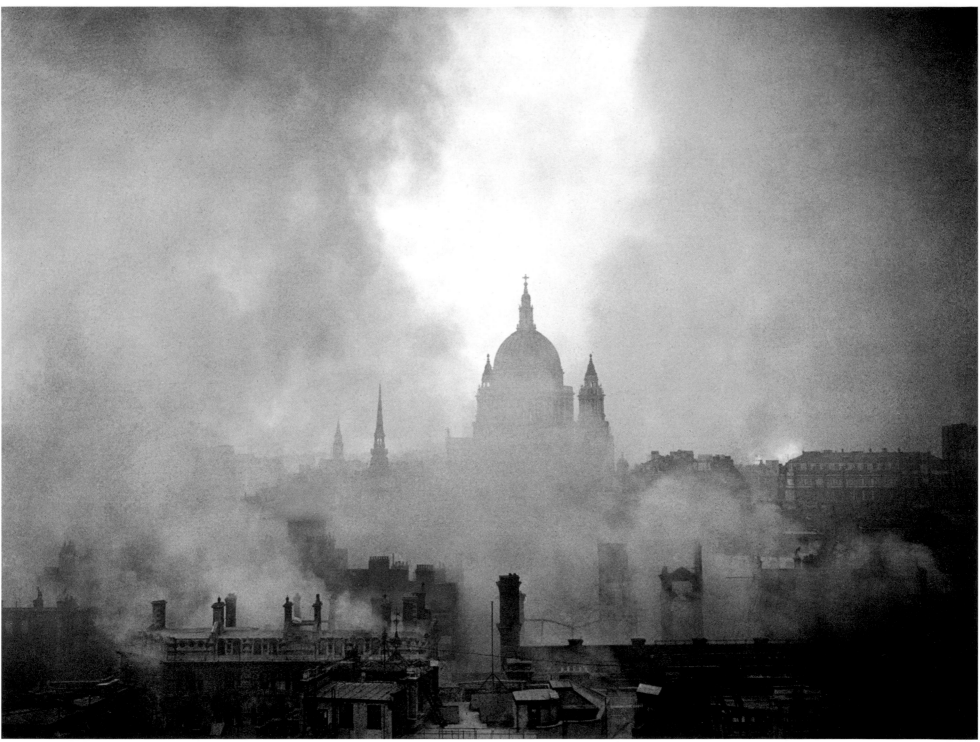

LONDON, MAY 11, 1941
St. Paul's Cathedral is shrouded in smoke after the last intense bombing raid of the Blitz.

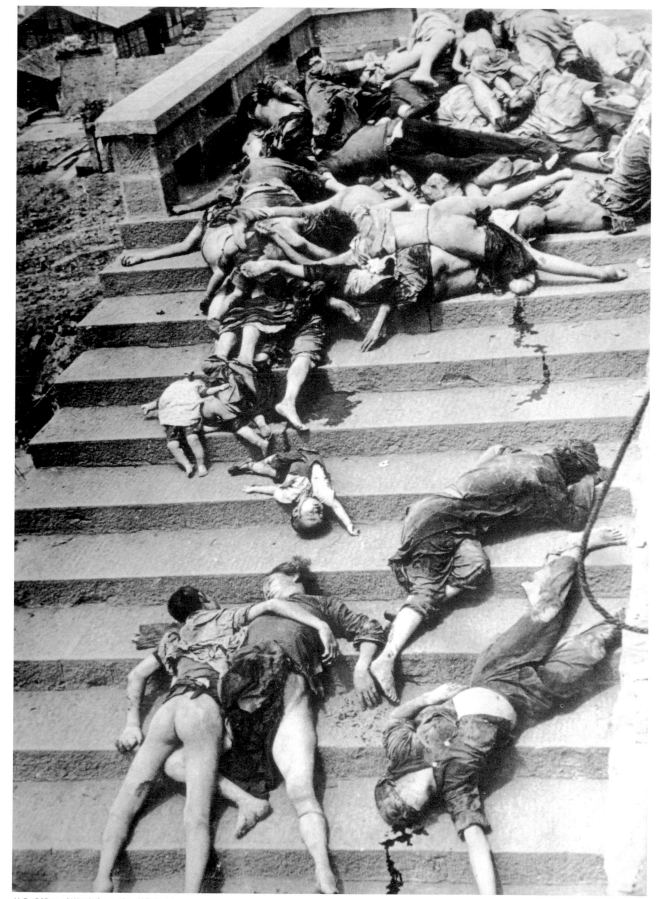

CHONGQING, CHINA, JUNE 5, 1941

In 1941, Japan's undeclared war on China, which had already claimed hundreds of thousands of lives since Japan's invasion of 1937, became increasingly brutal. This photograph shows the result of civilian panic during a Japanese air raid on the Chinese Nationalist capital of Chongqing, when more than 4,000 people were killed in the rush to shelters. The Nationalists and Mao Zedong's Red Army stood in uneasy alliance against Japan. Chinese civilian deaths in the war are not known; they certainly numbered in the millions.

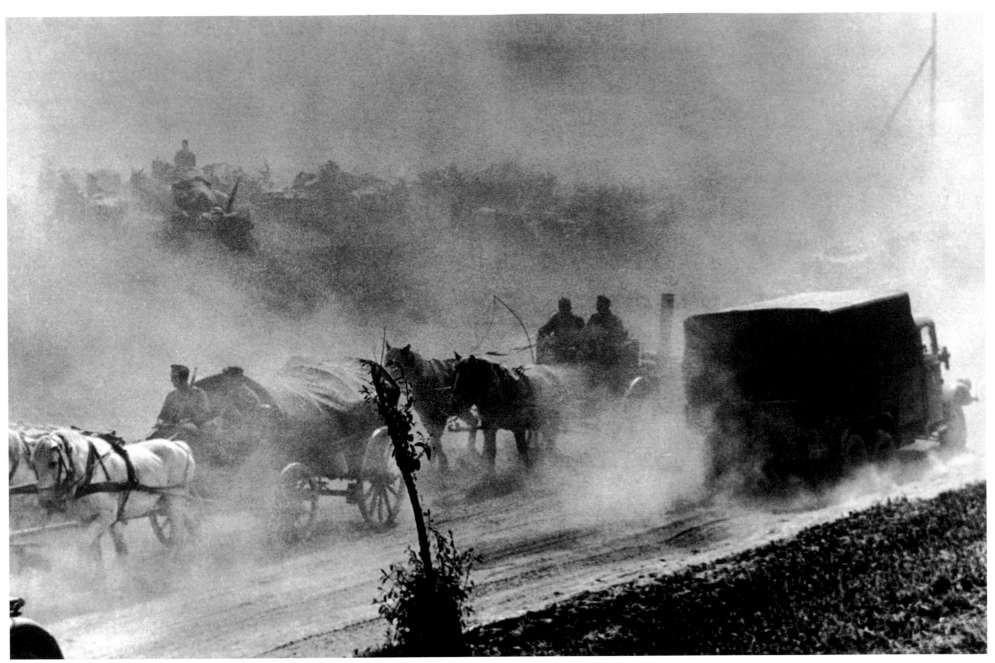

EASTERN FRONT, JULY 1941

On June 22, Germany invaded the Soviet Union in a stunning refutation of their alliance. The German army supported its massive deployment with horse-drawn supply wagons as well as trucks. The original caption of this photograph states, "German sources described the scene as the advance into Russia." The Russian people paid an extraordinary price for the invasion: estimates of wartime casualties in Russia range from 2.5 million civilians killed or seriously wounded to a total loss of population of 20 million people.

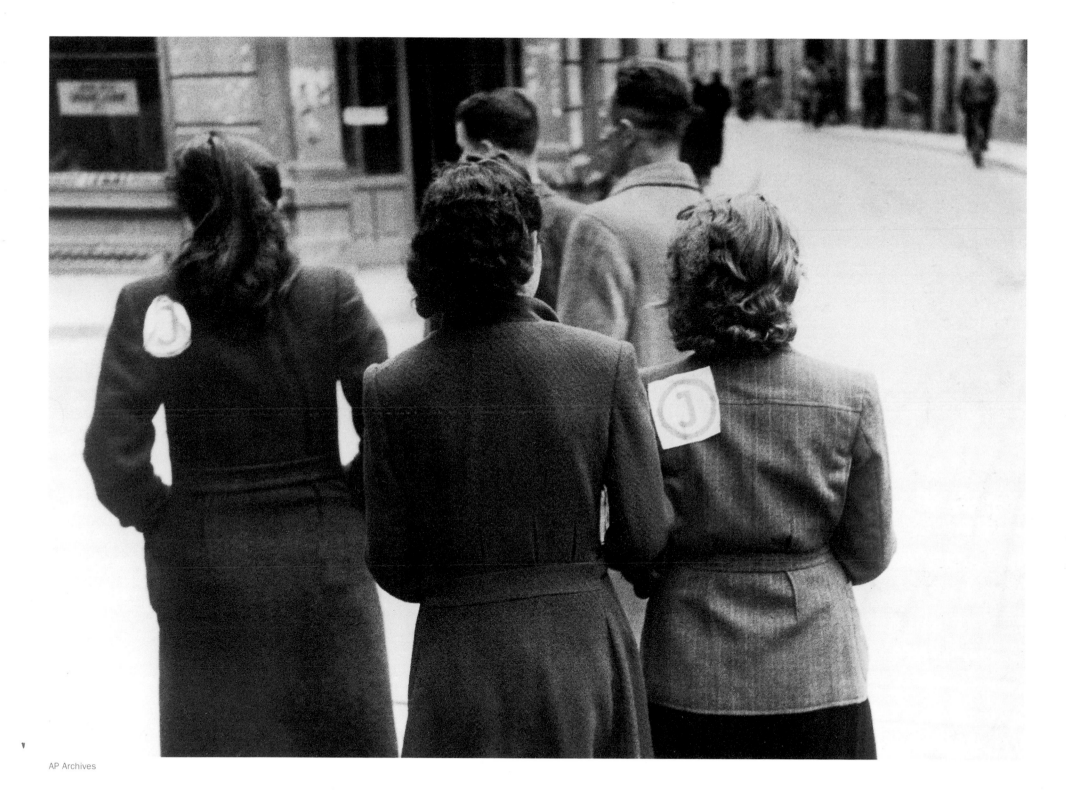

VILNIUS, LITHUANIA, JULY 25, 1941

Nazi directives that Jews be identified—first on their legal documents and later on their persons—proliferated in Germany and occupied Europe in the late 1930s. The ethnicity of these Lithuanians is proclaimed by their badges. Elsewhere, Jews were required to wear yellow Stars of David. Violence against Jews escalated as the German army advanced through the Baltic States. In September 1943, Jews remaining in the Vilnius ghetto were deported to concentration camps in Estonia, where most perished.

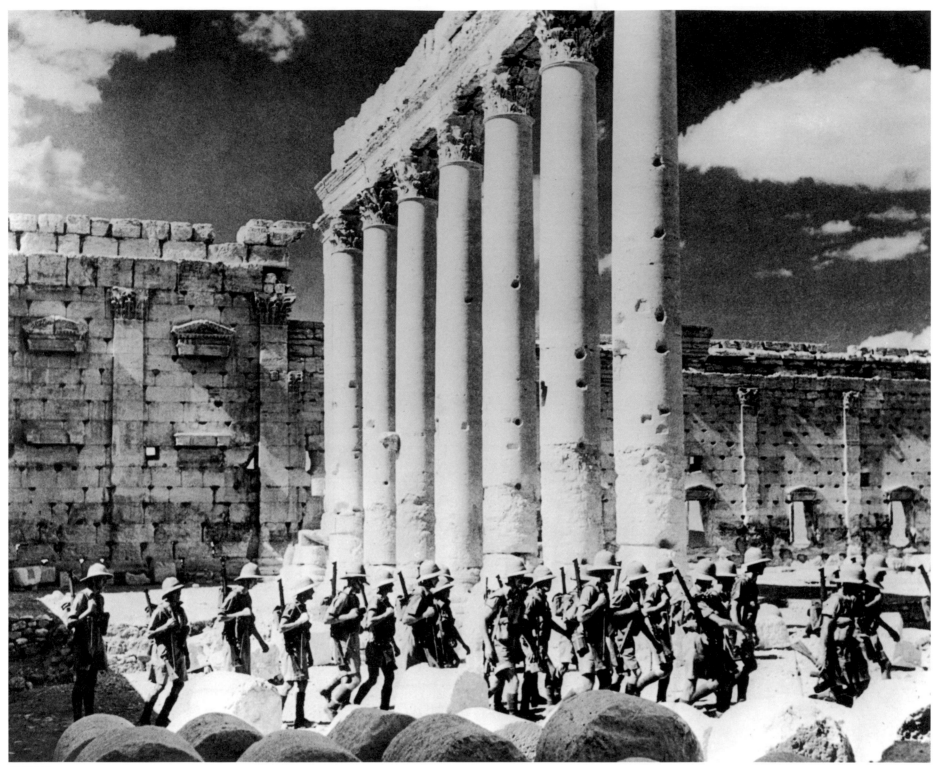

PALMYRA, SYRIA, SUMMER 1941

Syria had become, for all intents and purposes, a colony of France in 1920. It was still a French Mandate in 1940 and thus became an Axis-occupied nation when Germany conquered France. On June 14, 1941, British and Free French troops defeated the Vichy French forces there—one of the few successes in an otherwise bleak year for the Allies. Gen. Charles De Gaulle of the Free French forces promised to end the French Mandate in the event of an Allied victory, and the French finally departed Syria after the war, in 1946. Here, victorious British troops march through ruins of the Roman Empire.

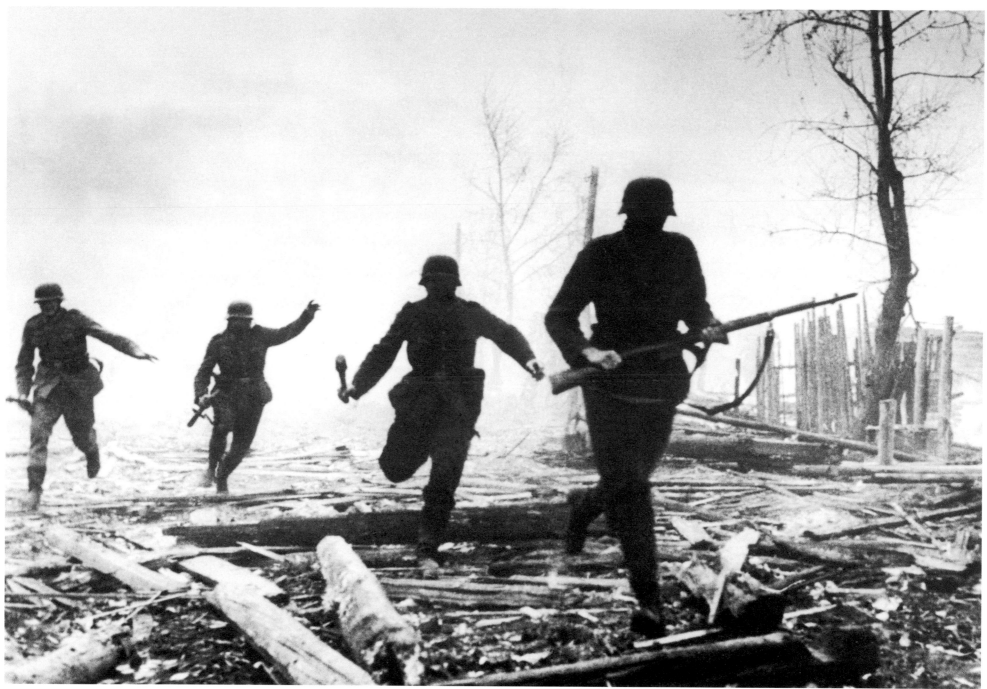

EASTERN FRONT, OCTOBER 1941

In October, when this photograph of German infantry was taken, the German High Command was
optimistic about reaching Moscow before the weather made further advances into Russia impossible.
Generals in the field were less sanguine. Their concerns were borne out when mud and snow forced the
German armies to halt for the winter twenty miles short of the Soviet capital on November 15.

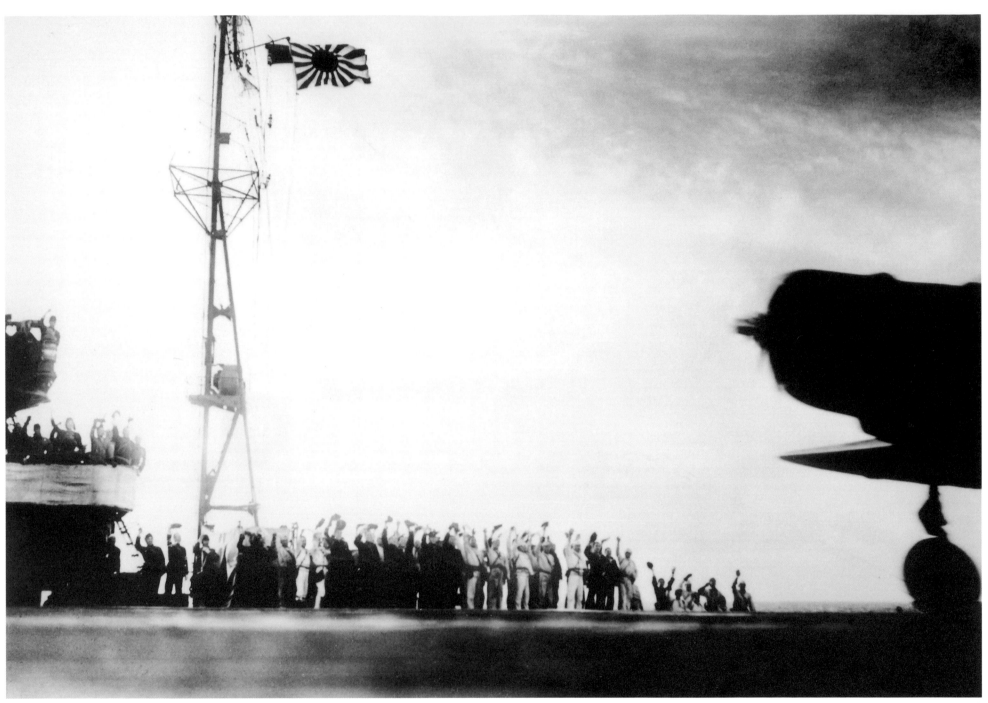

PACIFIC OCEAN, DECEMBER 7, 1941

In late July, the United States and Great Britain placed an embargo on oil supplies to Japan, setting the stage for war in the Pacific. In early December, Japanese admiral Isoroku Yamamoto sent a strike force of six aircraft carriers on a roundabout route to launch a surprise assault on the American naval base at Pearl Harbor in the Hawaiian Islands. In this photograph, from film captured later by American forces, a Type 97 Carrier Attack Plane is being launched from the flight deck of a Japanese aircraft carrier—believed to be either the *Zuikaku* or the *Shokaku*—in the second wave of the attack on the base.

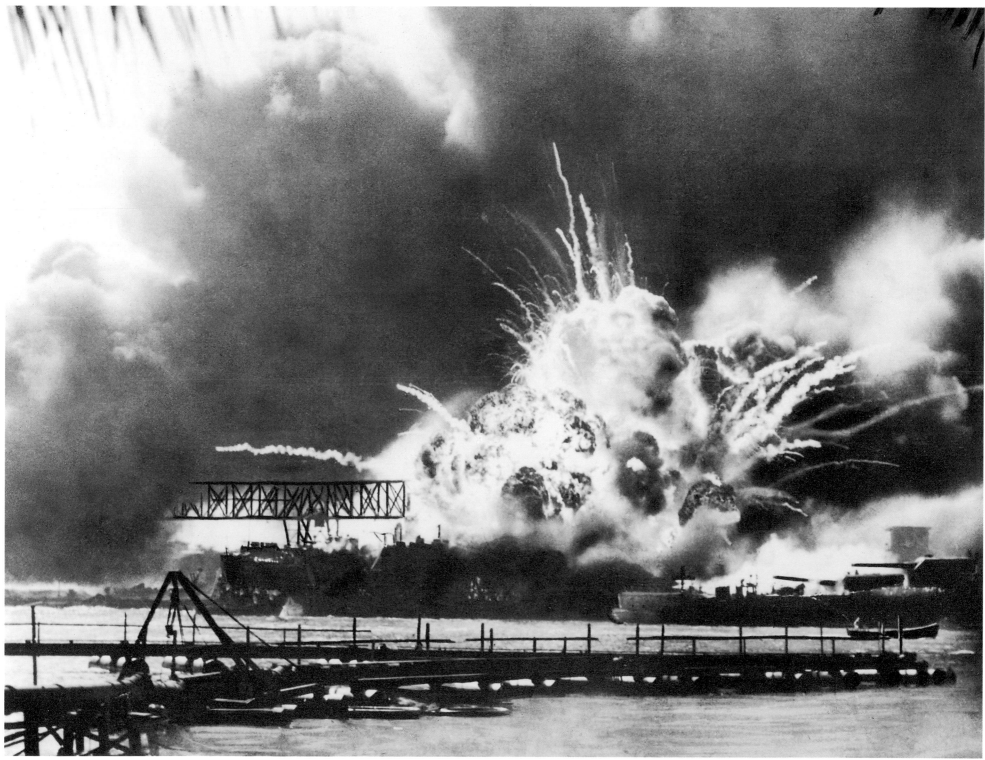

PEARL HARBOR, HAWAII, DECEMBER 7, 1941

Four of eight American battleships docked at Pearl Harbor went down in the surprise attack, one was beached, and the others badly damaged. More than 2,400 Americans died. In this photograph, the forward ammunition magazine of the destroyer USS *Shaw* explodes about a half-hour after three bombs hit the ship in the second wave of the attack. The *Shaw* was rebuilt and finished out the war, to be decommissioned in October 1945 and sold for scrap the next year.

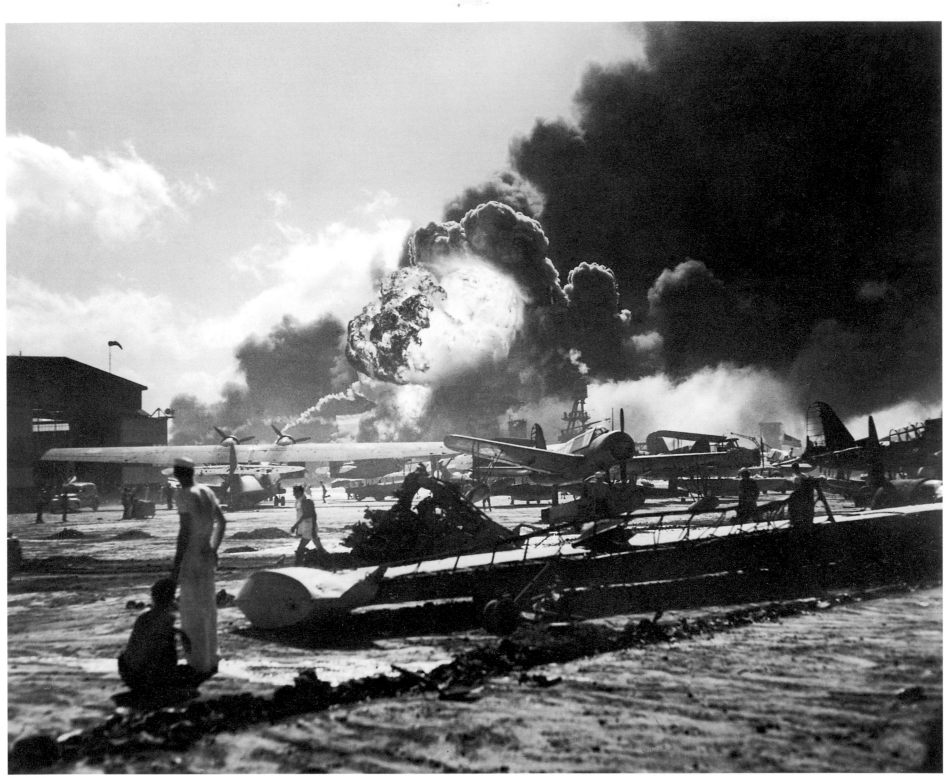

PEARL HARBOR, HAWAII, DECEMBER 7, 1941
Sailors standing among wrecked airplanes at Ford Island Naval Air Station look up at the
explosion of the USS *Shaw*. The Japanese assault on Pearl Harbor, along with landings in the Philippines,
robbed the United States of naval and air power in the Pacific for almost half a year.

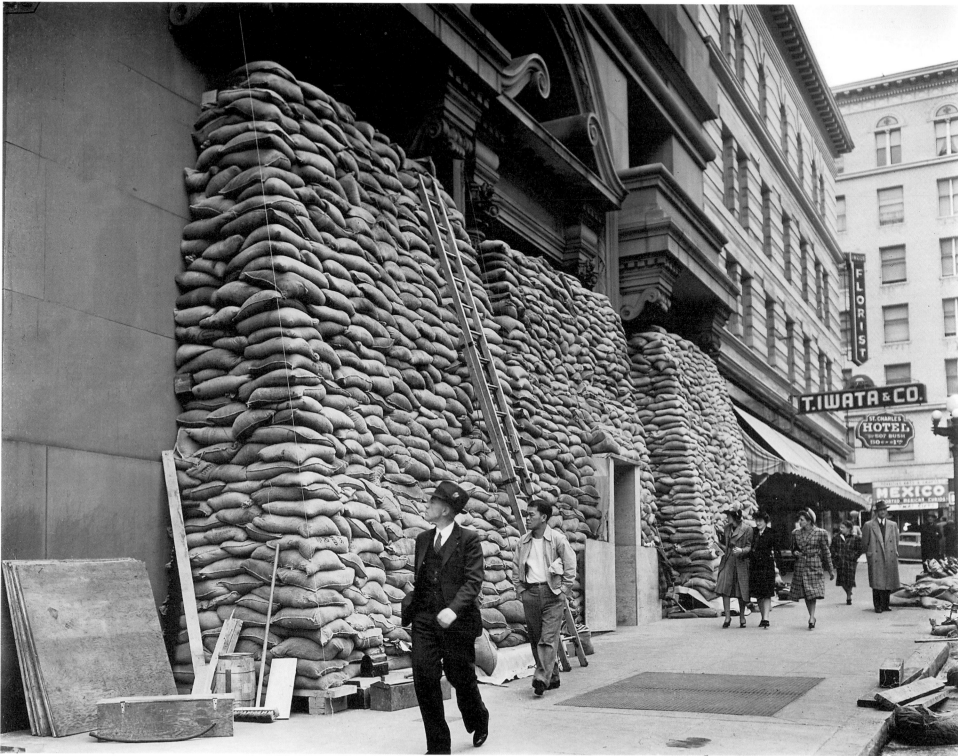

Jack Rice, AP Staff/AP Archives

SAN FRANCISCO, DECEMBER 13, 1941

The United States and Britain declared war on Japan the day after Pearl Harbor. Four days later, Germany and Italy declared war on the United States. A week after the attack, with America now at war, sandbags are piled high against the telephone company building in San Francisco, protection against possible Japanese air raids on the West Coast. Like Hitler's Blitz, Pearl Harbor steeled the resolve of those who were meant to weaken under withering assault. Americans, so long divided about entering the conflict abroad, rallied behind all-out war.

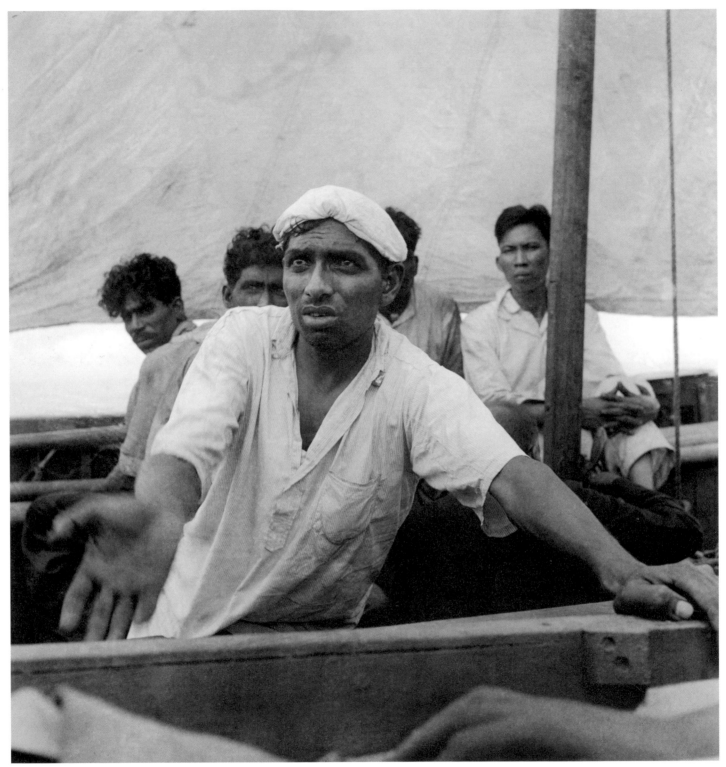

INDIAN OCEAN, JANUARY 1942

The naval war in the Pacific decimated shipping, and the seas were filled with castaways. In January 1942 a freighter carrying AP photographer Frank Noel home to New York was torpedoed by the Japanese three hundred miles off the coast of Singapore. Escaping into lifeboats, Noel and the crew drifted for five days under a relentless sun. During their ordeal, another lifeboat drifted alongside theirs, and Noel took this picture of one of its occupants, an Indian sailor begging for water. Neither Noel nor his companions had any to offer. Noel's boat eventually reached Sumatra, and his photograph won a Pulitzer Prize the following year.

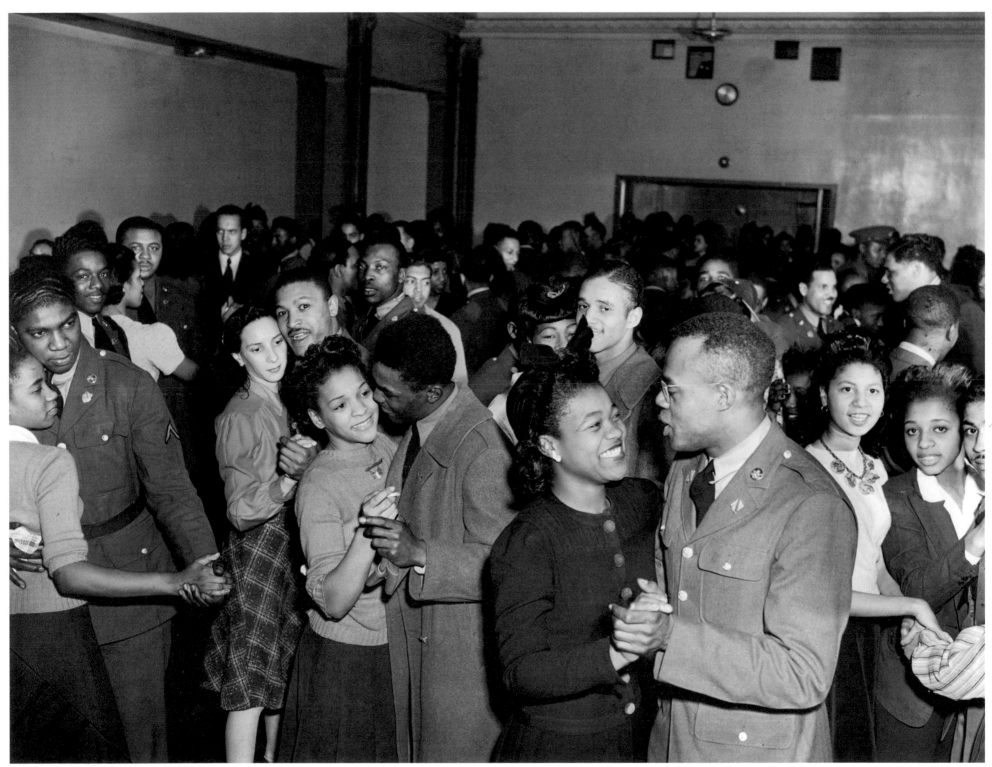

NEW YORK CITY, FEBRUARY 7, 1942

In 1941, the YMCA, YWCA, National Catholic Community Service, the National Jewish Welfare Board, the Travelers Aid Association, and the Salvation Army together formed the United Service Organizations to offer recreation for soldiers on leave. Here, servicemen stationed in the New York area are entertained at the weekly Saturday night USO dance held at the Harlem branch of the YMCA. Hostesses, as in all USO endeavors, were volunteers from the community. The original caption says, "Approximately two girls are invited for every boy who attends (troops average 250 each Saturday) so that plenty of girls are on hand."

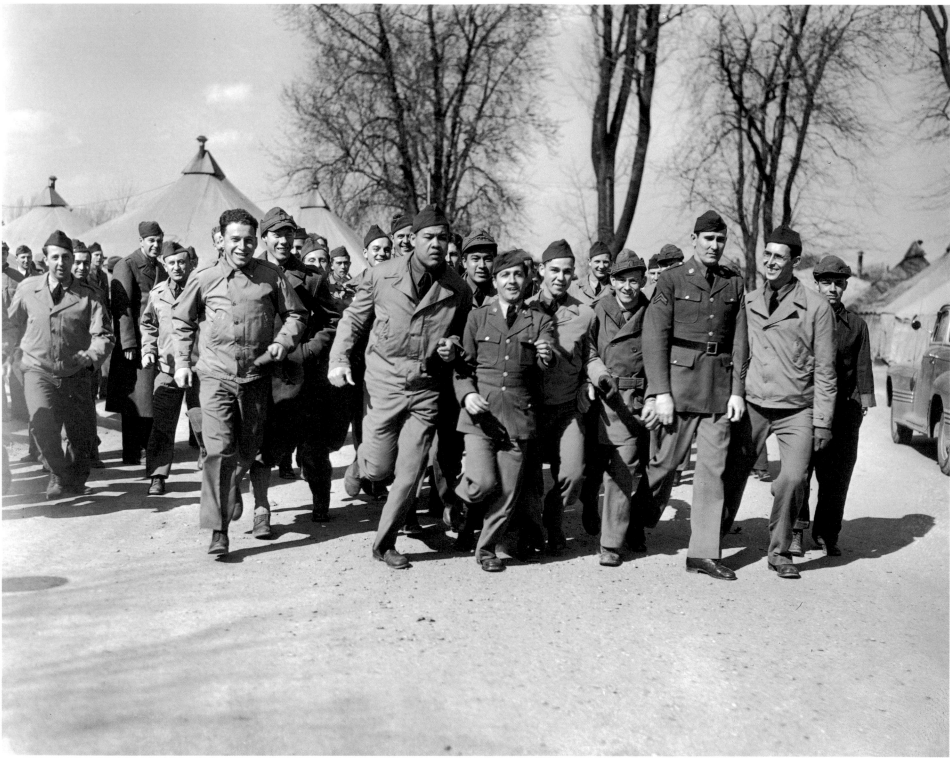

CAMP DIX, NEW JERSEY, MARCH 10, 1942

Boxer Joe Louis, an Army private, runs with fellow soldiers at Camp Dix. About
two weeks later, Louis successfully defended his heavyweight title at Madison Square Garden
in a fight to benefit the Army Emergency Relief Fund. Louis was listed as a physical education
instructor, but spent the war entertaining troops with boxing exhibitions.

PUYALLUP, WASHINGTON, APRIL 28, 1942

In the wake of Pearl Harbor, the United States began deporting Japanese-Americans from areas where they were thought to pose a security risk. This photograph shows the first arrivals at a newly built assembly center in Puyallup before their transfer to one of ten more permanent Relocation Centers. The War Relocation Authority shuffled or cordoned an estimated 120,000 people in its time.

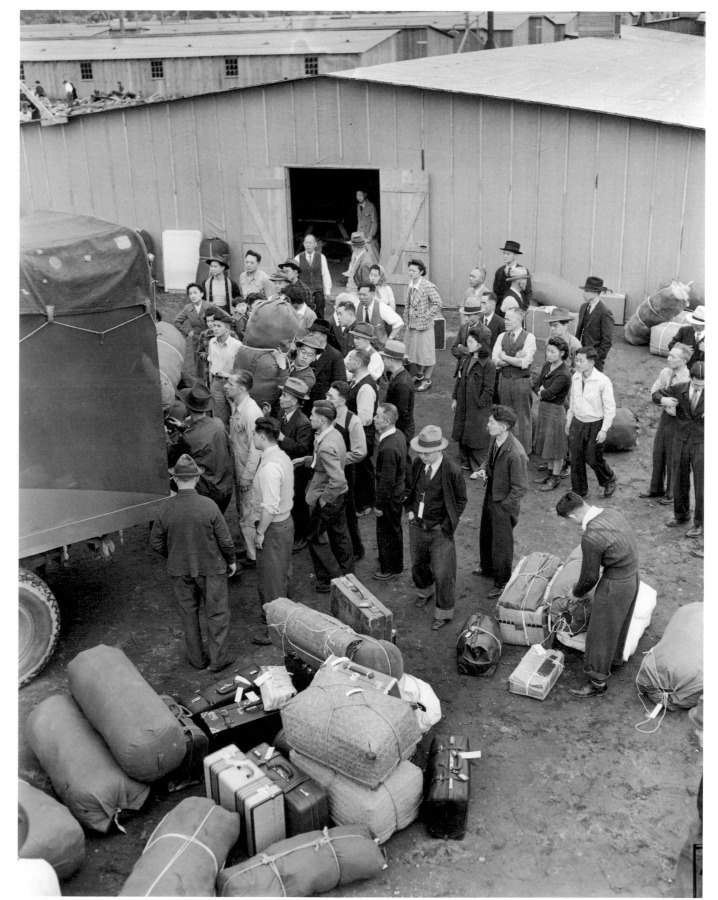

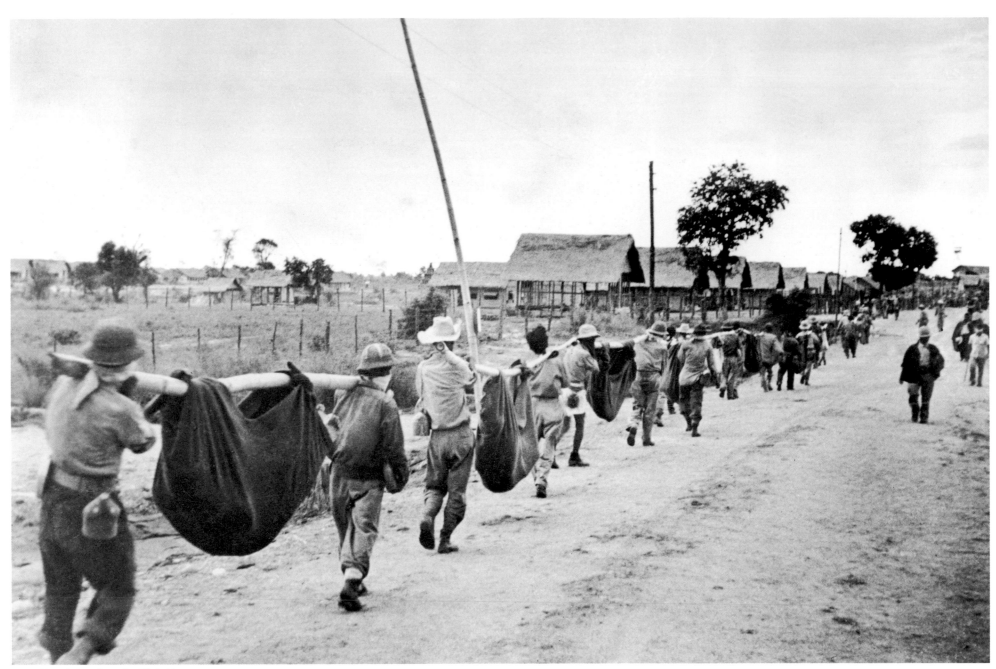

PHILIPPINES, APRIL 1942

The Japanese attacked Allied forces in the Philippines on December 8, 1941, soon bottling them up on the Bataan Peninsula. On April 9, 1942, 70,000 soldiers surrendered, their leader, Gen. Douglas MacArthur, having left for Australia in February under orders. Their weeklong journey to a prison camp 100 miles north is known as the Bataan Death March and is thought to have been one of the worst atrocities committed against POWs in the war. An estimated 54,000 soldiers reached the camp, the rest falling victim to exhaustion, starvation, and brutal treatment. This photograph is believed to show prisoners carrying their fallen comrades.

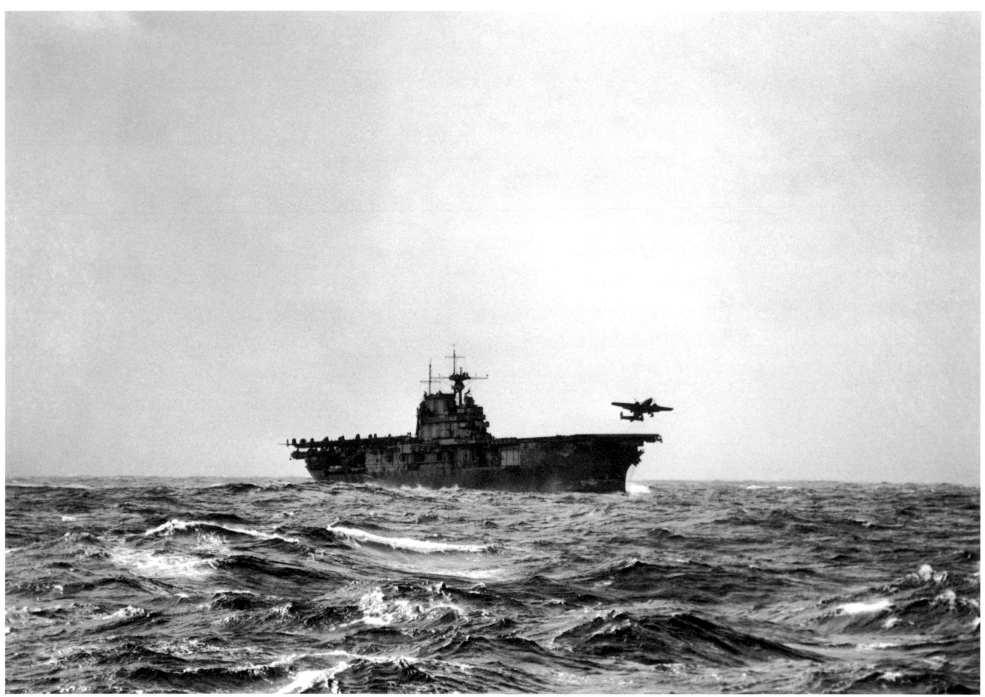

PACIFIC OCEAN, APRIL 18, 1942

Led by Lt. Col. James H. Doolittle, the Doolittle Raid of April 18 inflicted negligible damage on its intended target of Tokyo. But the attack had a greater consequence: raising morale in the United States and spooking the Japanese military establishment by demonstrating that bombers launched from aircraft carriers could reach Japan. None of the sixteen North American B-25B Mitchell bombers launched from the USS *Hornet*—one is seen taking off in this photograph—landed safely at its destination in China. Still, all but seven of the eighty airmen flying them survived the raid.

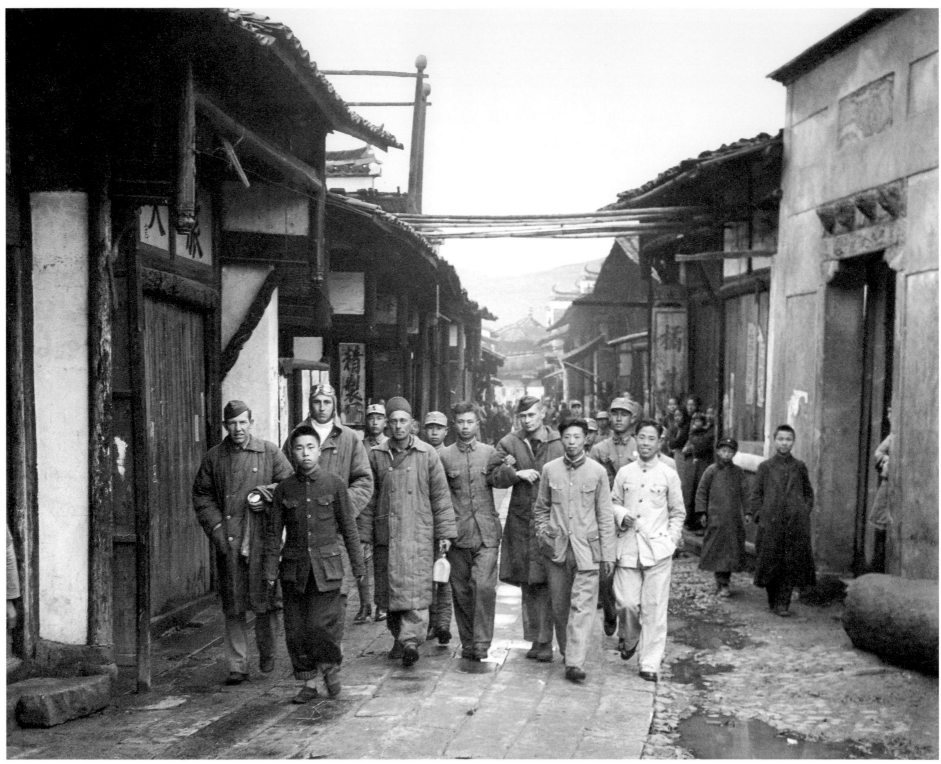

CHINA, APRIL 1942

Four Doolittle Raid crewmen who bailed out over China from Aircraft #14 are seen here in a
Chinese village before being reunited with other airmen. Japanese occupation forces conducted reprisals
in areas where Chinese civilians helped the American fliers to escape. Eight raiders were
captured by the Japanese and three were executed; one more died in prison.

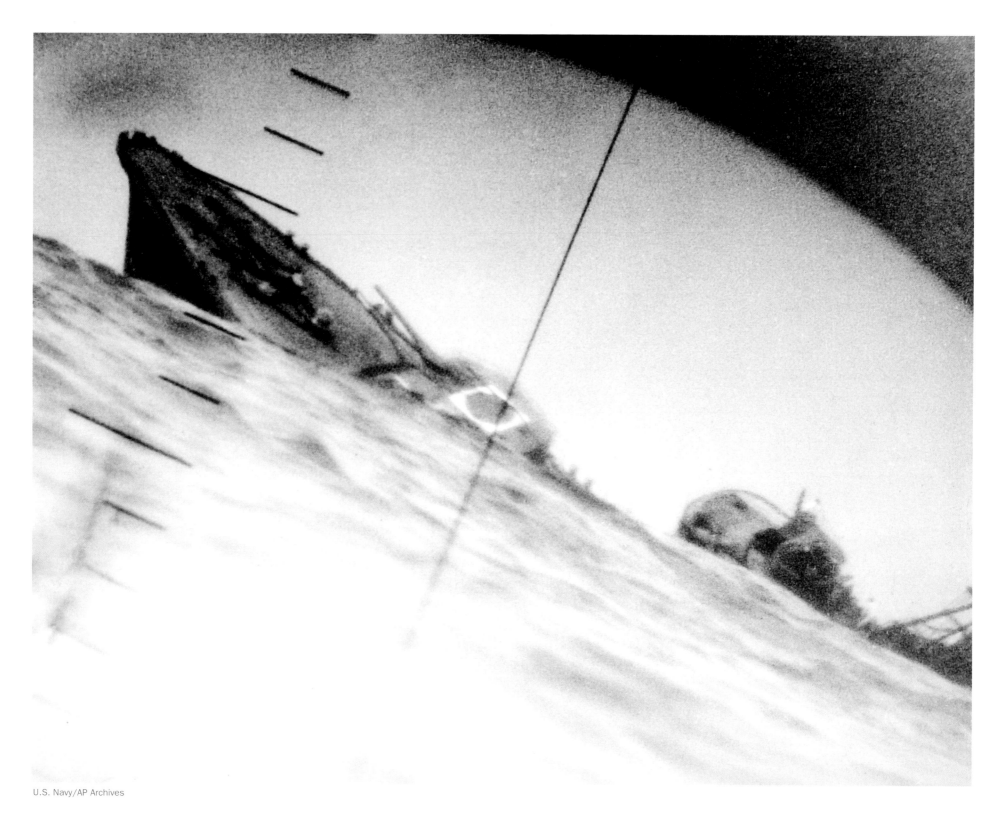

PACIFIC OCEAN, JUNE 1942

This picture is identified as showing a torpedoed Japanese destroyer photographed through
the periscope of the USS *Wahoo* or the USS *Nautilus*. Assuming that the date given for the
photograph is correct, the sub is the *Nautilus*, which sank the destroyer *Yamakaze* on June 25.
The *Wahoo* badly damaged the destroyer *Harusame* on January 24, 1943.

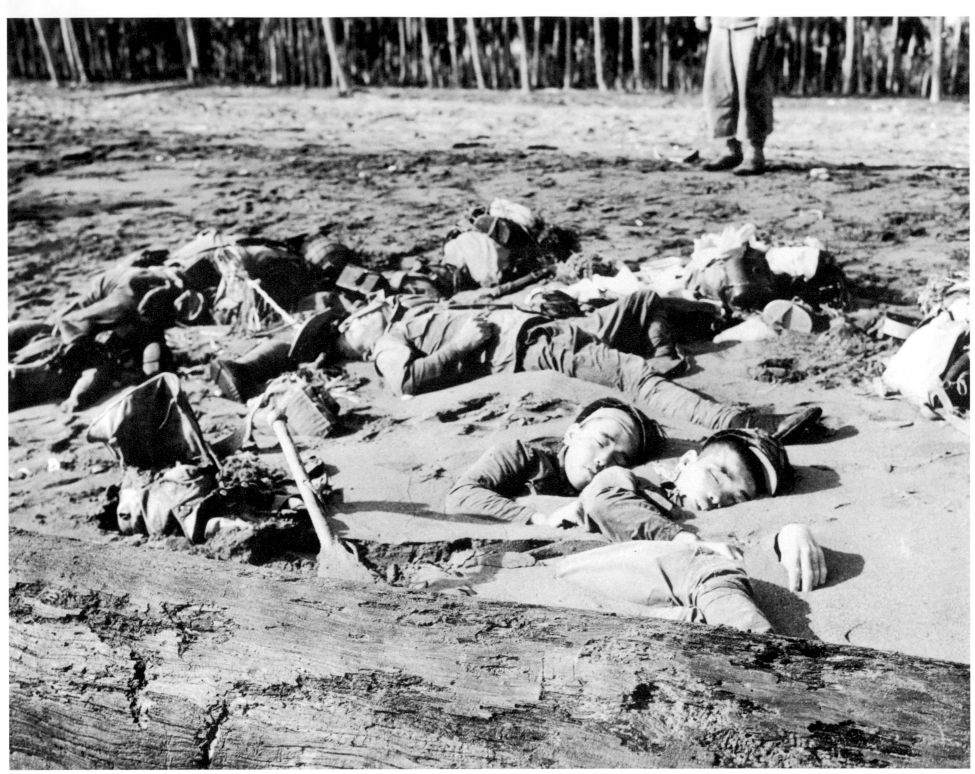

GUADALCANAL, SOLOMON ISLANDS, AUGUST 1942

The United States went on the offensive in the South Pacific after its crucial naval victory in June 1942 at Midway, where
Japan lost four aircraft carriers. The U.S. plan called for "island-hopping" landings, moving eastward and northward from the Solomons,
to get within bombing range of Japan. The first major objective was the island of Guadalcanal, where the Japanese were building an airstrip.
The Japanese lost about 25,000 men defending the Solomons—some are seen here—against much lower losses for the Americans.

GUADALCANAL, SOLOMON ISLANDS, FEBRUARY 1943

Weary U.S. soldiers come off a twenty-one-day combat rotation in the waning days of the Guadalcanal campaign. Guadalcanal became a protracted series of land and sea battles. The airstrip begun by the Japanese was renamed Henderson Field by the Americans, and eventually U.S. air power made it too hazardous for the Japanese to reinforce the island. The last Japanese soldiers left in early February 1943.

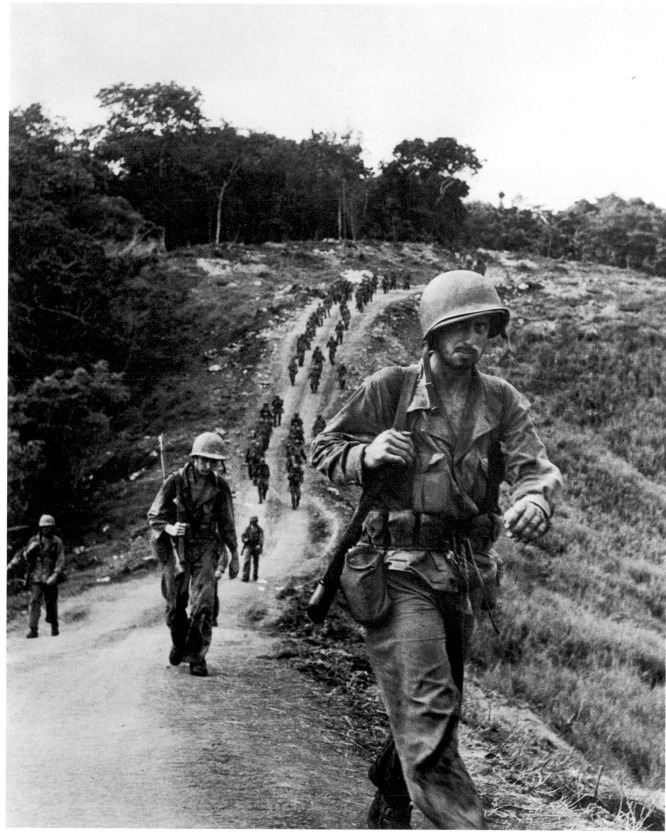

AP Archives

51

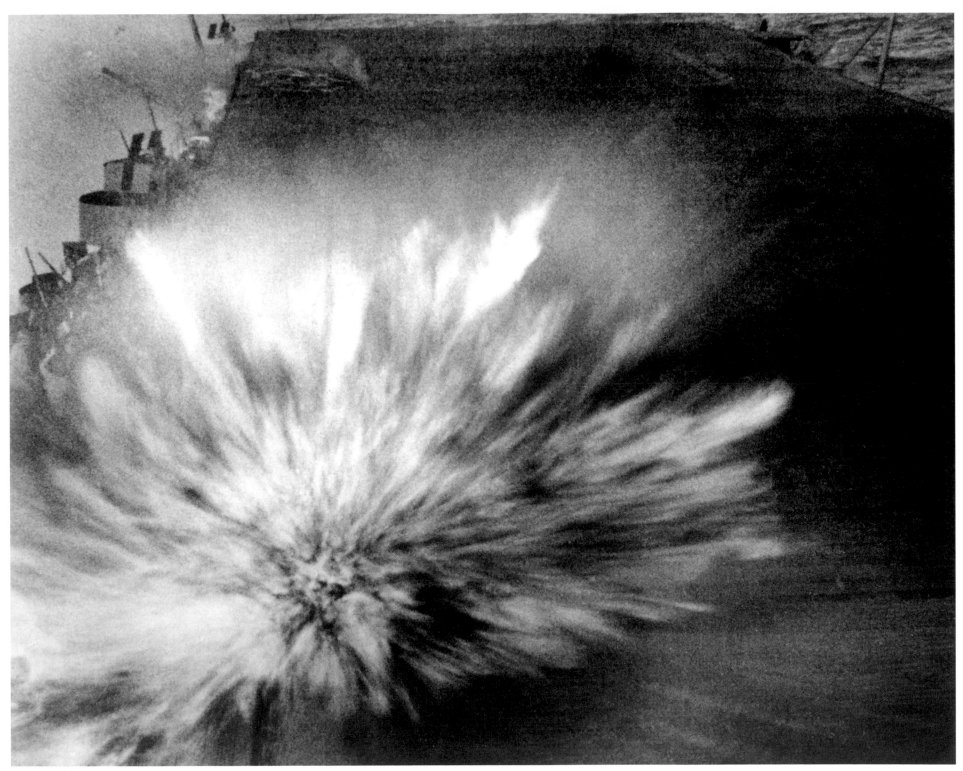

EASTERN SOLOMONS, PACIFIC OCEAN, AUGUST 24, 1942

The aircraft carrier USS *Enterprise* suffered serious damage in the Battle of the Eastern Solomons during the Guadalcanal campaign. This photograph of the carrier's flight deck has been attributed to Photographer's Mate 3rd Class Robert F. Read, who was thought to have been killed by the explosion shown. However, Samuel Eliot Morison, in his authoritative *History of United States Naval Operations in World War II*, stated that Read was killed by a bomb that had earlier hit the after-starboard gun gallery—which can be seen burning in the upper left—leaving the provenance of this picture in doubt.

LOS ANGELES,
OCTOBER 4, 1942

Actress Rita Hayworth donates bumpers in
response to a call to aid the war effort by
donating nonessential car parts. Early in the
war, the U.S. government promoted the
recycling of essential materials, including
paper, aluminum, tin, iron and steel, rubber,
silk stockings, and cooking fat. People
pitched in enthusiastically, wanting to do
their part. The recycling campaign
had a modest impact on war supplies
but boosted morale.

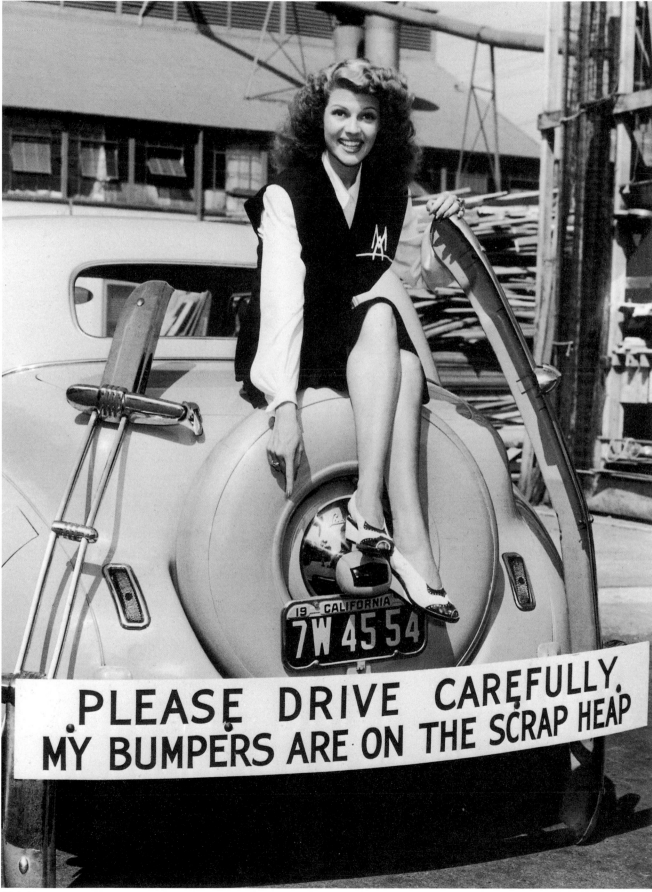

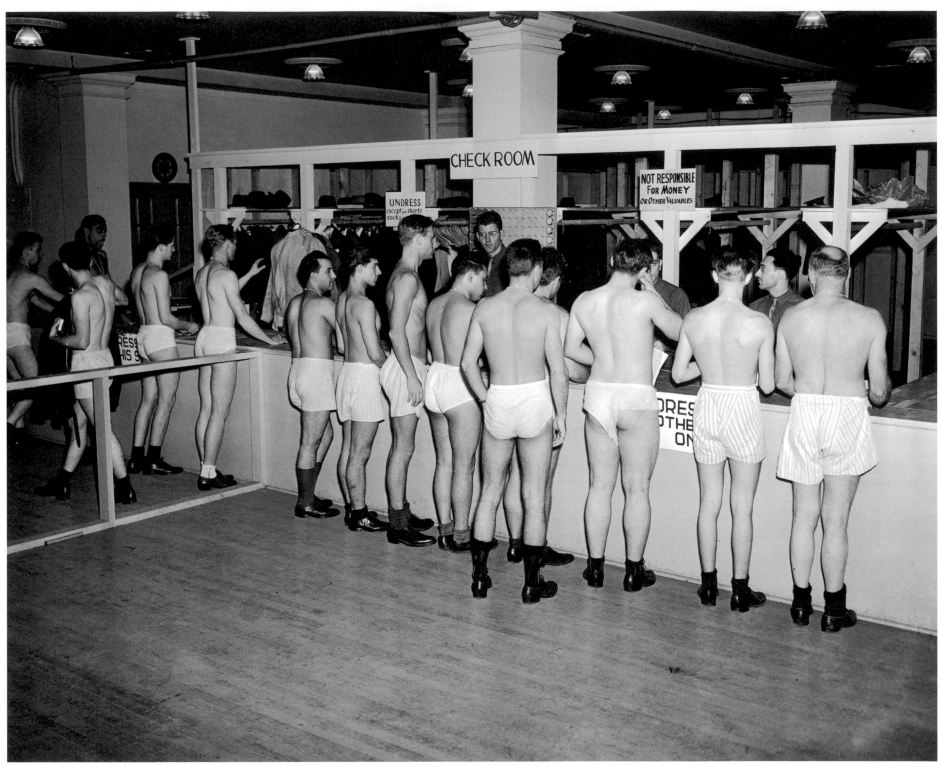

NEW YORK CITY, OCTOBER 7, 1942

Young men enlisting for service make the rounds of an induction center set up in
New York City's Grand Central Palace, usually used for conventions. After Pearl Harbor,
Selective Service registration was expanded to cover men aged 18 to 65. By war's end,
16 million American men and women had served in some branch of the armed forces.

NEW YORK CITY, OCTOBER 28, 1942
Employees of the New York Stock Exchange,
carrying wooden guns, begin a six-week course
in the basics of military drill. In 1942,
Americans believed that they might be
needed to defend their homeland.

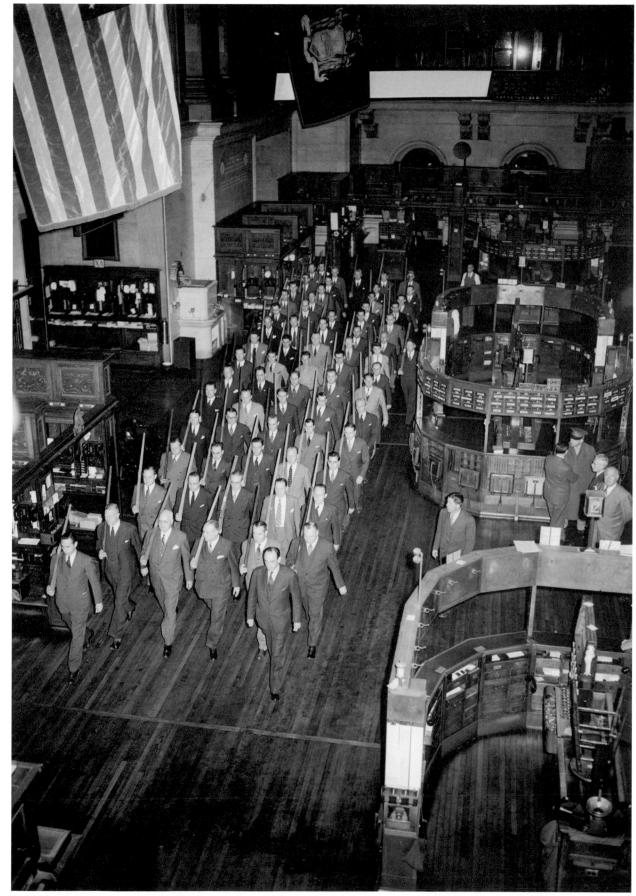

Matty Zimmerman, AP Staff/AP Archives

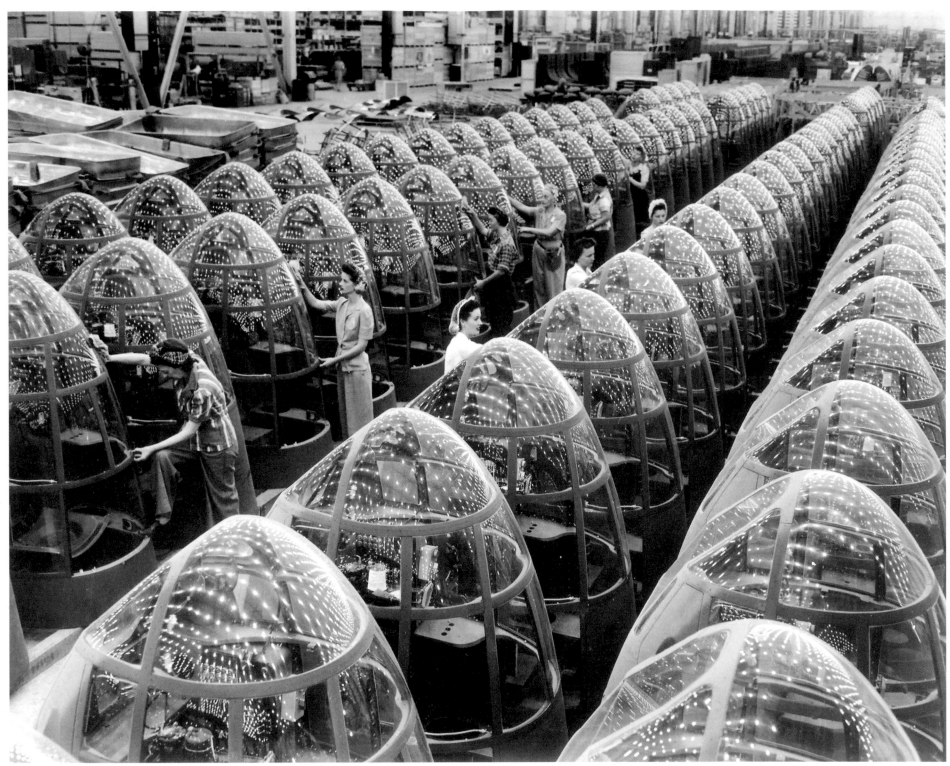

LONG BEACH, CALIFORNIA, OCTOBER 1942

An unprecedented number of jobs in vital industries opened to women when men went off to war. These employees are doing finishing work on nose cones for A-20J Havoc bombers at Douglas Aircraft's Long Beach, California, plant. With its glass nose to accommodate a bombardier, the A-20J was used as a lead plane in a formation of A-20Gs, which lacked the glass cone. Pilots in the A-20Gs would release their bombs when they saw the bombardier in the lead plane releasing his. Four hundred and fifty A-20Js were built.

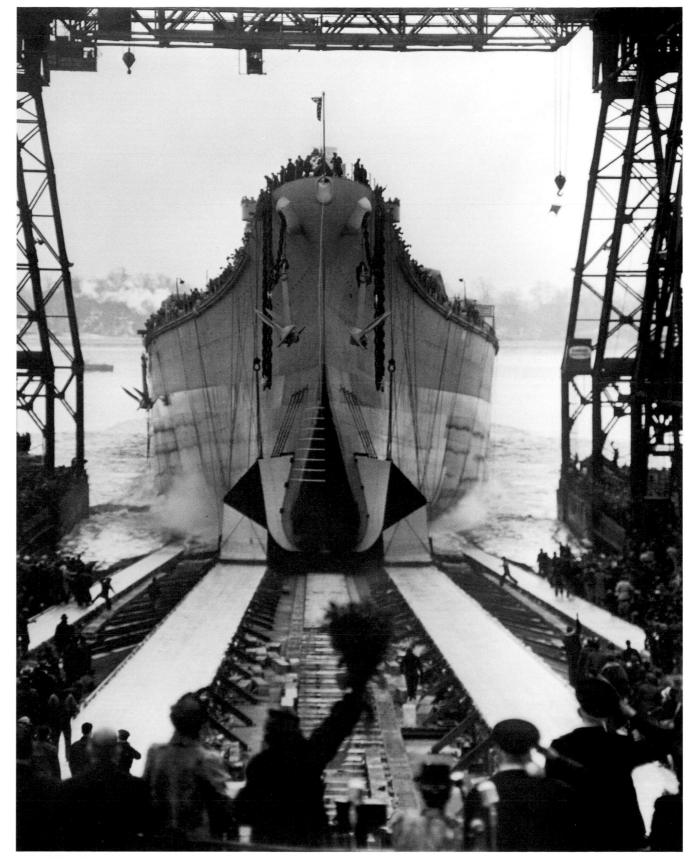

PHILADELPHIA,
DECEMBER 7, 1942
On the first anniversary of the Japanese
attack on Pearl Harbor, the battleship USS
New Jersey slides down the ways at the
Philadelphia Navy Yard. The conversion
of a peacetime economy to war production
in the United States astonished the world
and proved crucial to victory.

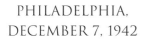
AP Staff/AP Archives

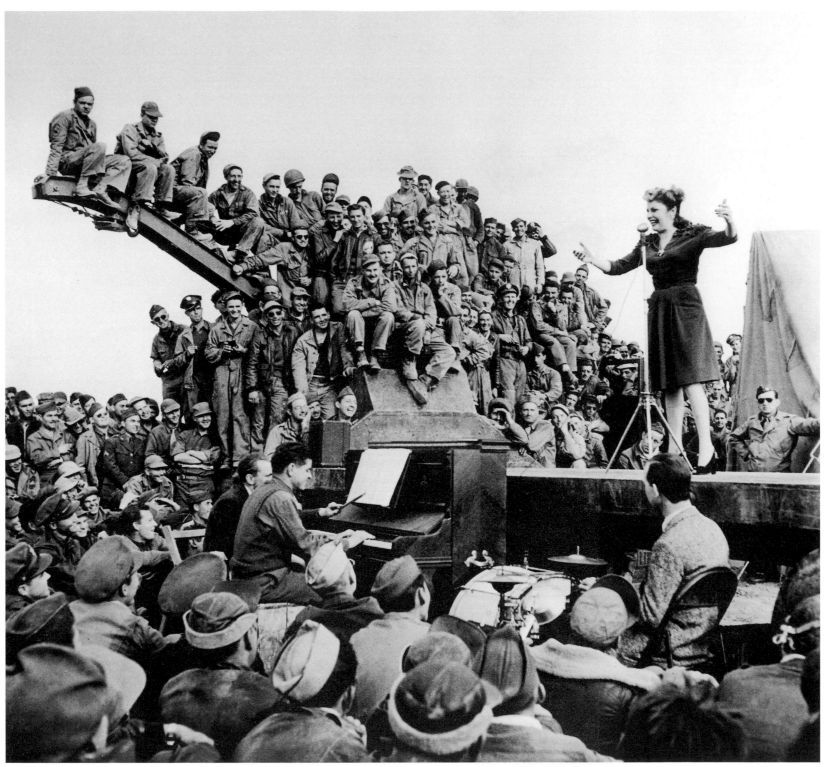

BISKRA, NORTH AFRICA, JANUARY 22, 1943

When American soldiers were posted overseas, the USO followed with top-flight entertainment. Comedian Martha Raye,
seen here performing for the U.S. Army Twelfth Air Force in North Africa, was devoted to the soldiers in the field and beloved
in return. Known as Colonel Maggie, she continued to do USO shows in war zones through the Vietnam War.
When she died in 1994, she was buried in the military cemetery at Fort Bragg, North Carolina.

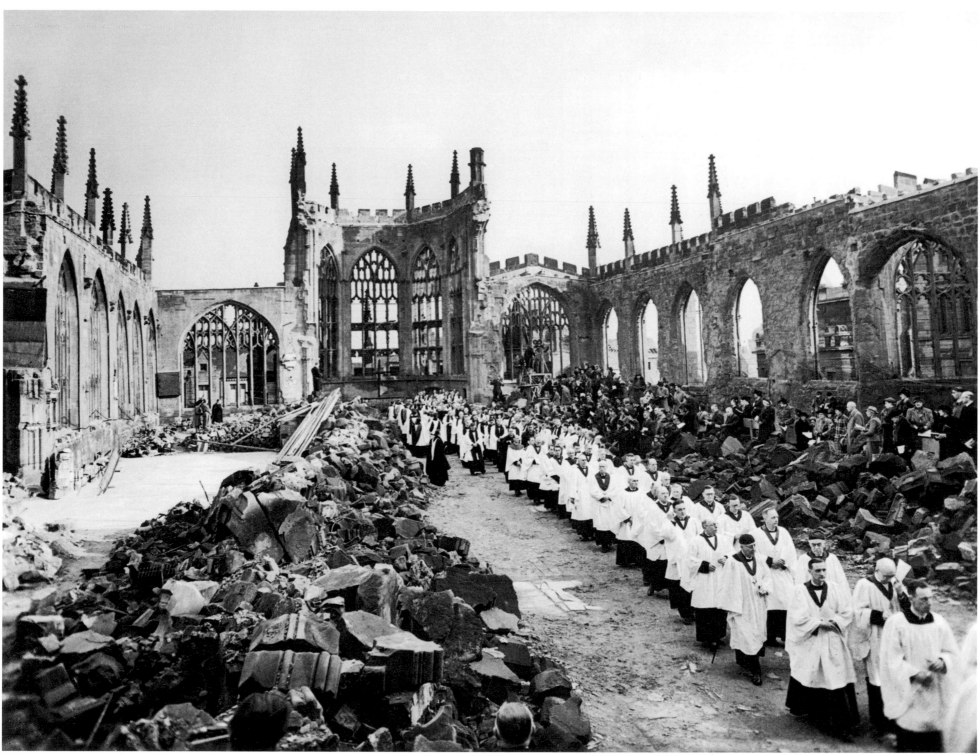

COVENTRY, ENGLAND, FEBRUARY 20, 1943
On the night of November 14, 1940, Coventry Cathedral was destroyed, in an air raid code-named
Operation Moonlight Sonata by the German Luftwaffe. Here, a service is being performed in the ruins.

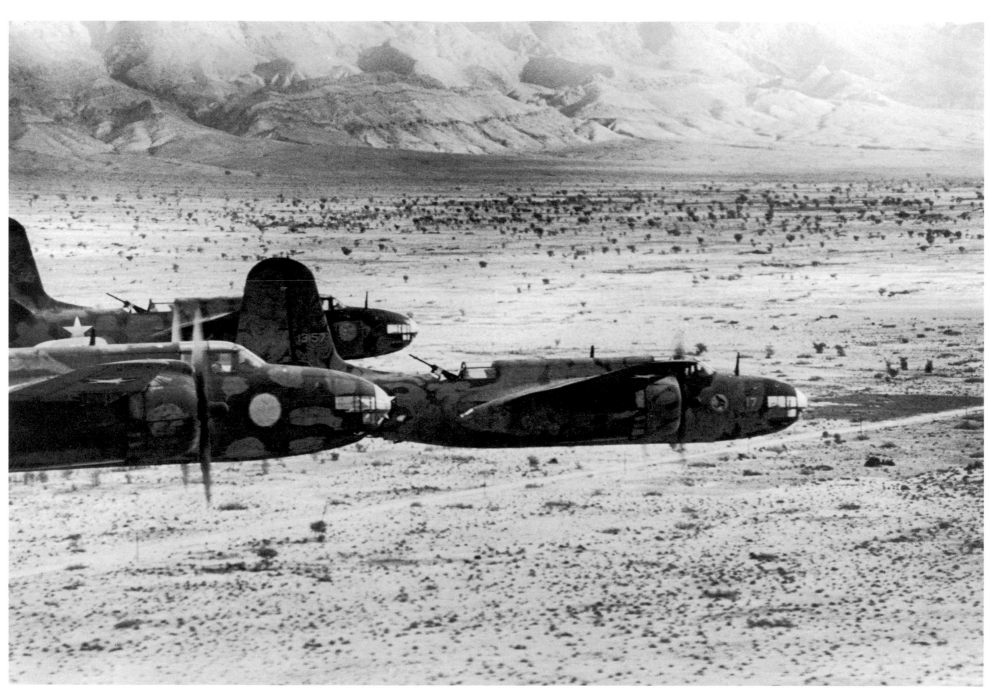

TUNISIA, FEBRUARY 1943

In 1943, the Allies finally dislodged the Axis forces from North Africa, setting the stage for the invasion of Italy. Here, Douglas A-20 Havoc bombers fly in close formation on a mission near Maknassy. These American bombers provided air support for Allied troops on the ground, helping to turn the tide against Rommel during difficult days in February. The course of battle in Tunisia persuaded German Field Marshal Erwin Rommel by early March that it would be futile for German and Italian troops to remain on the African continent.

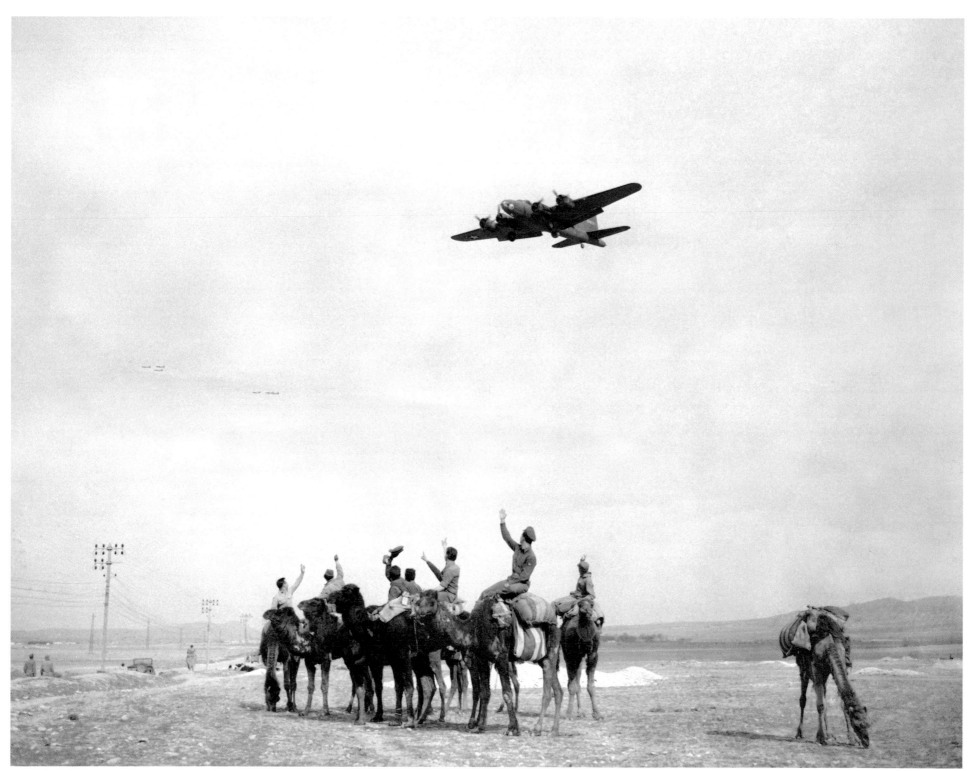

TUNISIA. MARCH 1943

American soldiers, riding camels while off duty, wave a greeting to a Boeing B-17 Flying Fortress. Tunisia was
an important testing ground for Allied commanders and soldiers. On March 3, Maj. Gen. George S. Patton Jr. took command
of U.S. forces there, and quickly galvanized his troops with victories on the ground. Both Patton and British Gen. Bernard L.
Montgomery distinguished themselves in North Africa and went on to crucial roles in the invasion of Europe.

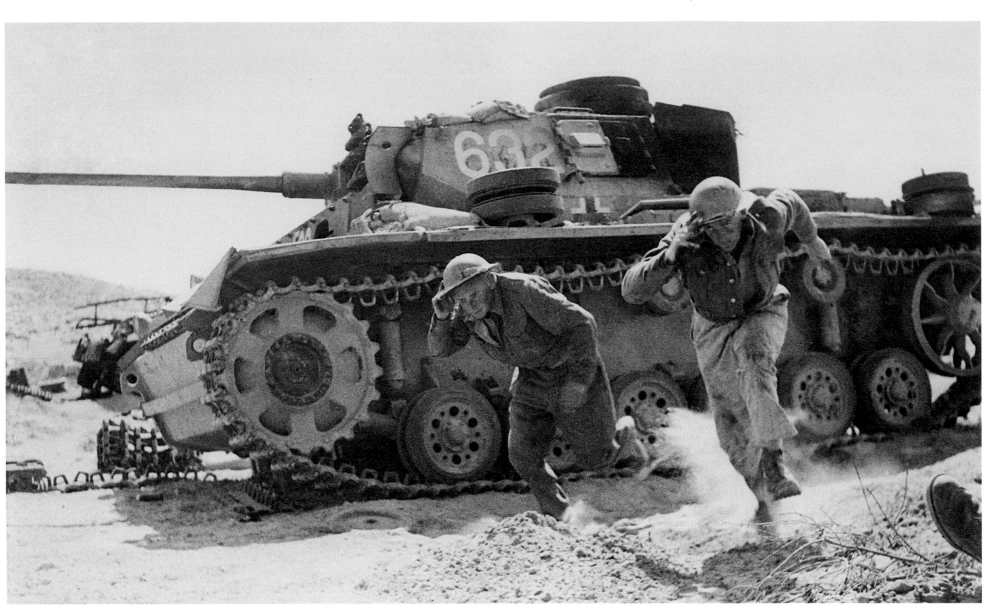

MEDENINE, TUNISIA, MARCH 1943

At Medenine, Rommel lost more than forty tanks in a disastrous attack on Montgomery's forces. Here, British sappers
make a dash for it after placing an explosive charge in a tank disabled in battle. In late April, the Axis forces in North Africa
were running out of food, ammunition, and gas. By May 13, all German and Italian troops in North Africa had surrendered
to the Allies, producing so many POWs that estimates of their number vary by as much as 100,000 men.

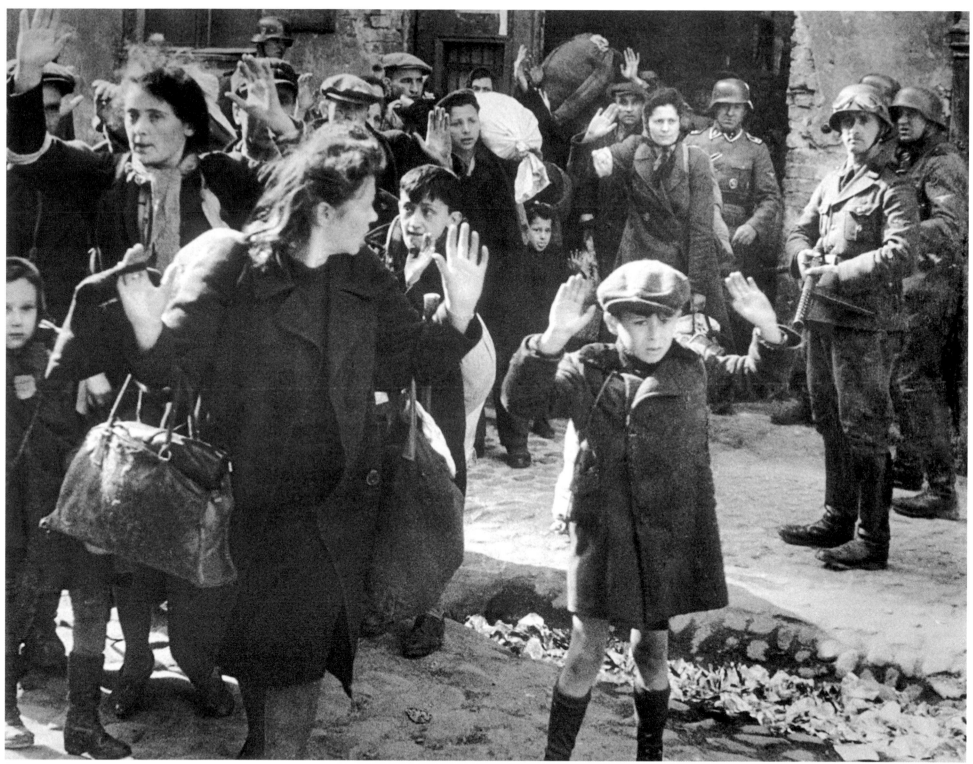

WARSAW, POLAND, APRIL 19-MAY 16, 1943

The best-known attempt of the Jews to resist the Nazis in armed struggle took place in the Warsaw Ghetto from April 19 to May 16. During the uprising, the SS captured and deported some 56,000 Jews from the ghetto to death camps and concentration camps. This photograph, of Jews before deportation, was included in an album, entitled *The Warsaw Ghetto Is No More*, that commander Jürgen Stroop had made for Heinrich Himmler, the Reichsführer of the SS. The album was captured by the Allies and introduced in the Nuremberg Trials as an exhibit. In the album, the photo was captioned, "Pulled out of Bunkers by Force."

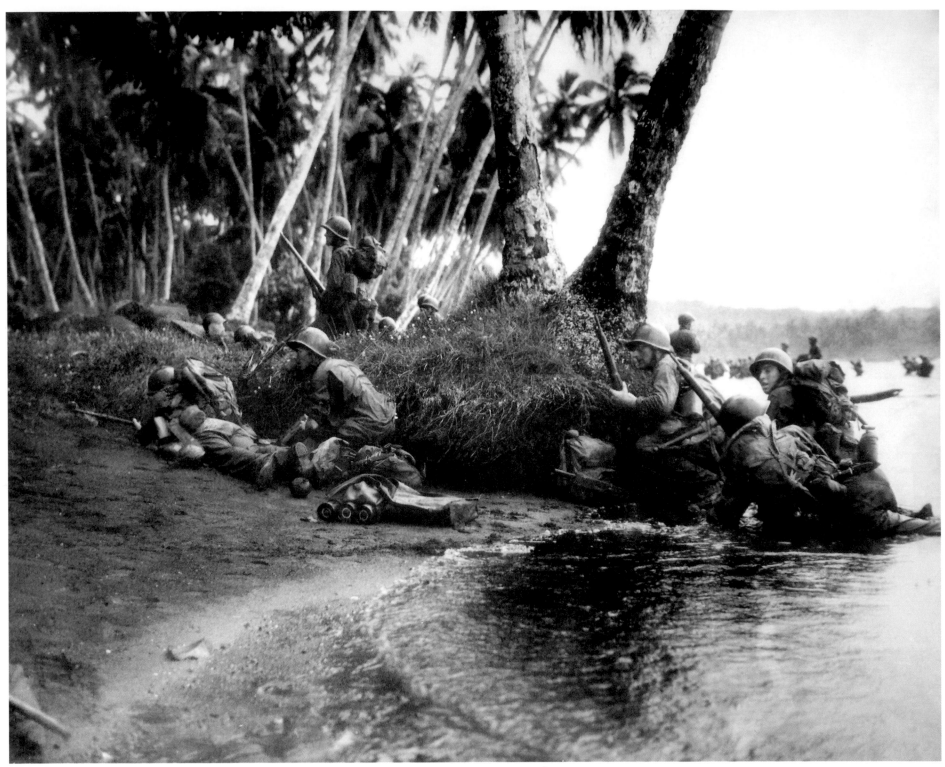

RENDOVA ISLAND, SOLOMON ISLANDS, JUNE 30, 1943

After their victories at Midway and Guadalcanal, the American commanders in the South Pacific debated strategy and marshalled their forces. It wasn't until summer that they moved simultaneously on the eastern Solomon Islands and New Guinea. The Solomons came under the leadership of Adm. William F. Halsey Jr., Commander in Chief, South Pacific. The landing on Rendova Island, where 200 Japanese soldiers were quickly overcome by 6,000 American troops, marked the beginning of this multi-pronged series of assaults. Here, Americans wade ashore on Rendova at the break of day in a heavy rainstorm.

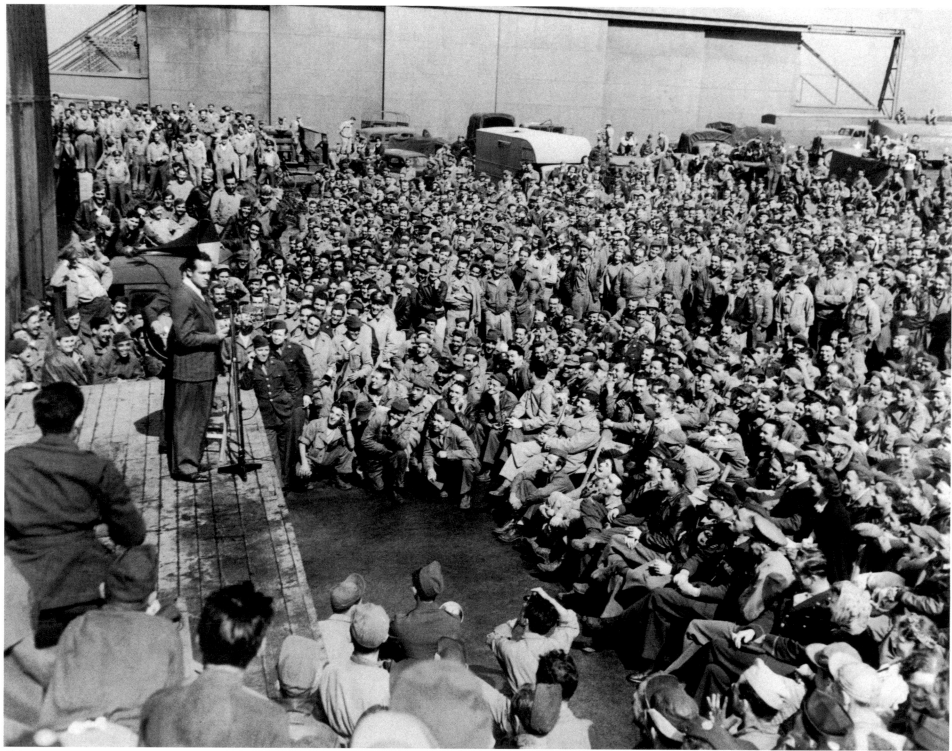

ENGLAND, JULY 27, 1943

Like Martha Raye, comedian Bob Hope endeared himself to servicemen with his indefatigable touring. Here, on his first USO tour of the European war zones, he entertains members of the U.S. Army Air Force at an airfield in Britain. He was accompanied on this trip by musicians from his radio show as well as actor Clark Gable.

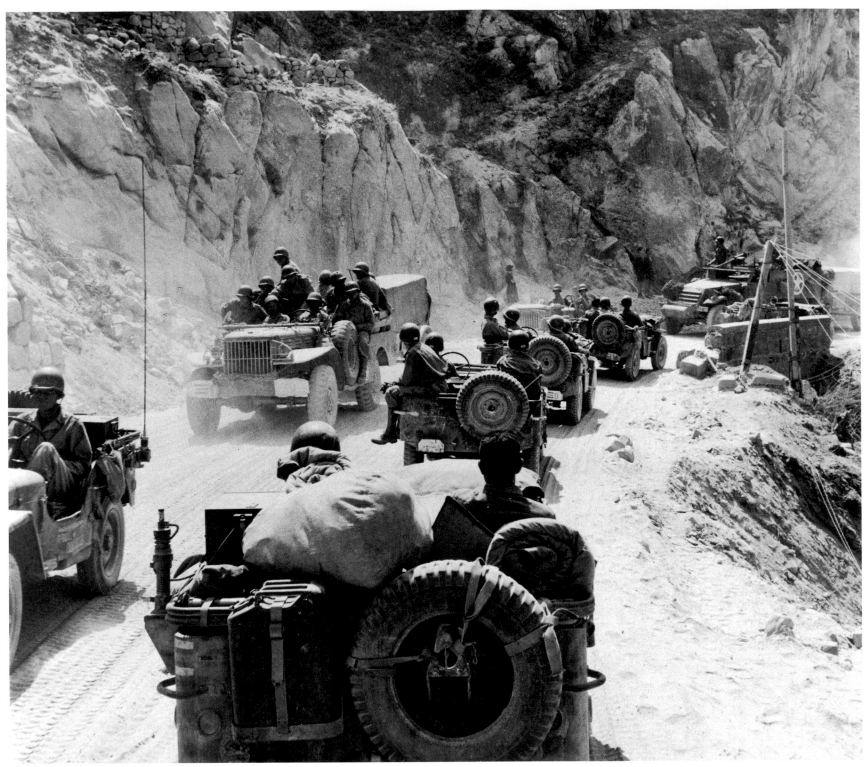

SICILY, AUGUST 1943

In January 1943, the Combined Chiefs of the American and British forces decided that their invasion of Europe should begin with Sicily. The landings—the U.S. Seventh Army under Patton and the British Eighth Army under Montgomery—came on July 10. The invasion was successful, but the German and Italian troops occupying the island succeeded in escaping. Here, an American troop convoy heads for the front along a mountain road near Nicosia.

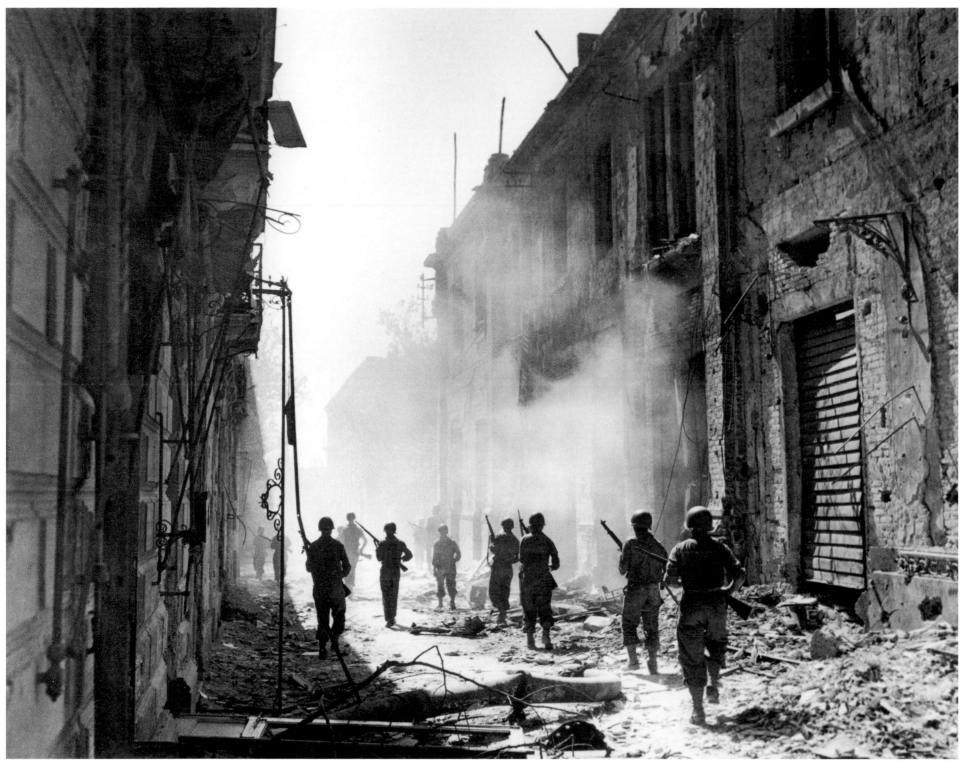

MESSINA, SICILY, AUGUST 1943

A U.S. reconnaissance unit searches for enemy snipers in Messina, liberated on August 17.

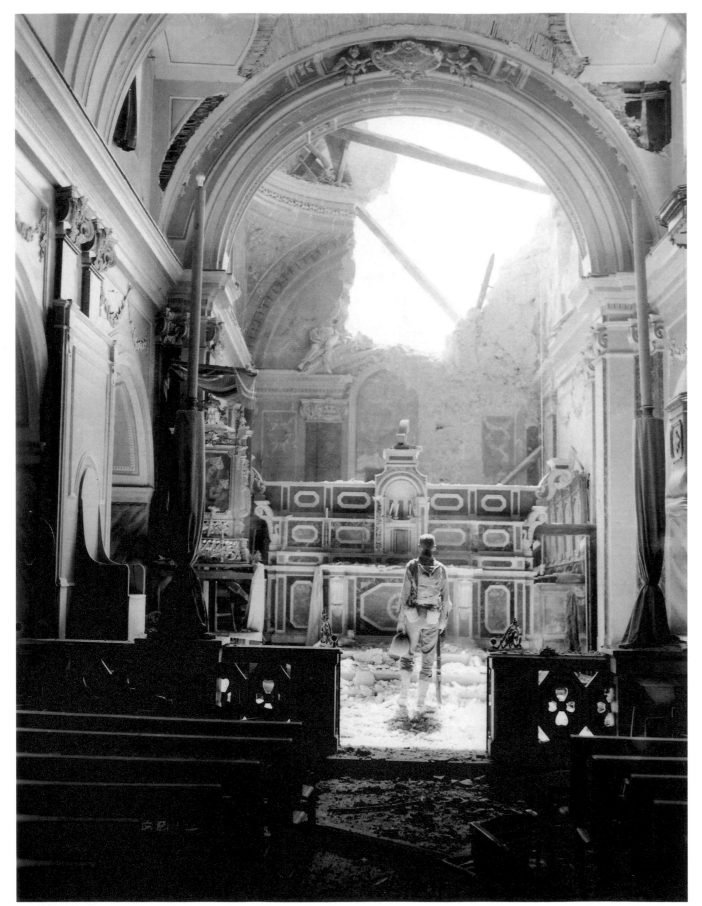

ACERNO, ITALY,
SEPTEMBER 23, 1943

Mussolini was overthrown in a coup on July 25, but the Italian surrender and the Allied invasion of the mainland were delayed until September, giving the Germans time to reinforce their positions in Italy. The U.S. Fifth Army and British Tenth Corps landed in Salerno on September 8 and fought their way to Naples by October 1, past blown bridges and bombed-out villages where German forces put up a stiff fight. Here, Pfc. Paul Oglesby of the Thirtieth Infantry Regiment stands before the altar of a damaged church in Acerno.

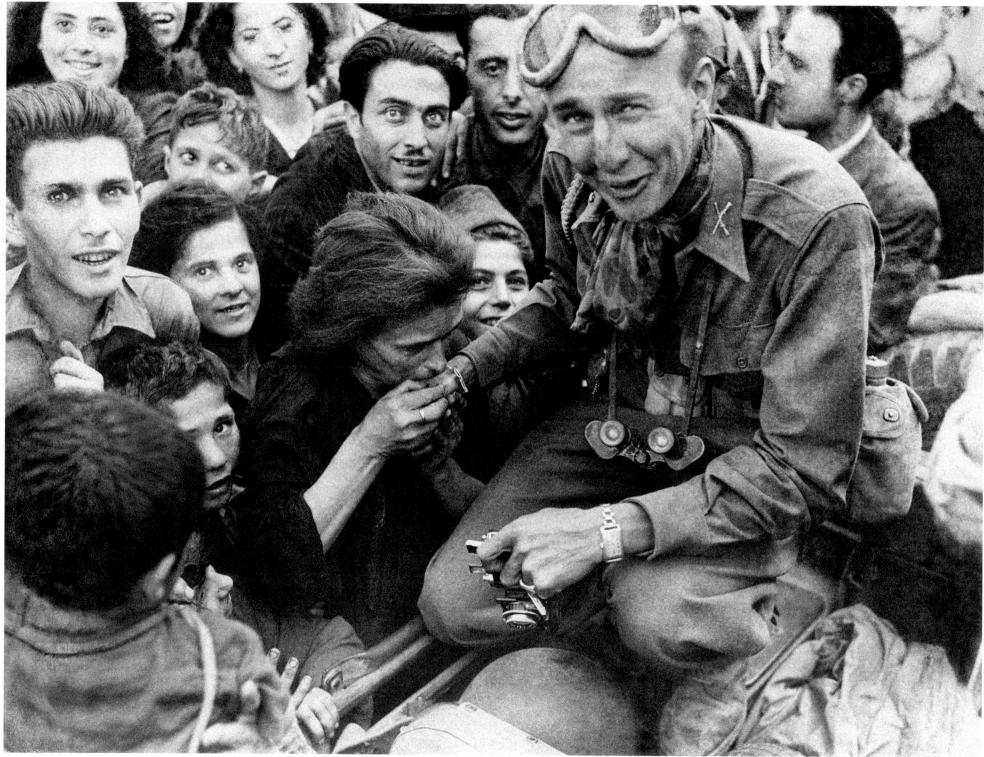

AP Archives

NAPLES, ITALY, OCTOBER 1943

An Italian woman kisses the hand of a U.S. soldier in Naples. The liberation of the city in early October gave the Allies an access point for men and supplies in Europe. The victors were initially discouraged to see that Naples had been almost totally destroyed, partly from Allied bombing but more by German demolition teams as they abandoned the city. Only churches and monasteries were spared. Soon, however, Allied bombers were flying missions over Europe from Italian airfields.

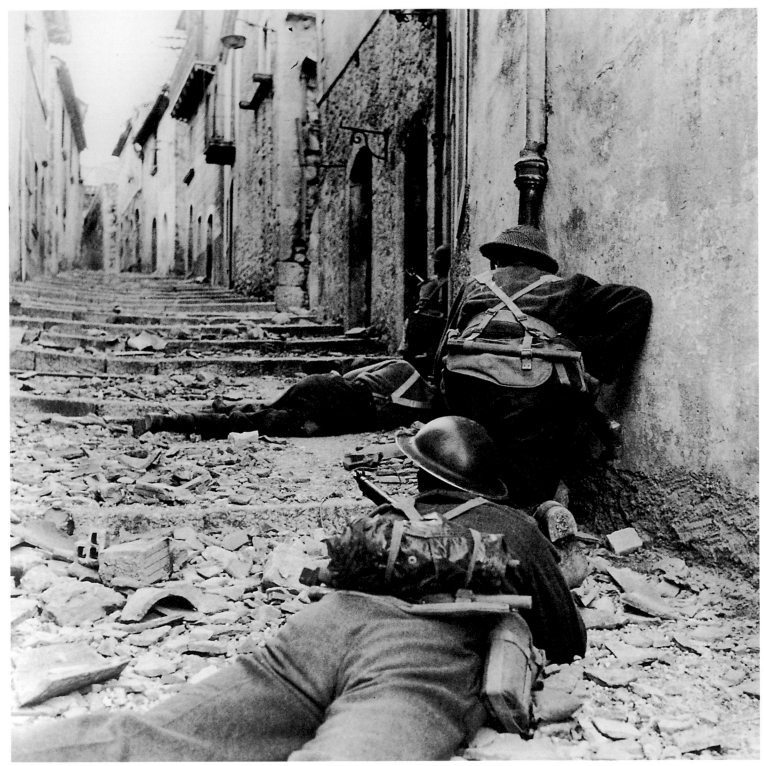

CAMPOCHIARO, ITALY, OCTOBER 23, 1943

Montgomery's Eighth Army had crossed the Strait of Messina from Sicily into Italy on September 3. They encountered little resistance at first, but neither were they positioned to assist the Salerno landings farther north. As they pushed north through central Italy, Canadian and New Zealand troops distinguished themselves. Here, infantrymen of the Canadian Carleton and York Regiment advance under sniper fire on an uphill backstreet in the mountain village of Campochiaro.

CISTERNA ROAD, ITALY, MID-FEBRUARY 1944

Allied troops take advantage of a quiet moment to relax in a ditch that runs parallel to the Cisterna road. In less than two weeks, they will be defending the road against a German advance.

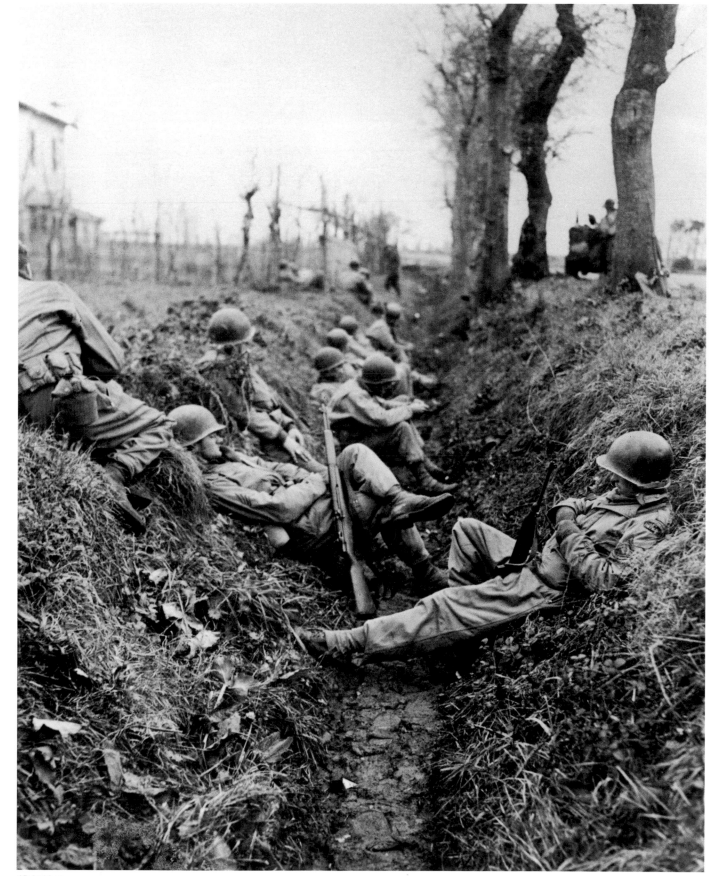

AP Archives

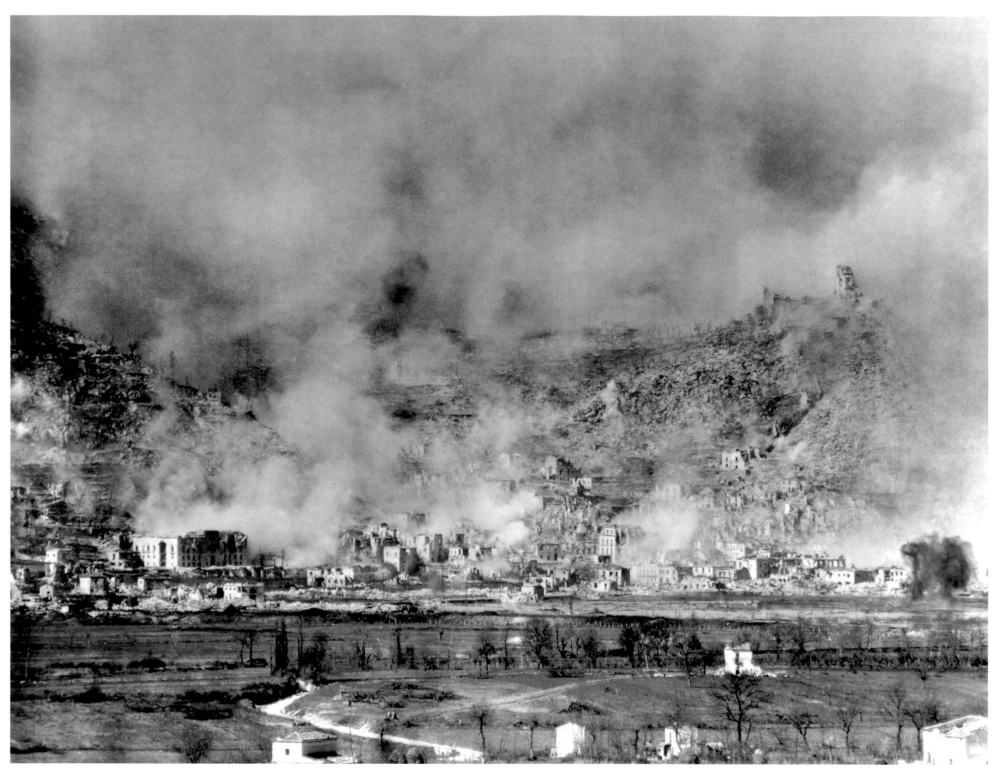

CASSINO, ITALY, FEBRUARY 1944

When the German army bottled up the Allied forces by shelling from the heights of Monte Cassino, the frustrated commander of the ground troops below asked that the historic monastery at the top be bombed, although there was no evidence that the Germans were using it for cover. The monastery was destroyed on February 15 (its ruins are visible at the top of the escarpment over the town of Cassino), and the rubble did indeed provide cover for the enemy. After more intense bombing in March, the town and heights still did not yield, and the effort was temporarily abandoned. The Germans finally withdrew on May 17.

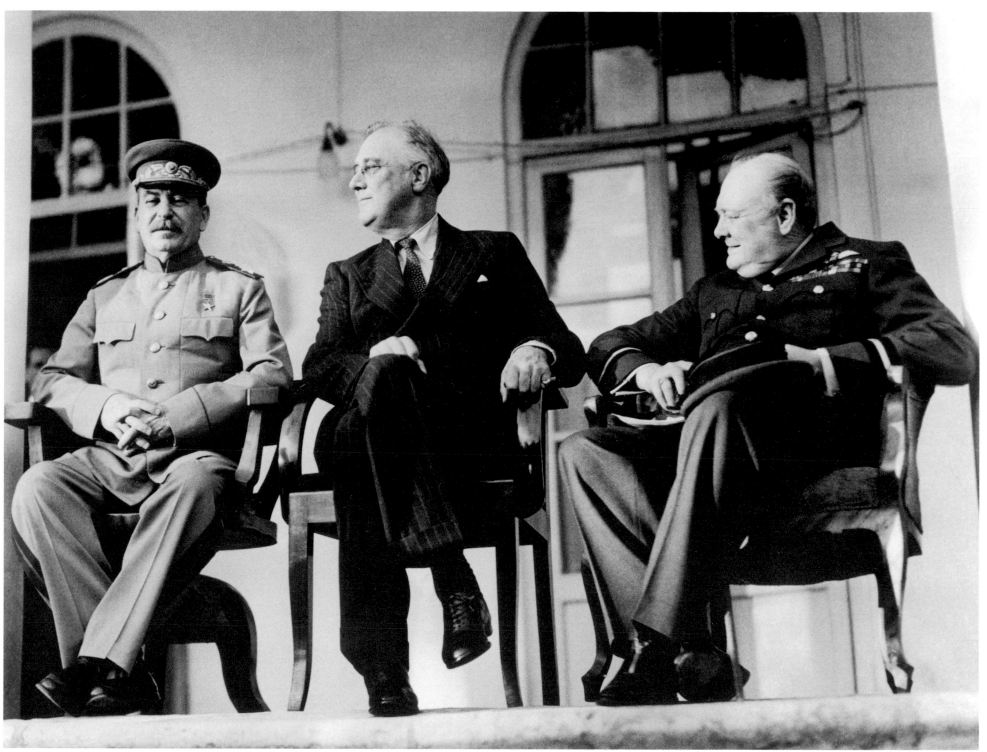

TEHRAN, IRAN, NOVEMBER 28–DECEMBER 1, 1943

Soviet Premier Josef Stalin, U.S. President Franklin D. Roosevelt, and British Prime Minister Winston Churchill sit for photographs on the porch of the Russian Embassy in Tehran. At this first meeting of the "Big Three," Stalin pressed for a second front in Europe, and Roosevelt and Churchill agreed to launch an invasion in the spring of 1944. A week after the conference, Gen. Dwight D. Eisenhower was named Supreme Commander of the Allied Expeditionary Force and Gen. Bernard L. Montgomery was made ground commander.

HUON PENINSULA,
NEW GUINEA,
SEPTEMBER 6, 1943

Gen. Douglas MacArthur, Supreme
Allied Commander, Southwest Pacific,
planned the campaign in New Guinea;
it was a complicated operation calling
for an amphibious landing combined
with airborne and overland assaults.
Here, MacArthur observes the first
airborne attack by the Allies in
the Pacific, as the 503rd Parachute
Regiment drops on an unused airfield
near Lae on the Huon Peninsula. The
Americans encountered little opposi-
tion, and among other positive results
was this picture-perfect image of a
general leading his troops.

BOUGAINVILLE, SOLOMON ISLANDS, NOVEMBER 1943

A U.S. soldier wounded in the invasion of Bougainville is hoisted aboard a Coast Guard transport. Bougainville had a large Japanese garrison, and on November 1, the Americans landed an equally substantial force at Empress Augusta Bay, as Halsey's forces continued to move eastward through the Solomons. Fifty miles of jungle separated the two forces, however, and the main battle was not joined until the following March. The result: 8,000 Japanese casualties, 300 American casualties, and a decisive U.S. victory.

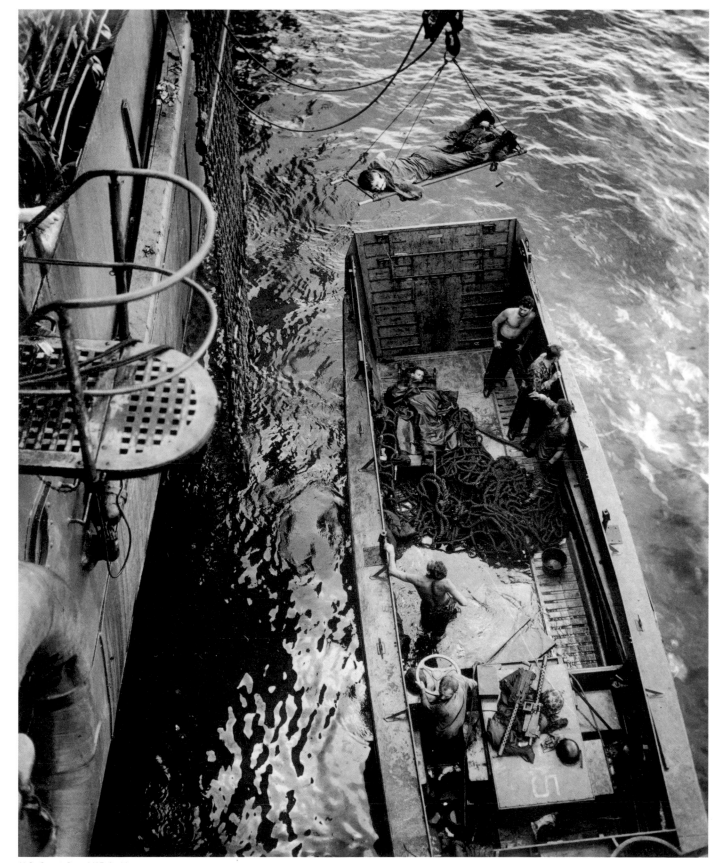

U.S. Coast Guard/AP Archives

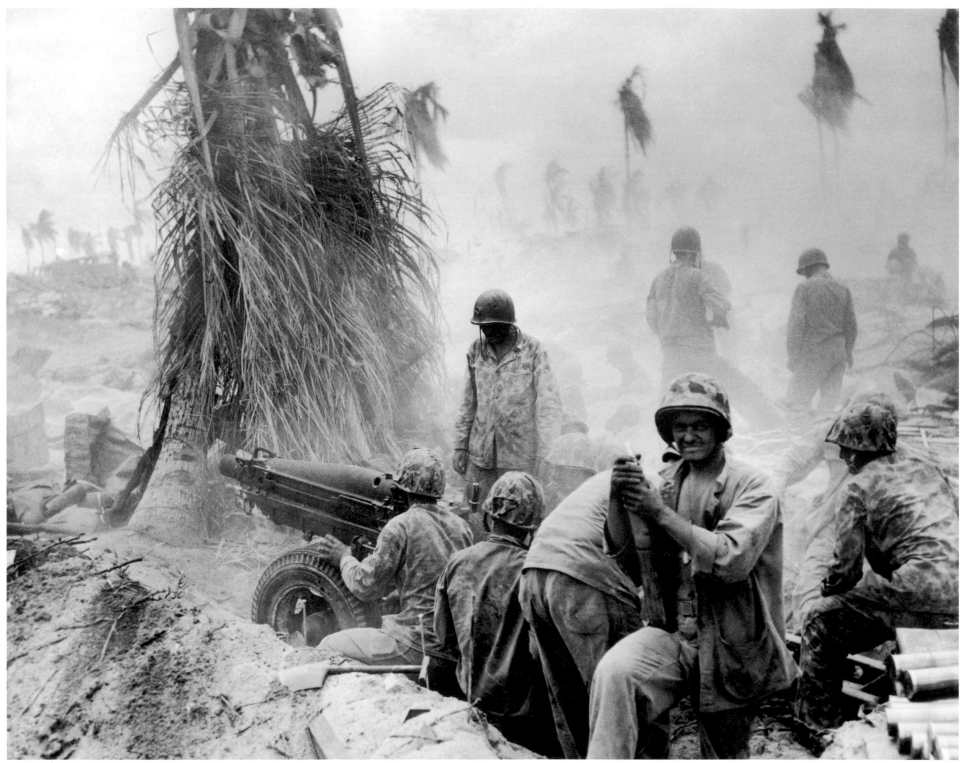

TARAWA, GILBERT ISLANDS, NOVEMBER 1943

The Gilbert Islands to the north fell to Adm. Chester W. Nimitz's command. On November 20 at Tarawa, U.S. Marines made their first amphibious landing in the Pacific under fire, losing roughly one-third of the 5,000 men in the invading force before they reached the beach. The Marines finally triumphed but the carnage, vividly documented by the many photographers with the troops, provoked an outcry in America. The helmet of the Marine standing behind the field gun in the center of the photograph was pierced by a Japanese bullet, but he was unharmed.

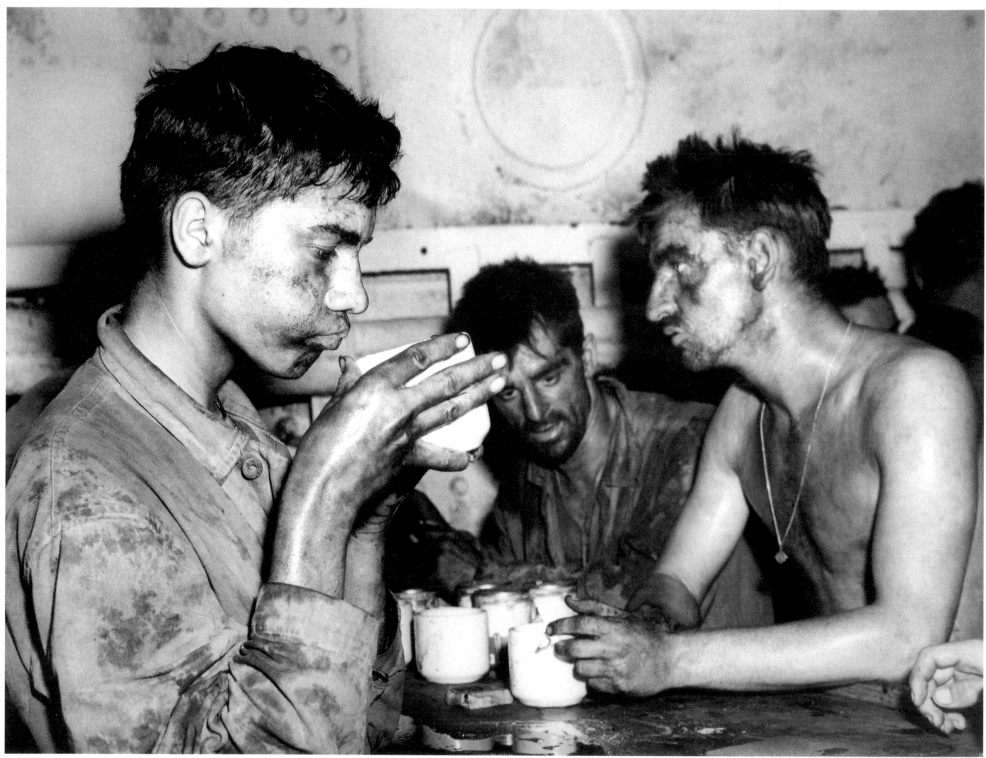

Chief Photographer's Mate Ray R. Platnick, U.S. Coast Guard/AP Archives

ENIWETOK ATOLL, MARSHALL ISLANDS, FEBRUARY 20, 1944

Nimitz's forces pressed on to the Marshall Islands. There, he used his massive sea and air superiority to good effect, simultaneously invading Eniwetok Atoll and launching carrier-based assaults to cripple the nearest Japanese base on Truk in the Caroline Islands. U.S. Marines took the atoll in three days with light casualties and threw themselves into the task of building airfields for the next advance. Here, grimy and weary after two days and nights in the battlefield, Marines take a rest. Nineteen-year-old Pfc. Faris M. "Bob" Tuohy lifts a coffee cup.

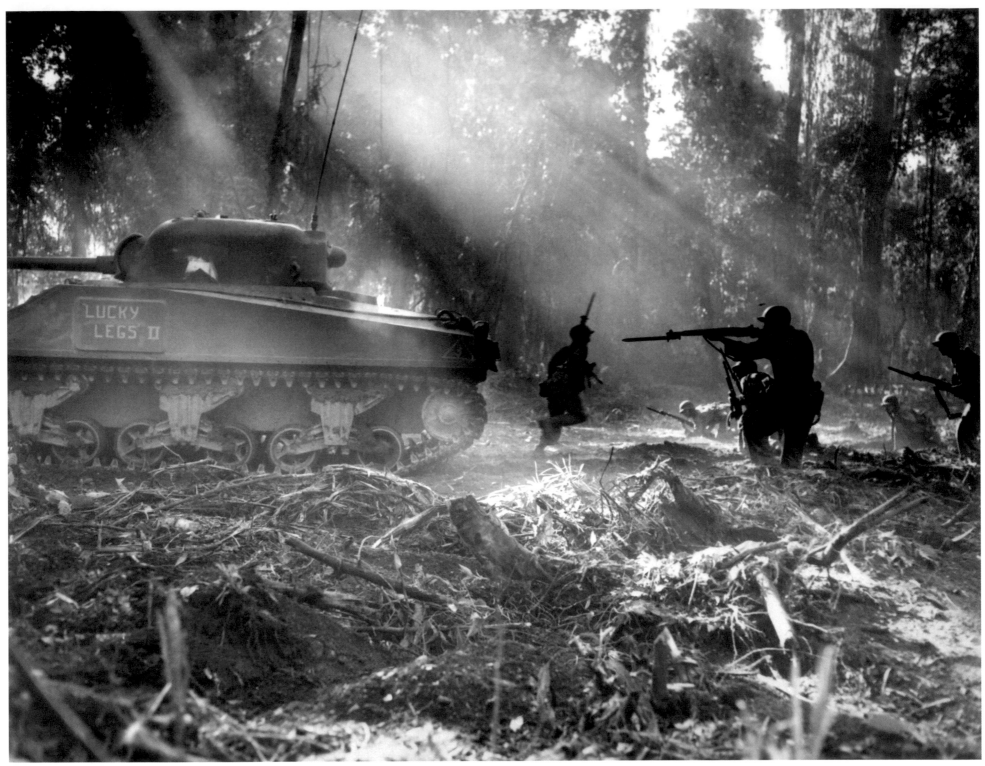

BOUGAINVILLE, SOLOMON ISLANDS, MARCH 1944

Following in the cover of a tank, American infantrymen secure an area on Bougainville,
after Japanese forces infiltrated their lines during the night.

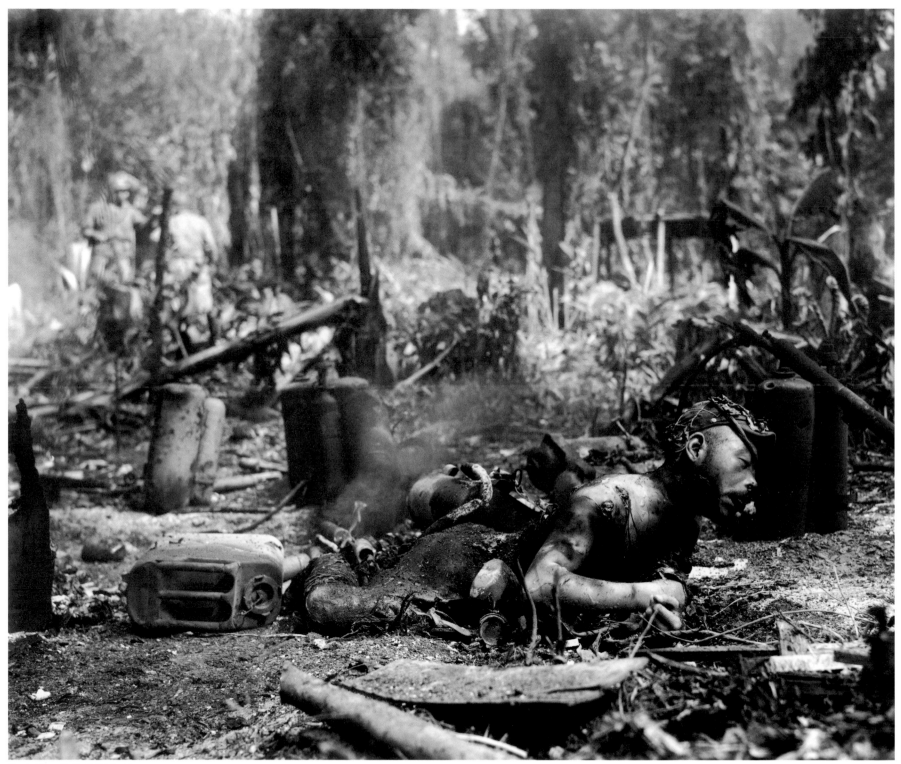

BOUGAINVILLE, SOLOMON ISLANDS, APRIL 1944

This Japanese soldier entered the American command post at Empress Augusta Bay and tried to destroy the company
food dump with an incendiary grenade. The grenade ignited flamethrowers stored in the same building, killing the soldier.

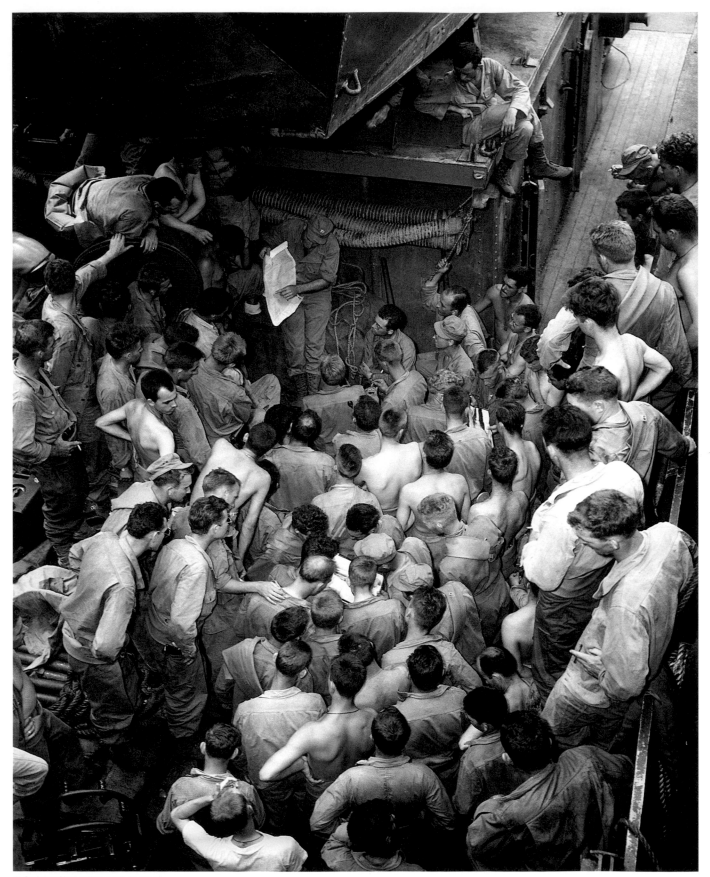

NEW BRITAIN, NEW GUINEA,
DECEMBER 1943

After taking the Huon Peninsula,
MacArthur looked to clear the southern
end of New Britain to secure the strait
between that island and New Guinea.
The first landings took place at Arawe
on December 15. A predawn assault in
small rubber rafts was repulsed before
troops in more traditional landing craft
secured a beachhead. Here, aboard a
troop transport, a captain briefs his
men before the operation.

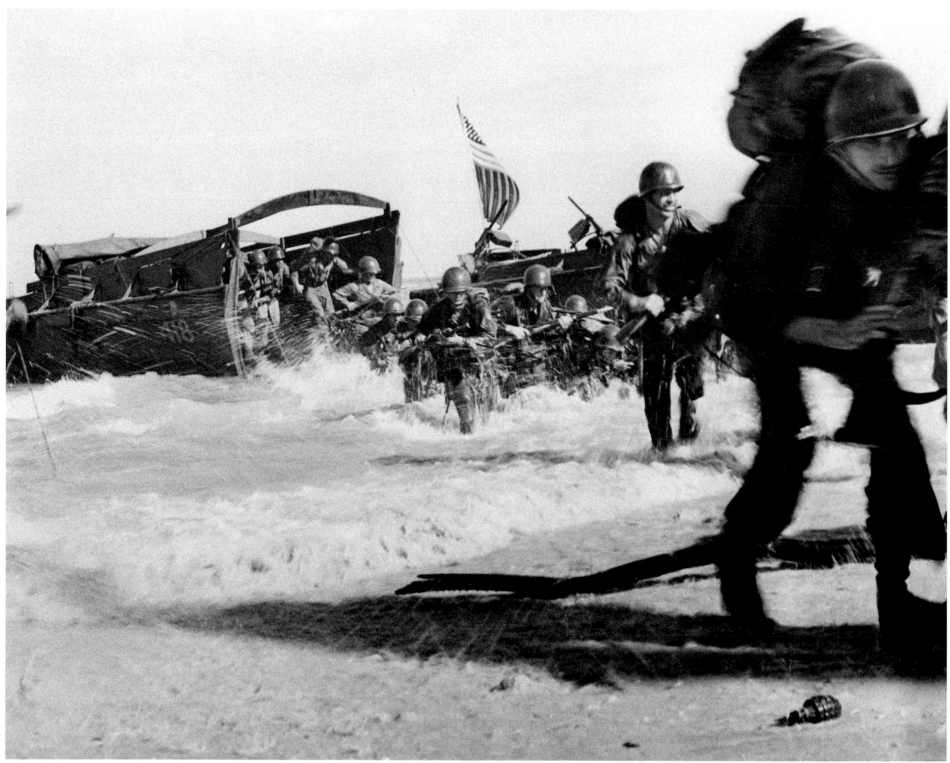

WAKDE ISLAND, NEW GUINEA, MAY 18, 1944

By midsummer 1944, Gen. MacArthur had overcome the Japanese in New Guinea and was ready to prepare for his return to the Philippines. The capture of an airfield on Wakde Island occurred during the latter days of the New Guinea campaign. Here, U.S. soldiers in the vanguard of the attacking force leave their Higgins boats, racing through the surf to the beach. In the 1930s, Higgins Industries of New Orleans invented a shallow-draft vessel that, when adapted to the needs of the U.S. Marines, became the favored landing craft for amphibious operations in World War II.

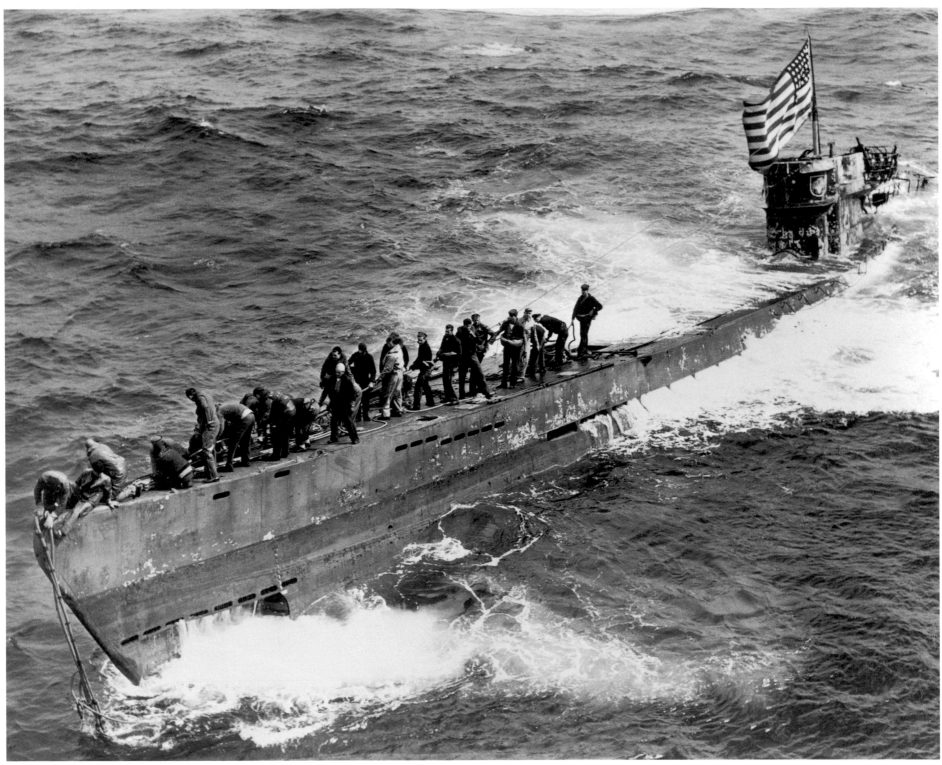

ATLANTIC OCEAN, JUNE 4, 1944

The American flag flies from the conning tower of German submarine U-505, captured
near Cape Blanco in French West Africa. Sailors from the destroyer escort USS *Pillsbury*
boarded U-505, marking the U.S. Navy's first capture of a ship of war on the high seas
since 1815, when the USS *Peacock* seized HMS *Nautilus* in the War of 1812.

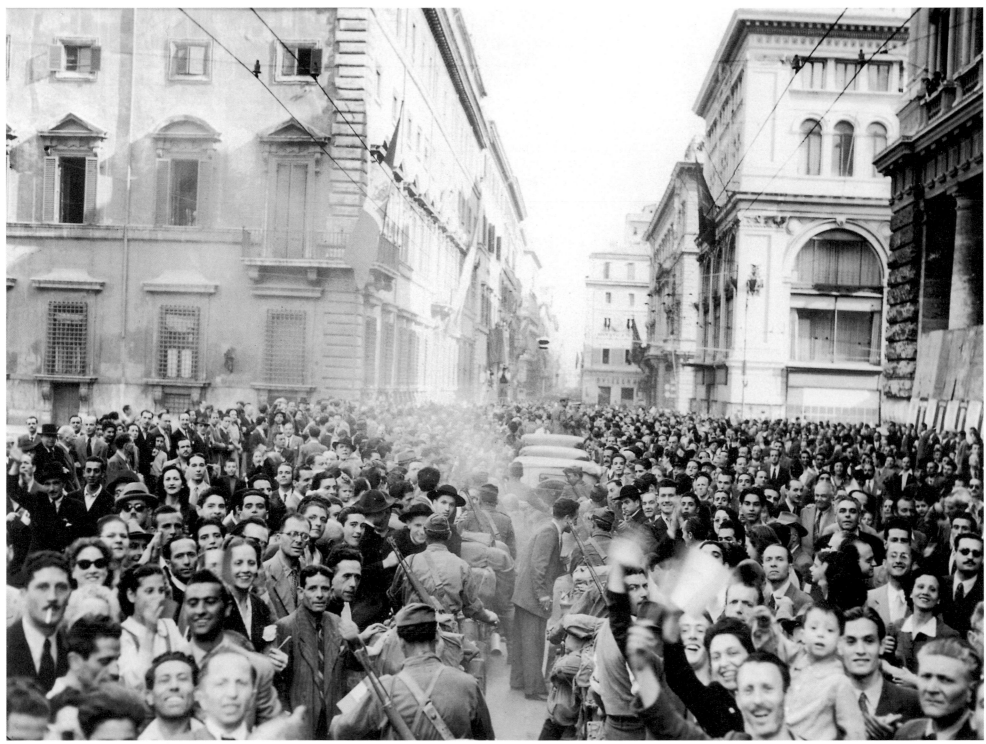

AP Archives

ROME, JUNE 5, 1944

Romans crowd the streets to cheer soldiers of the U.S. Fifth Army as they make their way
through the city. Americans first entered Rome the night of June 4 and carried on in pursuit
of the German army while most civilians stayed indoors. But when the rest of the
Allied troops appeared in force the following day, a festive mood took hold.

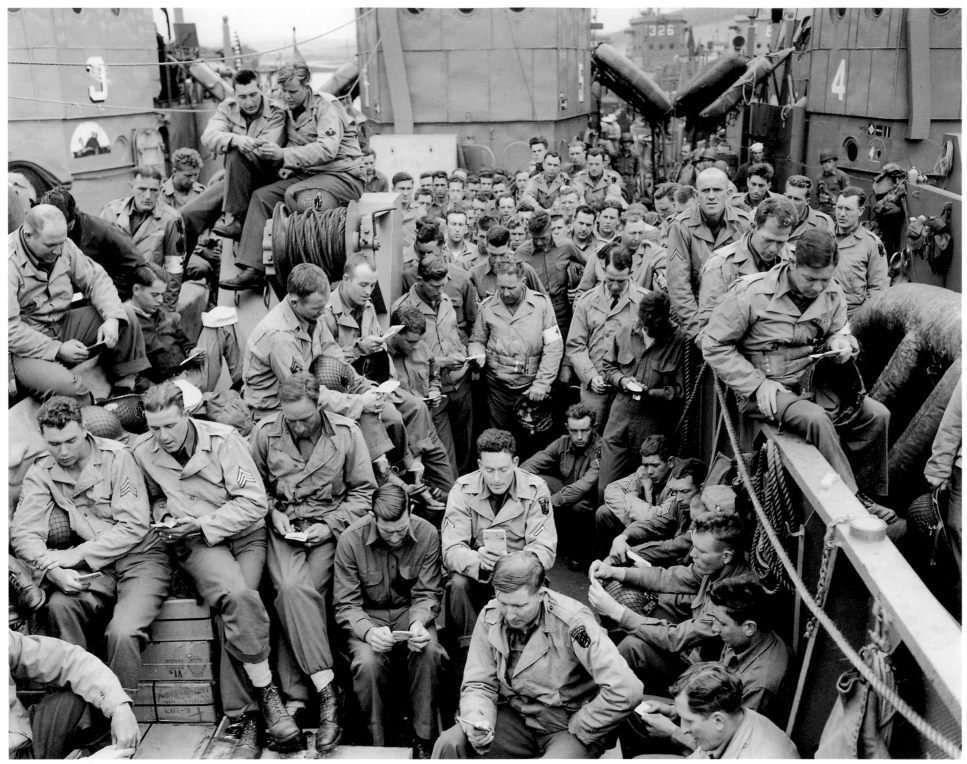

Peter J. Carroll, AP Staff/AP Archives

ENGLISH CHANNEL, JUNE 5, 1944

U.S. servicemen take part in a Protestant prayer service aboard a landing craft
delivering them to Normandy for the D-Day invasion. Code-named Operation
Overlord, the mammoth Allied assault on the beaches of France—so long discussed,
argued over, and planned for—marked a turning point in the war in Europe.

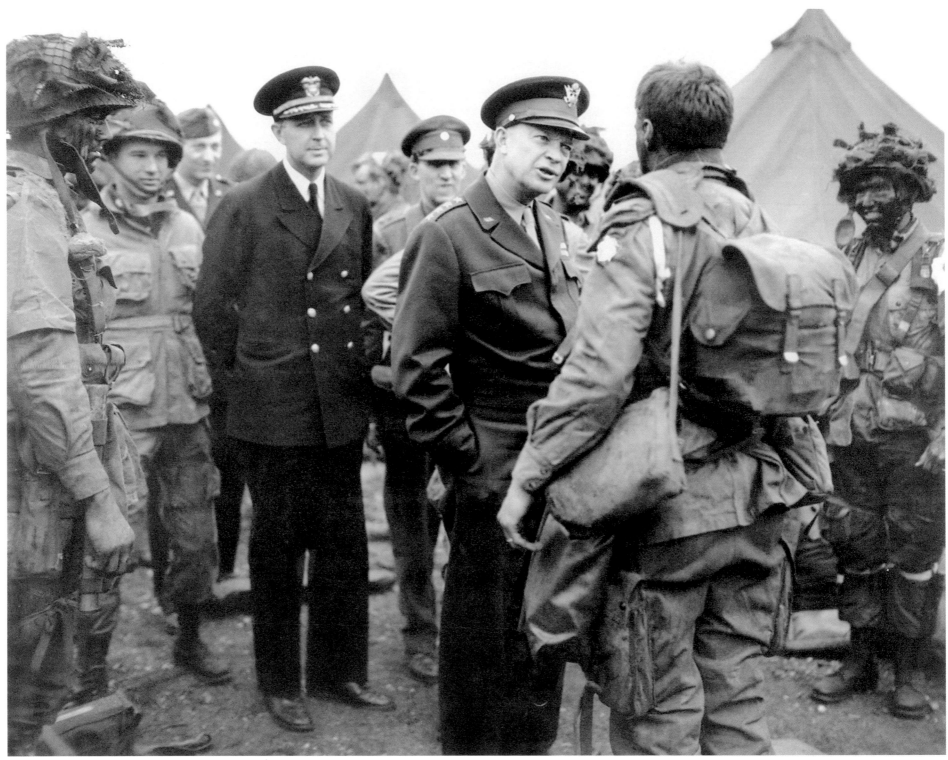

GREENHAM COMMON, ENGLAND, JUNE 5, 1944
Supreme Commander Eisenhower visits paratroopers of the 101st Airborne
Division at the Royal Air Force base in Greenham Common about three hours
before they are due to board their planes to join the first D-Day assault.

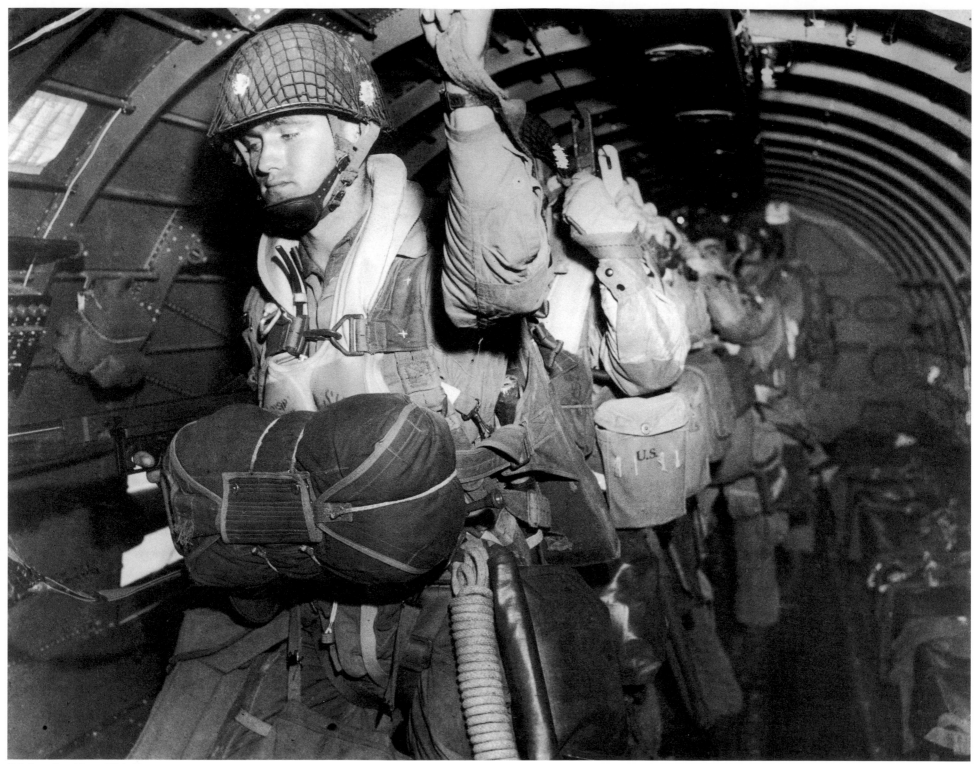

FRANCE, JUNE 6, 1944

These U.S. paratroopers, fixing their static lines, are about to jump over Normandy on D-Day before dawn. The decision to launch
the airborne attack in darkness instead of waiting for first light was probably one of the few Allied missteps on June 6, and there was
much to criticize both in the training and equipment given to paratroopers and glider-borne troops of the 82nd and 101st airborne
divisions. Improvements were called for after the invasion; the hard-won knowledge would be used to advantage later.

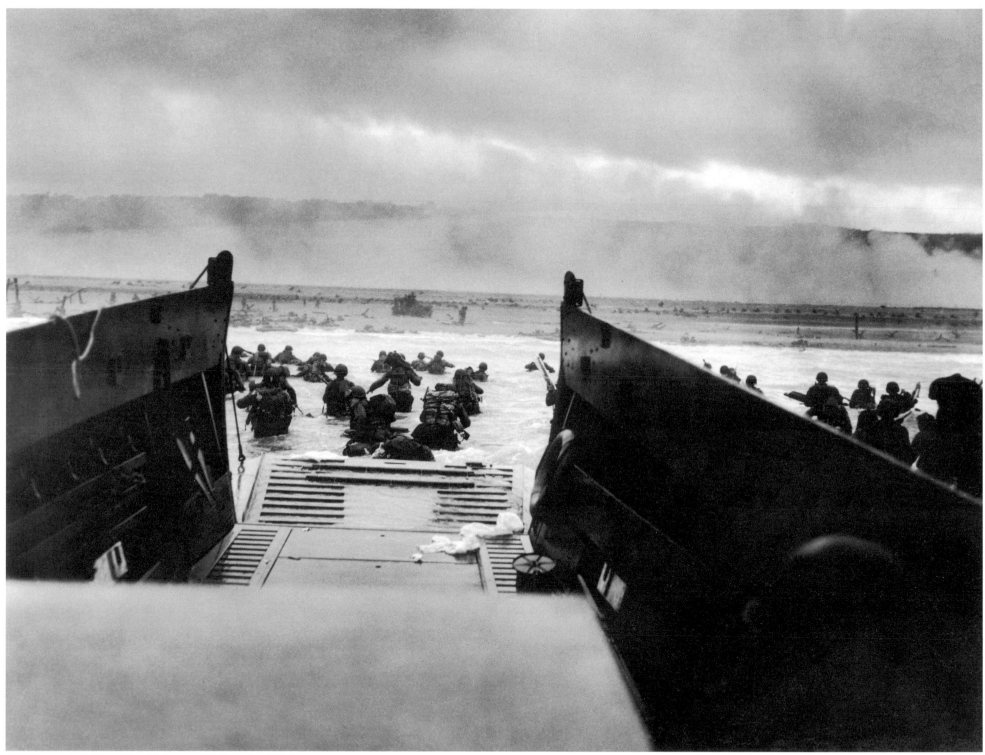

NORMANDY, JUNE 6, 1944

Among the objectives on D-Day, the beach code-named Omaha was the best fortified. Allied commanders felt it had to be taken nonetheless, to dislodge the Germans dug in between Utah Beach to the west—also assigned to the Americans—and the British-targeted beaches code-named Gold, Juno, and Sword to the east. At Omaha Beach, the Americans came ashore under intense fire and took the heaviest casualties in the battle, landing about 40,000 men, with 2,200 killed or wounded. This photograph is believed to show E Company, Sixteenth Regiment, First Division, in the first wave of the attack.

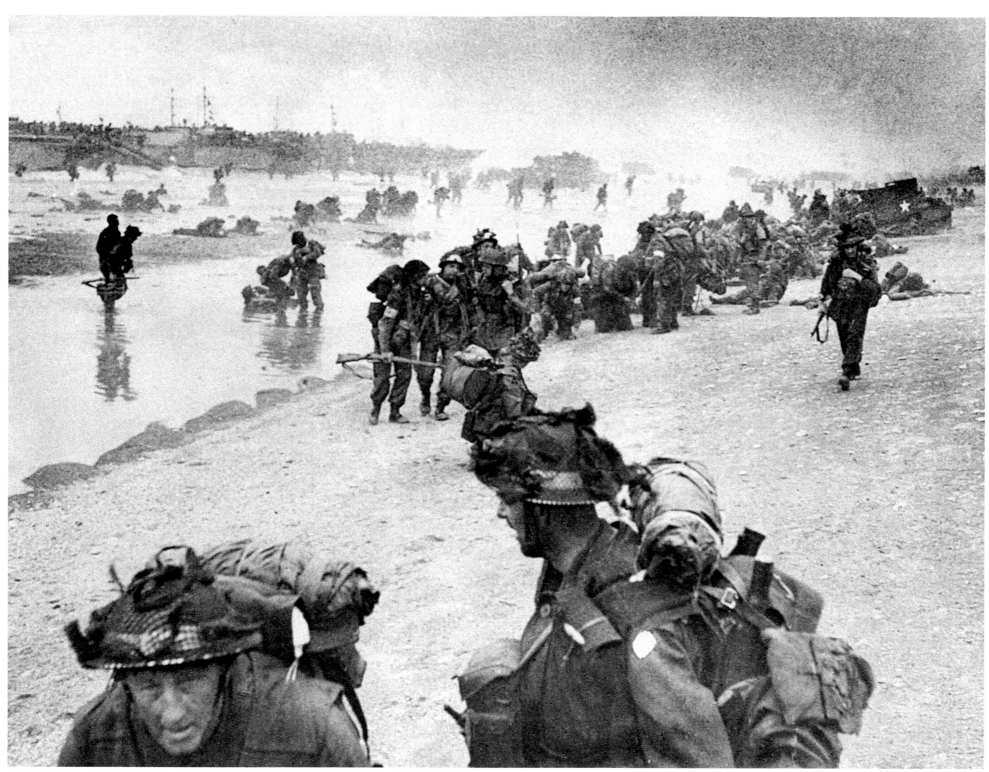

NORMANDY, FRANCE, JUNE 6, 1944

The British fared well at Gold Beach, with 25,000 landed and 400 casualties; and at Sword Beach, with 29,000 landed and 630 casualties.
But the Canadians at Juno Beach (21,400 landed, 1,200 casualties) encountered fire similar to what the Americans experienced at Omaha.
In both places, most of the casualties were sustained in the first hour, when assault teams faced roughly a one-in-two chance of being
wounded. Here, wounded British troops from the South Lancashire and Middlesex regiments are being helped ashore on Sword Beach.

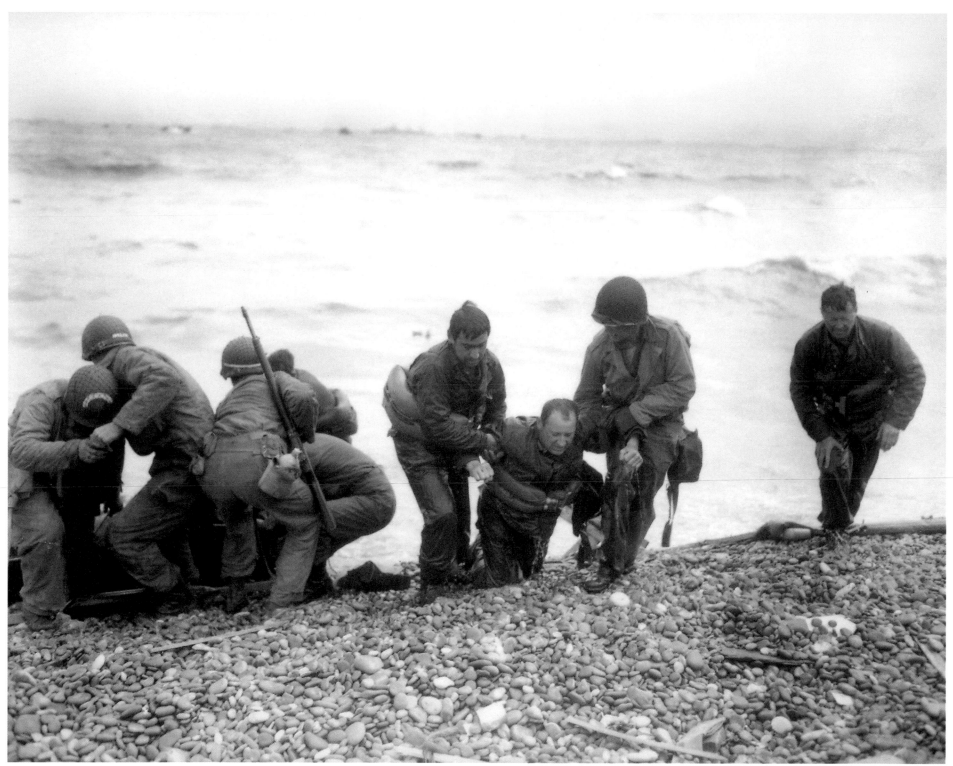

NORMANDY, FRANCE, JUNE 6, 1944

At Utah Beach, the Americans landed about 20,000 men, with 190 casualties. Here, survivors from
a Higgins boat sunk by German coastal defenses are helped ashore on Utah Beach. A typical Higgins boat could land
a platoon of thirty-six men with their equipment, or a jeep and twelve men, while maneuvering in heavy surf.

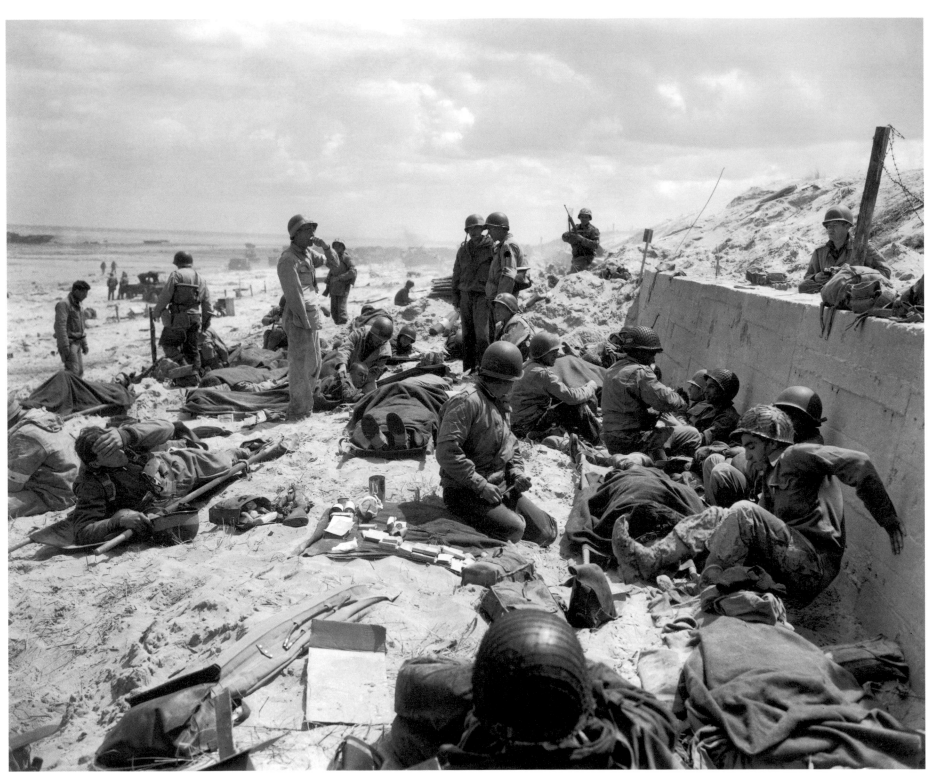

NORMANDY, FRANCE, JUNE 1944

When darkness fell on June 6, about 175,000 American, Canadian, and British troops had entered
Normandy by sea and air. An estimated 4,900 were killed, wounded, or missing—2,200 of them in
the assault on Omaha Beach. Here, American soldiers lie on stretchers and sit propped against a sea wall
awaiting transportation back to England for treatment after being wounded in the landings.

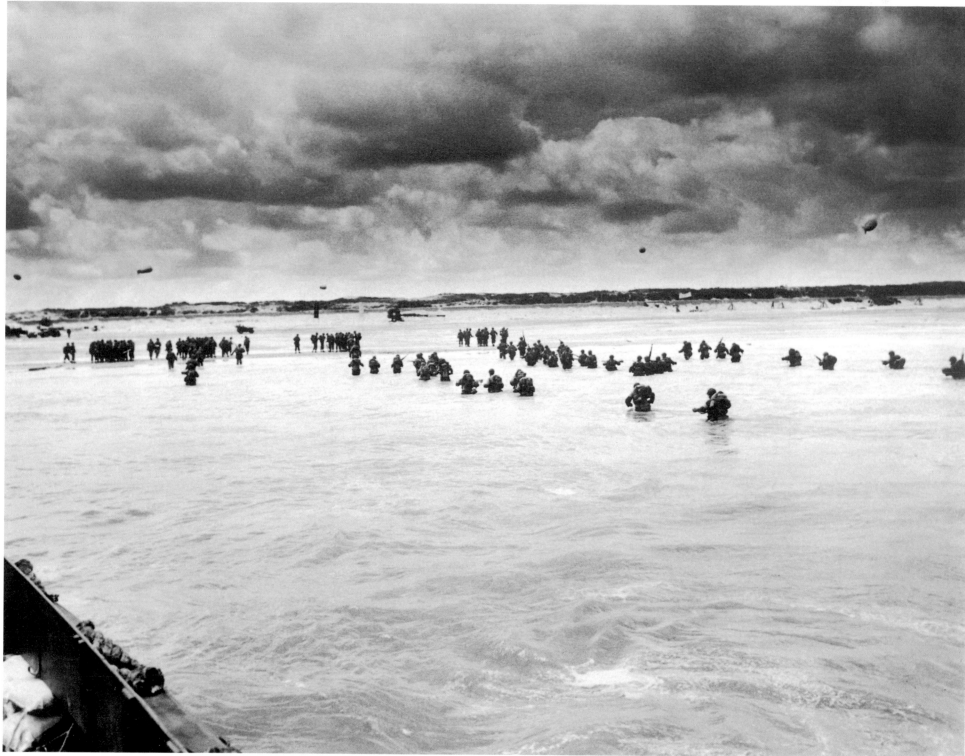

NORMANDY, FRANCE, JUNE 1944

U.S. troops continue to come ashore after the beachheads were secured. The
landings were mostly completed by June 16; a storm that lasted from June 19 to 22 destroyed
the artificial harbor that the Americans had built on Omaha Beach.

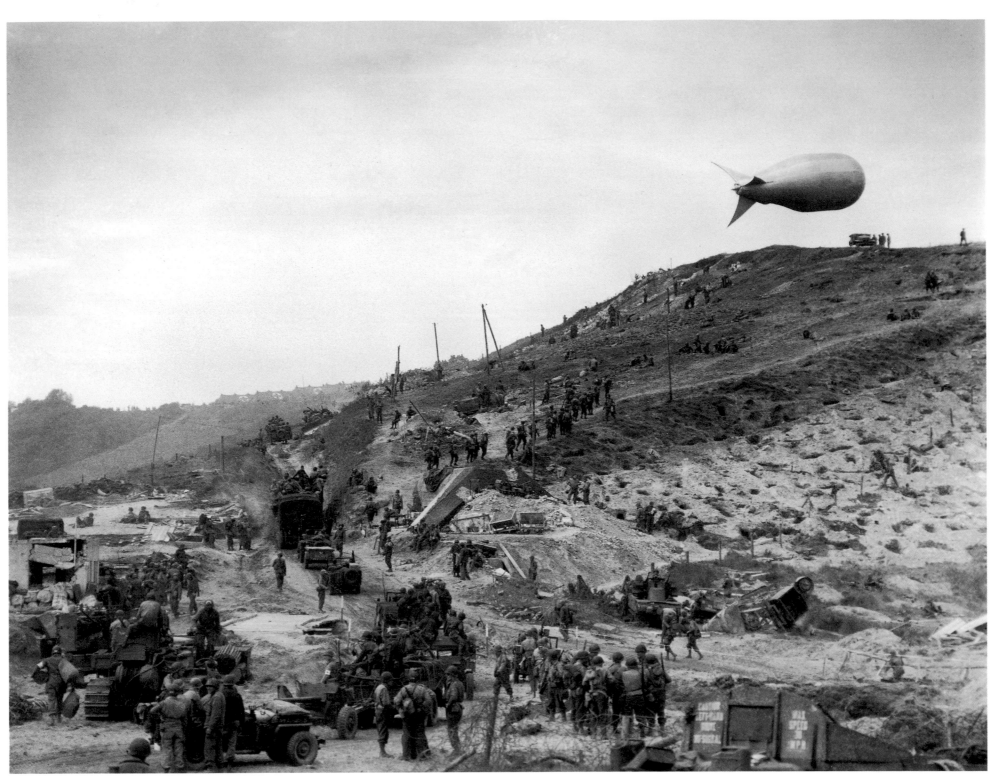

Jack Rice, AP Staff/AP Archives

NORMANDY, FRANCE, JUNE 10, 1944

By the end of June, the Allies had landed upward of one million men and more than 170,000 vehicles in Normandy.
The decisive fact of D-Day was that the Allies were able to establish beachheads that the enemy could not dislodge,
providing the invading army with a staging area to marshal its troops and equipment and break out into France.
Here, troops move inland from Omaha Beach over ground that had been heavily contested four days earlier.

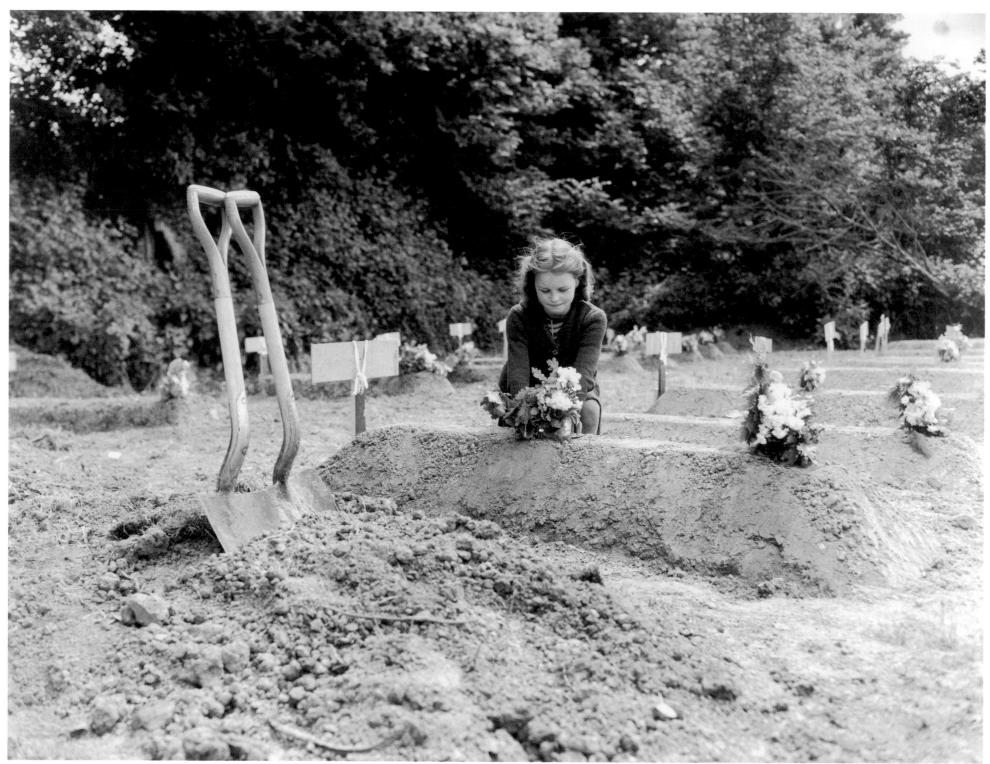

NORMANDY, FRANCE, JUNE 12, 1944

A French girl places flowers over the freshly dug grave of an American glider soldier killed in the D-Day invasion. The gliders used on D-Day were crewed by a pilot and copilot and towed by Curtiss C-46 and C-47 aircraft. Each could carry a jeep, a 75mm howitzer, a specially designed bulldozer, or thirteen men with their supplies and equipment. Glider casualties were especially high, largely because it proved almost impossible to land in small fields partitioned by tall hedgerows.

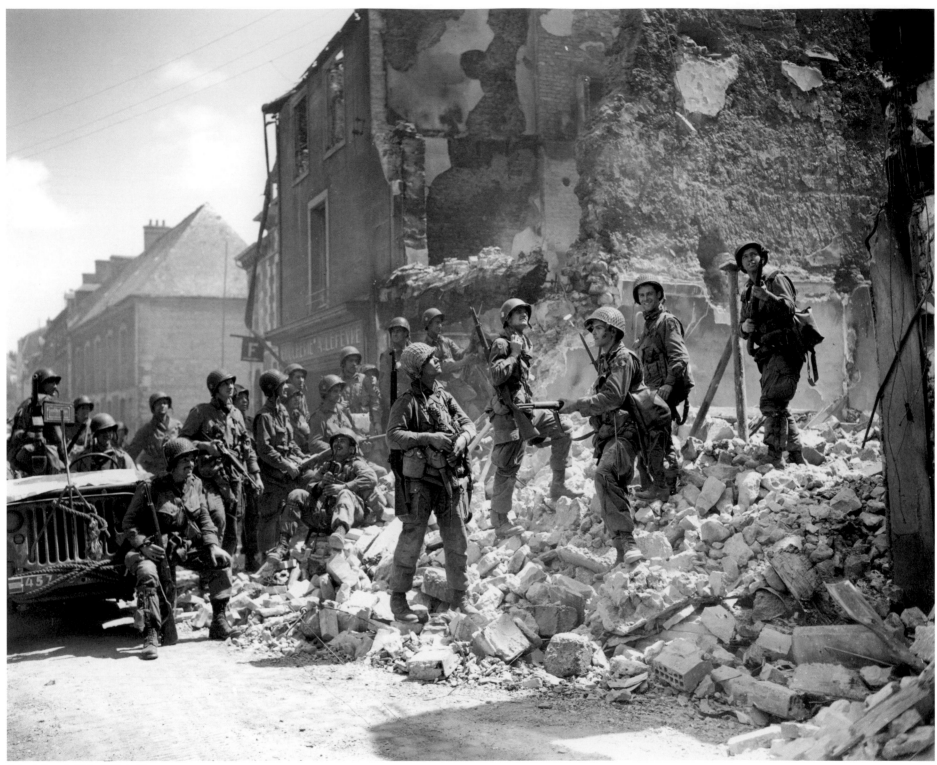

CARENTAN, FRANCE, JUNE 1944

The city of Carentan, located between the two American landing beaches of Utah and Omaha, was a key
early objective of the Normandy campaign. It was defended by crack troops of the German Sixth Paratroop Regiment.
It took the Americans until June 11 to mount a powerful offensive, and the city was finally cleared in the evening of
June 12. After the battle, U.S. soldiers stand on the remains of a house as they inspect damage in the city.

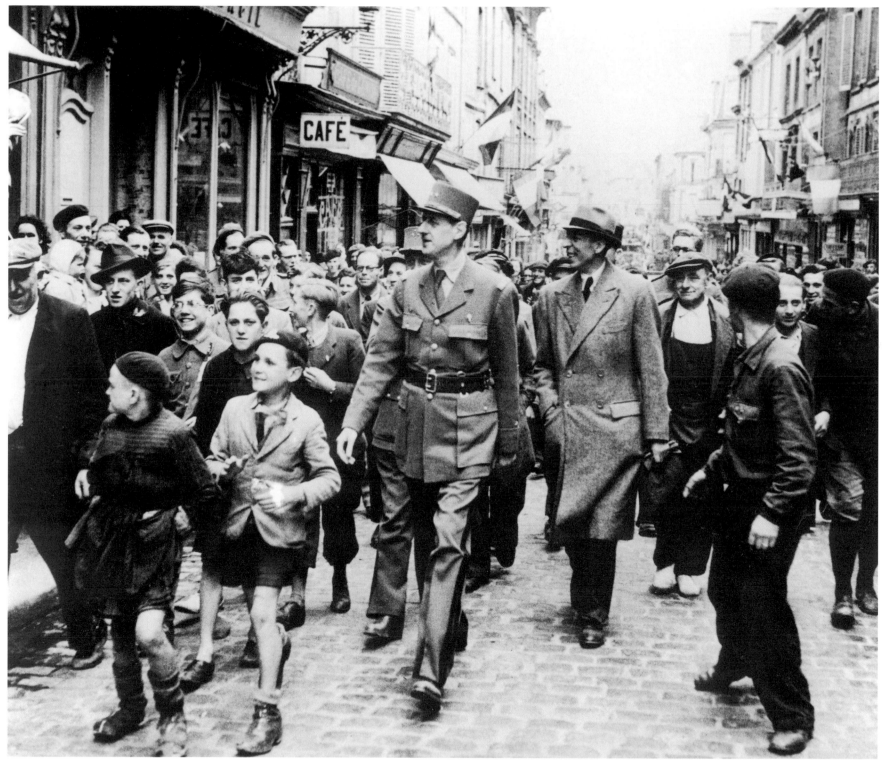

BAYEUX, FRANCE, JUNE 14, 1944

French Gen. Charles de Gaulle, leader of the Free French Movement, is followed by a welcoming
crowd as he walks through the streets of liberated Bayeux, taken on D-Day plus one. This was his first
day on French soil in four years. He was to make a triumphal entry into Paris on August 25,
and by November he was appointed head of the French Provisional Government.

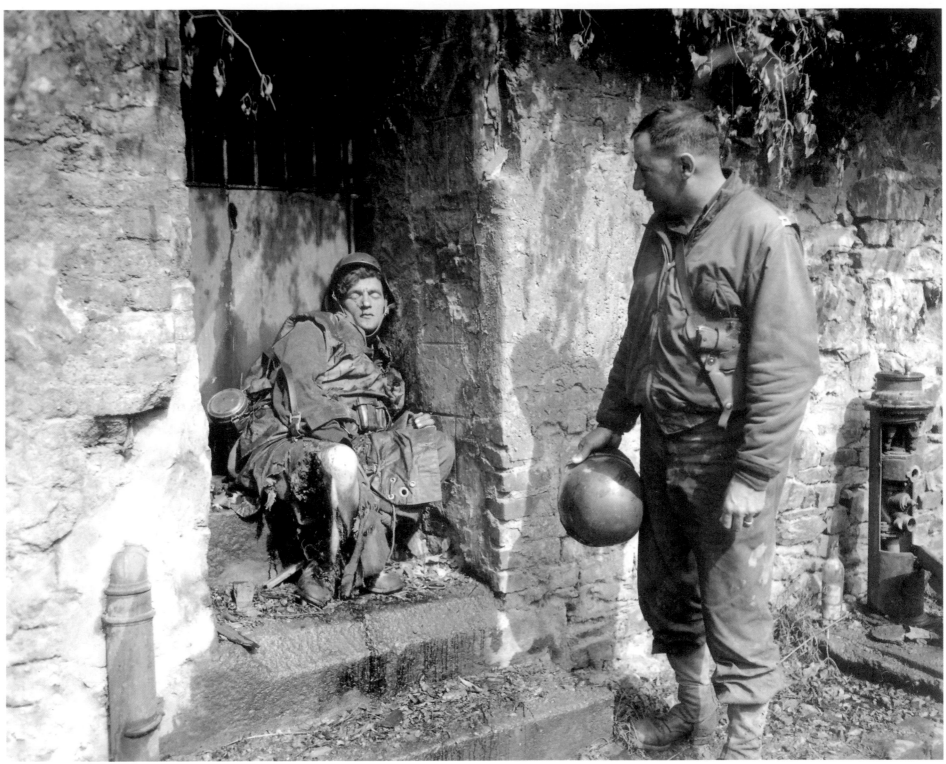

CHERBOURG, FRANCE, JUNE 27, 1944

As the nearest major port, Cherbourg was a prime objective of the forces landed on D-Day. Germans fiercely defended
the port and destroyed its installations before surrendering on June 27. A temporary port was built, and it handled a vast quantity
of war matériel in the ensuing months. This dead German soldier was one of the city's "last stand" defenders. Capt. Earl Topley,
right, who led one of the first American units into the city on June 27, said the German killed three of his men.

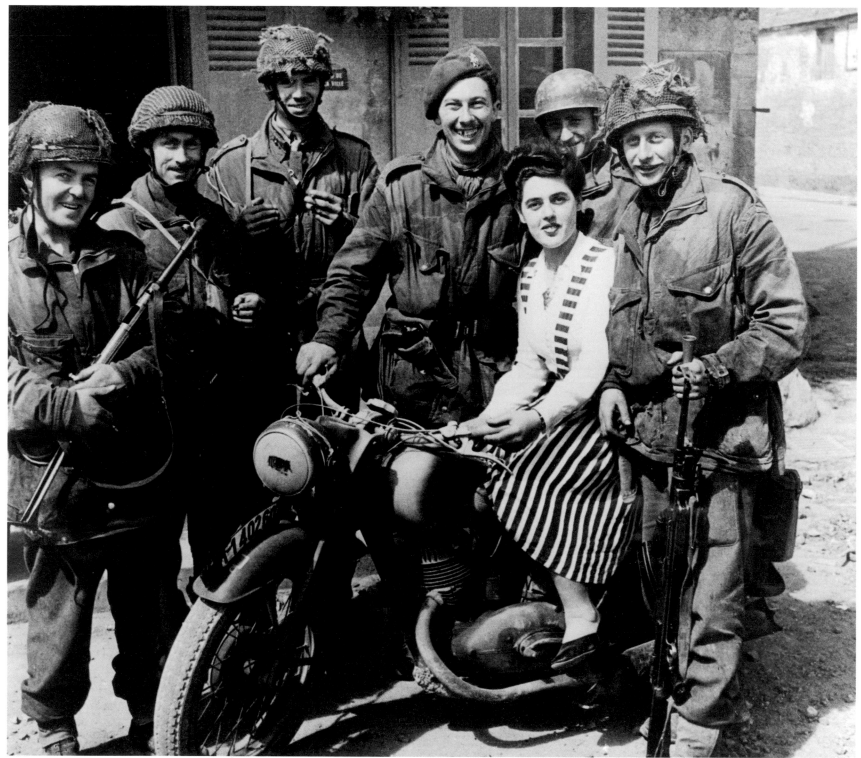

NORMANDY, JUNE 1944
A young French woman poses with British glider troops.

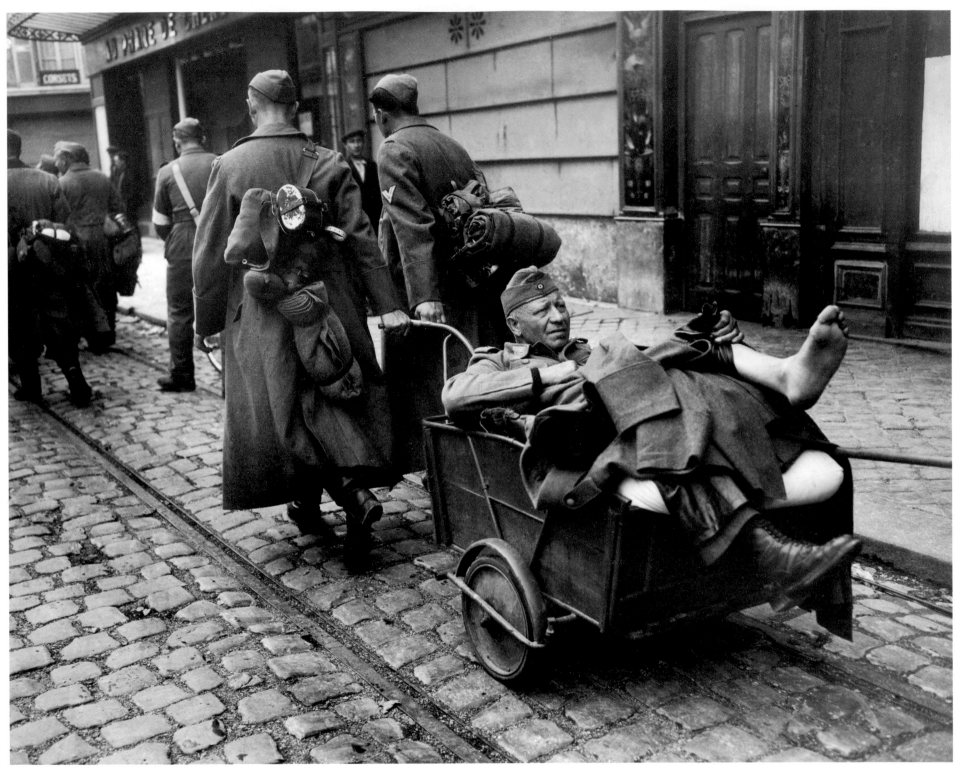

CHERBOURG, FRANCE, JULY 1944

A wounded German soldier is being towed by his companions on their way to a POW camp.

TRUK, CAROLINE ISLANDS, JULY 2, 1944

Truk was the site of a major Japanese base that the Americans devastated with air attacks to neutralize its value in defending Eniwetok and the Mariana Islands. Here, in the skies over Truk, a Japanese dive bomber is headed for destruction. Lt. Com. William Janeshek, pilot of the Navy Consolidated PB4Y that hit the bomber, said the gunner visible in the rear cockpit had acted as if he was about to bail out. Instead, the gunner suddenly sat down and was still in the plane when it hit the water and exploded.

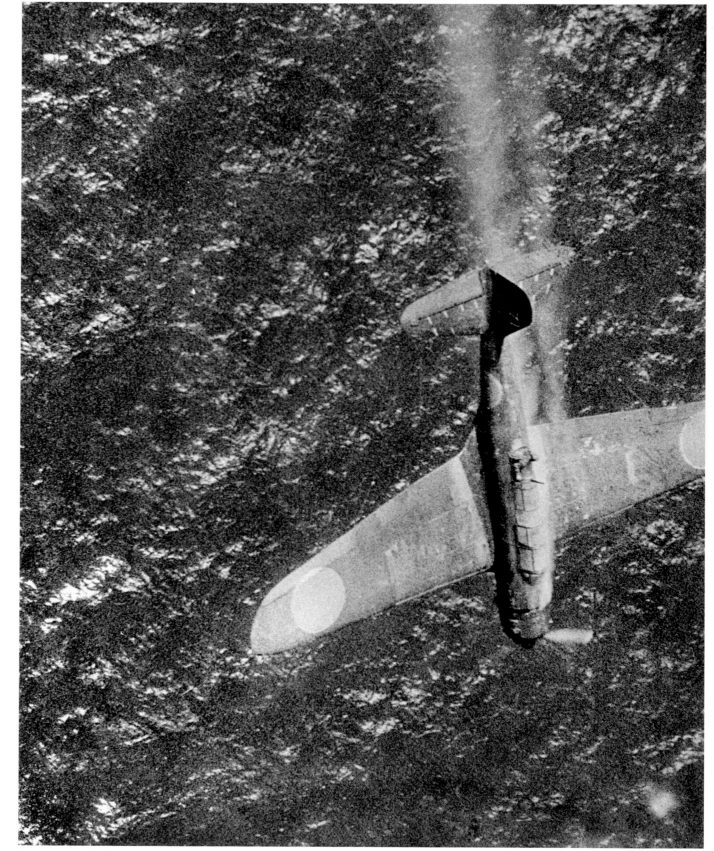

U.S. Navy/AP Archives

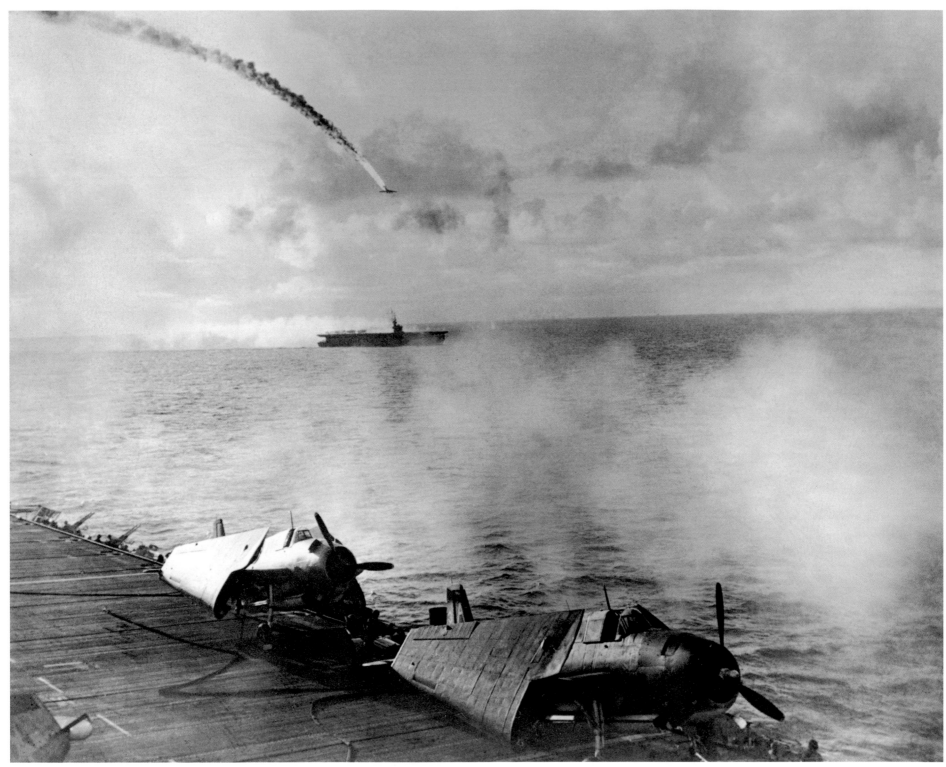

MARIANA ISLANDS, JULY 1944

With the capture of the Mariana Islands—especially Saipan, Tinian, and Guam—in summer 1944, American forces penetrated Japan's inner ring of defences: Japan, the Philippines, Formosa, and China were now within striking distance of U.S. long-range bombers. A decisive factor in the success of the operation was Adm. Raymond A. Spruance's Fifth Fleet, which scored a decisive victory in the Battle of the Philippine Sea in June and provided air cover for Marine landings in June and July. Here, a Japanese aircraft is shot down as it attacks the escort aircraft carrier USS *Kitkun Bay* during the Marianas campaign.

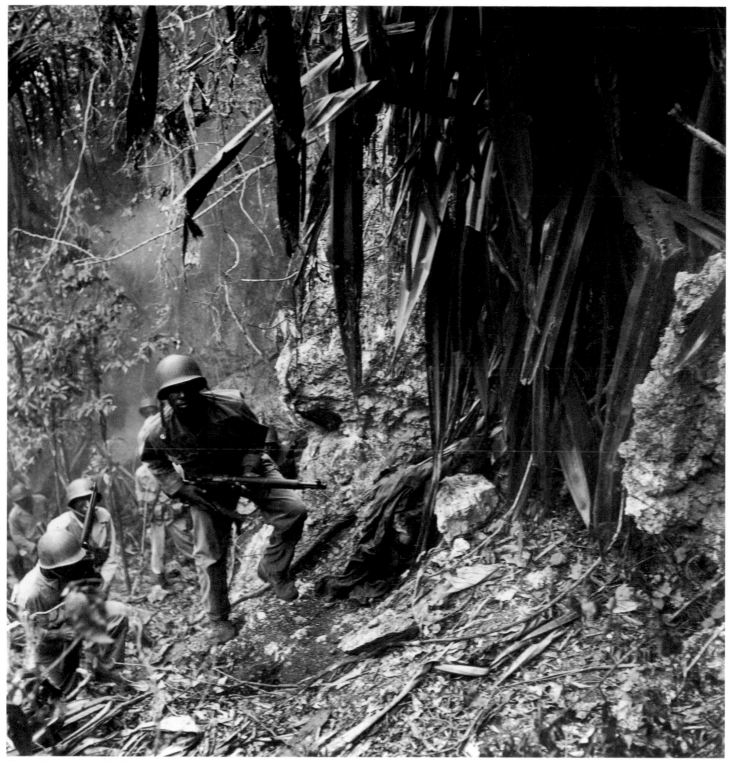

Charles P. Gorry, AP Staff/AP Archives

GUAM, MARIANA ISLANDS, MARCH 10, 1945

U.S. troops in the Pacific islands continued to find enemy holdouts long after the main Japanese forces had either surrendered or disappeared. Guam was considered cleared by August 12, 1944, but parts of the island were still dangerous half a year later. Here, patrolling Marines pass a dead Japanese sniper. These Marines may belong to the Fifty-second Defense Battalion, one of two black units sent to the Pacific.

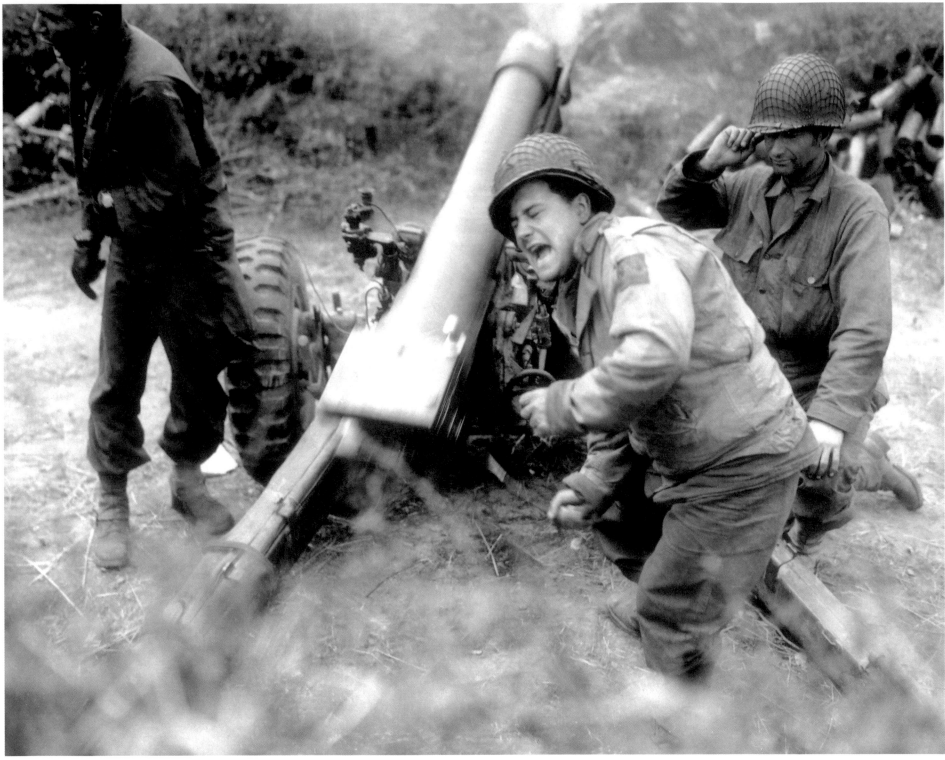

CARENTAN, FRANCE, JULY 11, 1944

The bloodiest phase of the Normandy campaign was the first three weeks of
July—the Battle of the Hedgerows—culminating in the occupation of Saint-Lô. Here, three
men of an American artillery brigade bombard retreating German forces near Carentan,
where little forward progress had been made since the city had been taken in June.

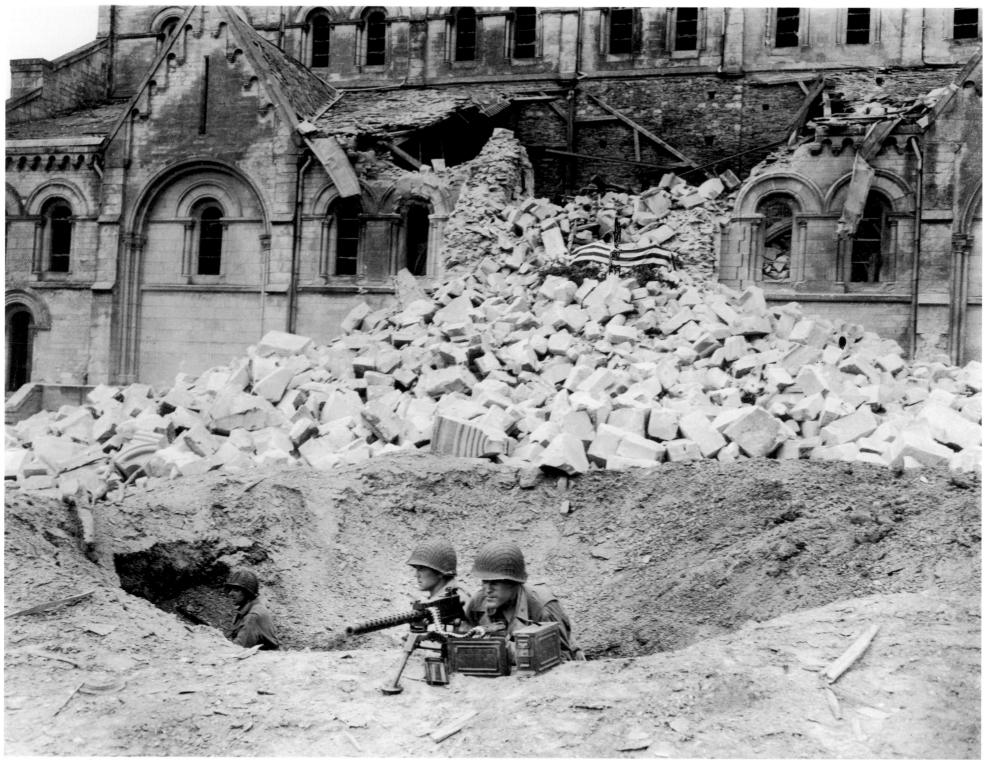

Harry Harris, AP Staff/AP Archives

SAINT-LO, FRANCE, LATE JULY, 1944

Covered with the American flag, the body of Maj. Thomas D. Howie, commander of the Third Battalion,
116th Infantry, rests amid the ruins of the Cathedral of Notre-Dame in Saint-Lô. Howie had been killed outside
of the city on July 17, by mortar fire, and the task force that entered the city the next day carried
his body by ambulance and jeep as a symbol of their comradeship and will to win.

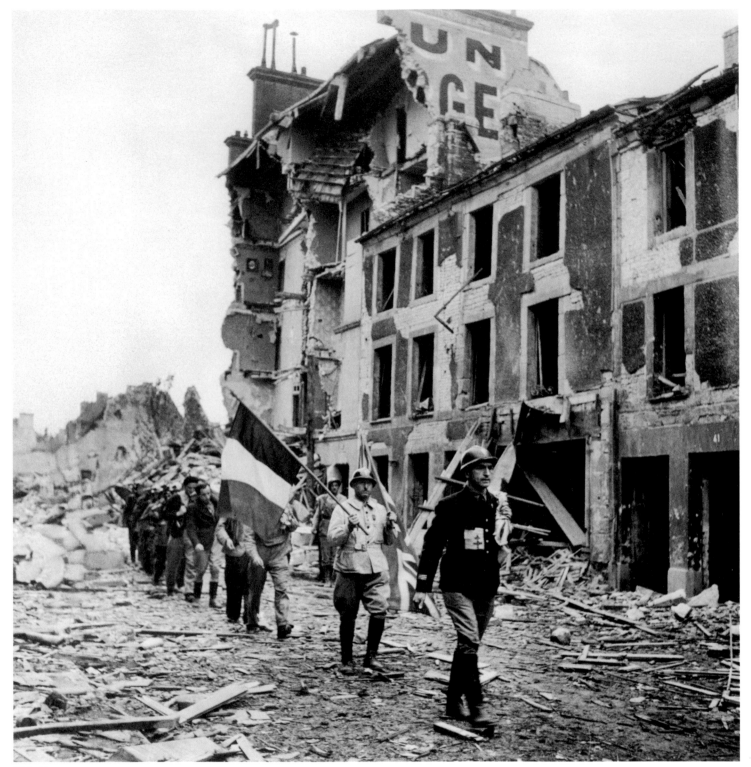

CAEN, FRANCE, JULY 27, 1944

Members of the French Resistance, the underground civilian movement organized to fight the German occupation, carry French and British flags as they collect medical supplies for villages to the south after the British liberation of Caen. The Allies had hoped to take Caen on D-Day, but tough resistance made that impossible until late July.

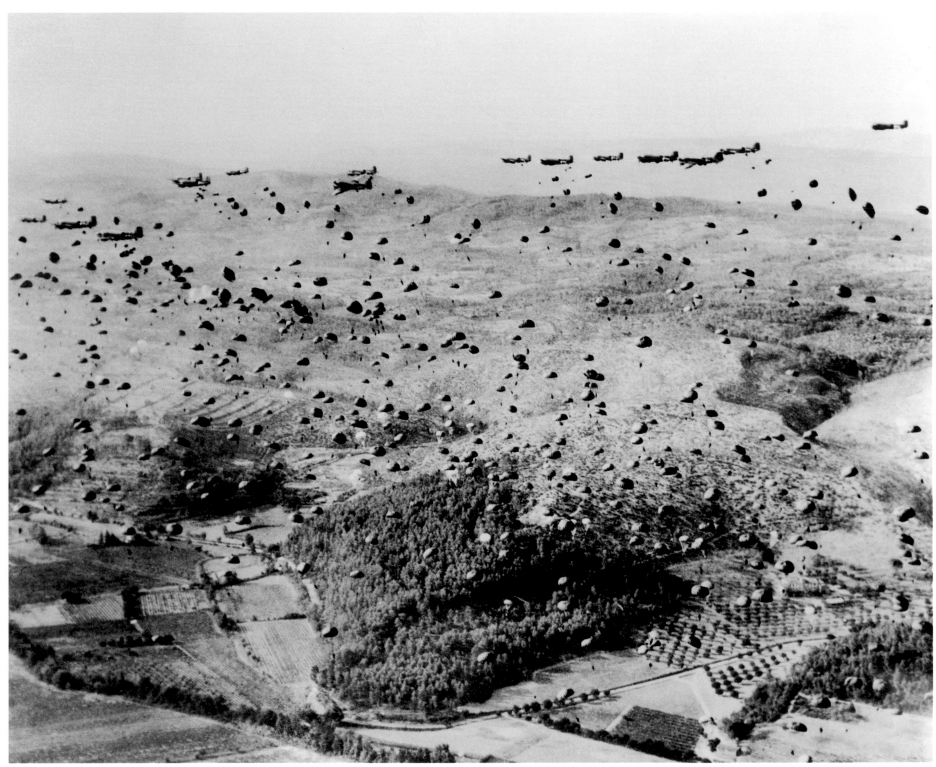

U.S. Army Air Force/AP Archives

SOUTHERN FRANCE, AUGUST 15, 1944

Curtiss C-47 aircraft drop more than 5,000 paratroopers of the First Airborne Task Force, along with supplies, between Nice and Marseille as part of Operation Anvil Dragoon. Since mid-1943, the Allies' plan for an invasion of Europe had included a landing in southern France as well as the main thrust into Normandy. Allied leaders kept putting this off but by the summer of 1944 realized that a major French Mediterranean port city would be an important asset. Anvil Dragoon (August 14-18) succeeded in establishing the beachhead.

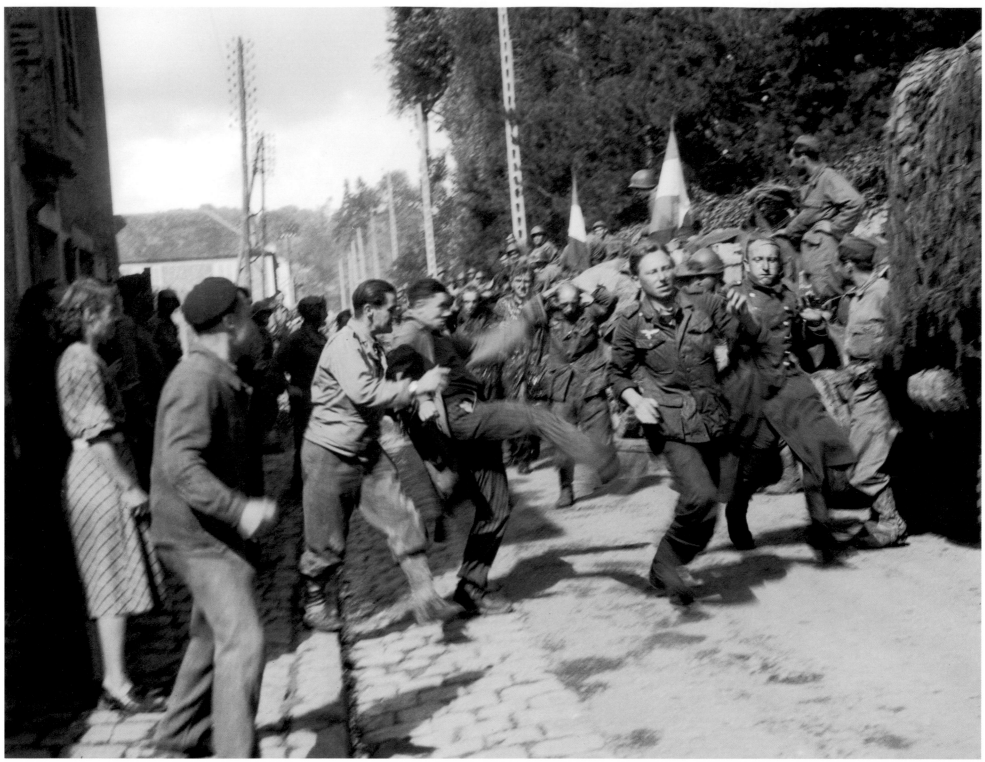

Dan Grossi, AP Staff/AP Archives

JOUY-EN-JOSAS, FRANCE, AUGUST 24, 1944
One day before the liberation of Paris, Frenchmen kick and jeer German prisoners
as they are led through the town of Jouy-en-Josas, eleven miles from the capital.

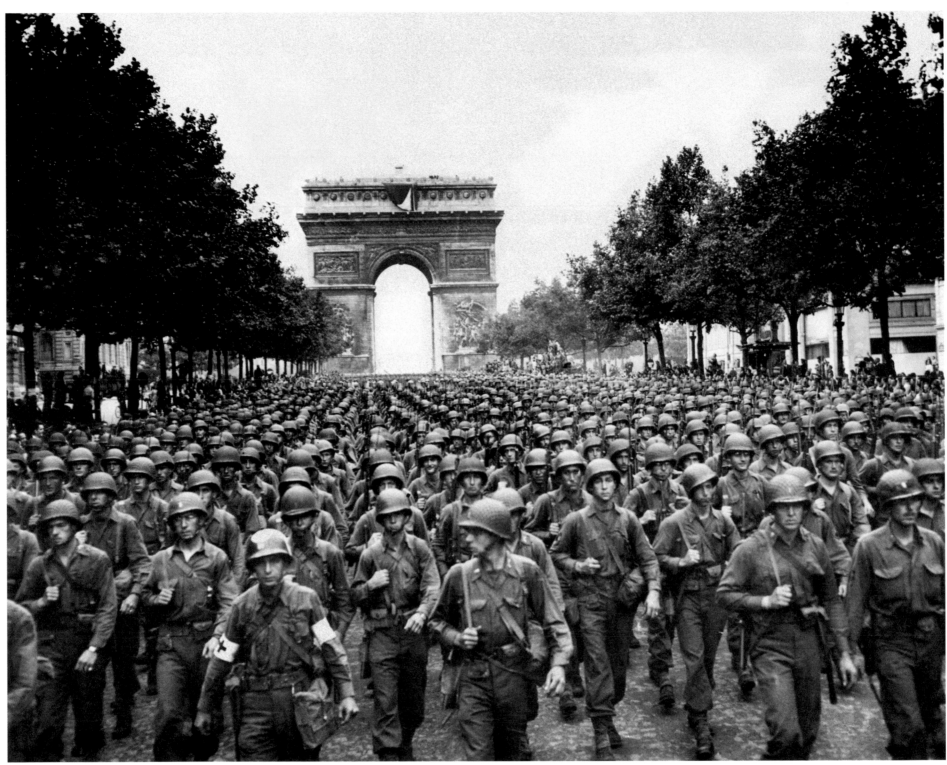

Peter J. Carroll, AP Staff/AP Archives

PARIS, AUGUST 29, 1944

Eisenhower did not consider Paris a vital military objective and chose not to commit troops to the capital after D-Day.
But events, and the French, forced a change of plan. After the French Resistance staged an uprising on August 19, he relented,
and American and Free French troops made a peaceful entrance on August 25. Here, four days later, soldiers of Pennsylvania's
Twenty-eighth Infantry Division march along the Champs-Elysées, with the Arc de Triomphe in the background.

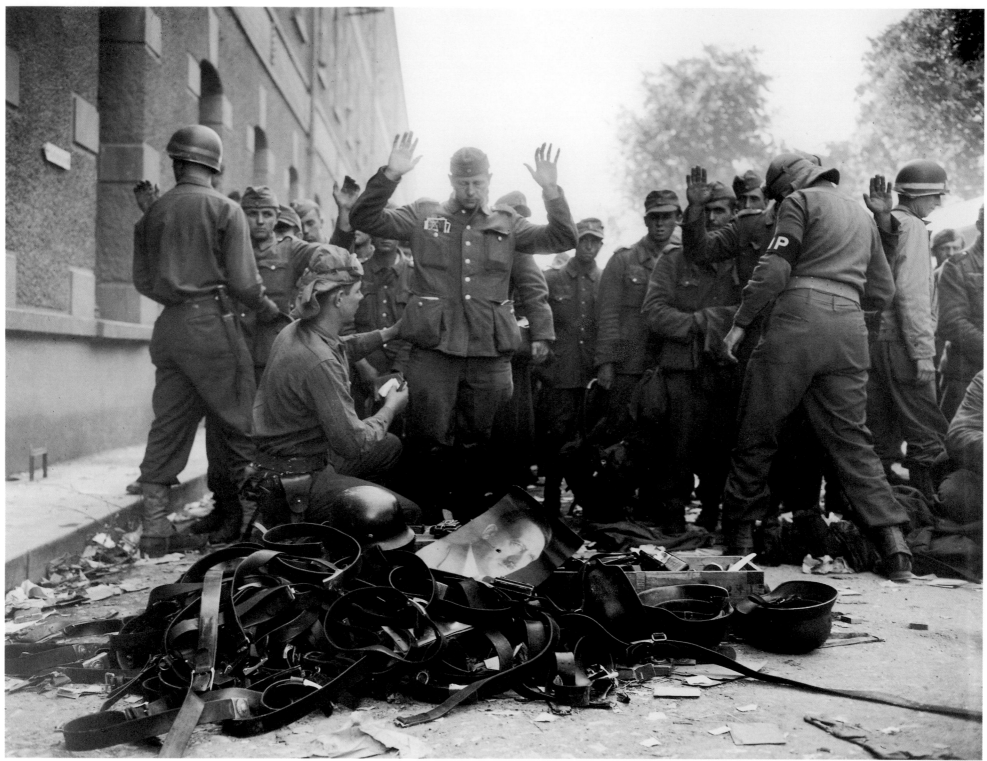

Harry Harris, AP Staff/AP Archives

MAUBEUGE, BELGIUM, SEPTEMBER 6, 1944

The First Army liberated Maubeuge on September 2. Here, a U.S. military patrol searches a column
of German prisoners. The pile of confiscated items in the foreground includes a picture of Hitler.

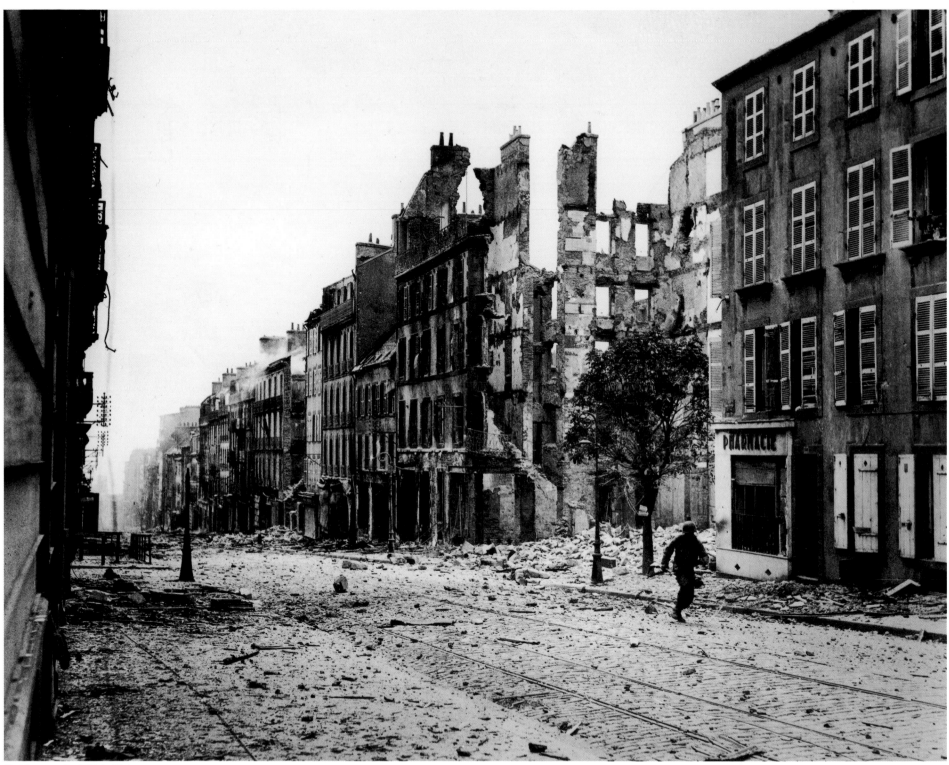

BREST, FRANCE, MID-SEPTEMBER 1944

The coastal city of Brest, a jumping-off point for U-boats preying on Allied convoys in the Atlantic, fell after a six-week siege. Here, an American soldier dashes to a new position in house-to-house fighting against German snipers.

AACHEN, GERMANY, SEPTEMBER 1944
Advance units of the First Army reached the German border on September 11. Aachen was the first
German city to fall to the Allies, on October 21. Here, American troops rest outside the city.

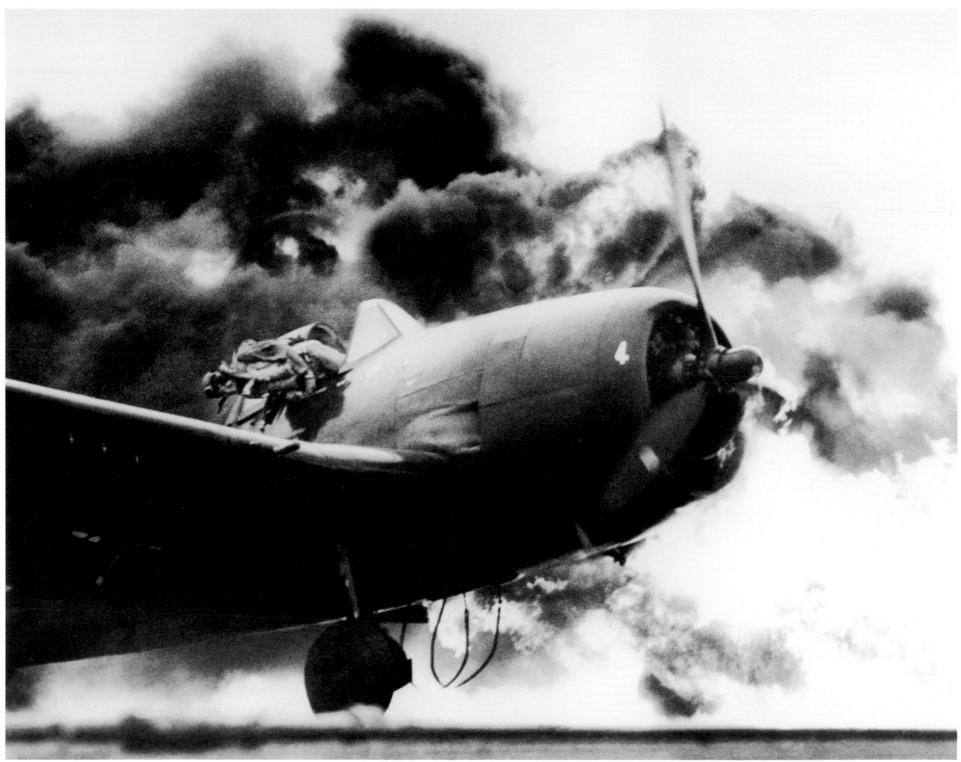

PACIFIC OCEAN, SEPTEMBER 1944
Ensign J. G. Fraifogl, of Mansfield, Ohio, throws himself from the cockpit of his Grumman
F6F Hellcat fighter to escape a fire that started when an auxiliary gas tank from his aircraft skidded
across the flight deck of the USS *Ticonderoga* and was slashed by the propellor.

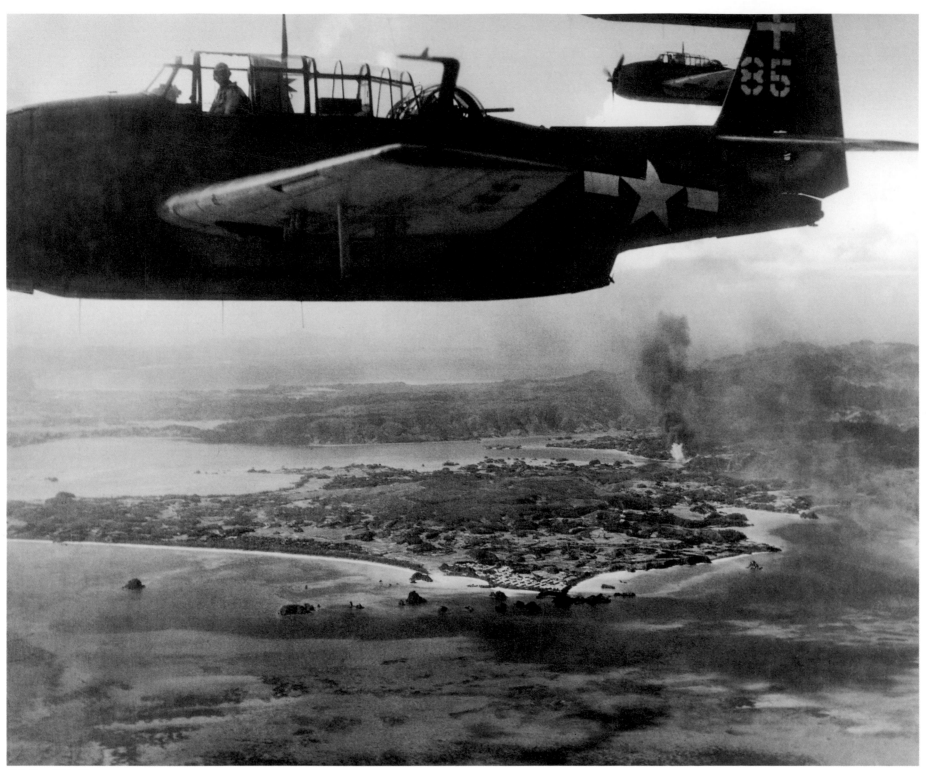

OKINAWA, JAPAN, MID-OCTOBER 1944

The decisive U.S. strategic achievement in the Pacific naval war was the creation of a fleet of fast carriers and support ships that could stage attacks on Japanese targets far from U.S. land bases. The invasion of Okinawa was not to take place until April 1945, but in October 1944, U.S. carrier-based aircraft began to bomb military targets on the island in preparation for invading the Philippines, farther south. Here, Grumman TBM-1C Avenger torpedo bombers carry out a mission on Okinawa. Smoke from fires started by the bombing is visible at center right.

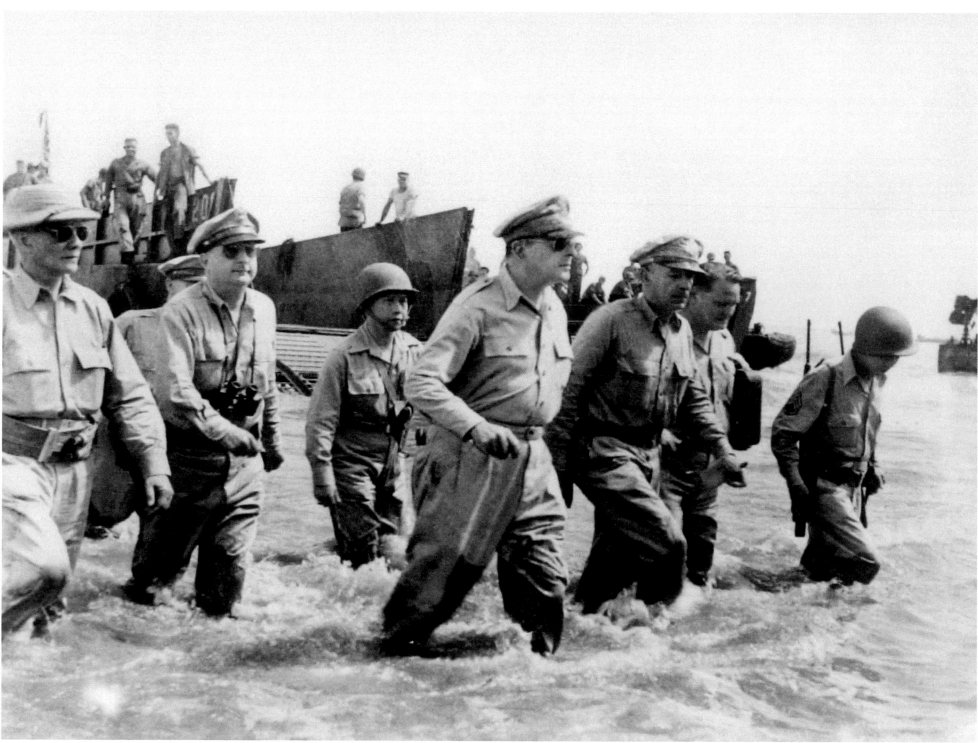

LEYTE, PHILIPPINES, OCTOBER 20, 1944

Gen. Douglas MacArthur's triumphant return to the Philippine Islands was a victory of sorts over senior U.S. naval chiefs who wanted to bypass the large island chain in favor of more strategic targets. And it took place on a truly epic stage, amid forces shaping the Battle of Leyte Gulf, the largest naval battle in history, which began three days later. Here, MacArthur wades ashore on Leyte Island after U.S. forces recaptured the beach from the Japanese, savoring a moment that Americans back home could relish, too. To his left is Lt. Gen. Richard K. Sutherland, his chief of staff.

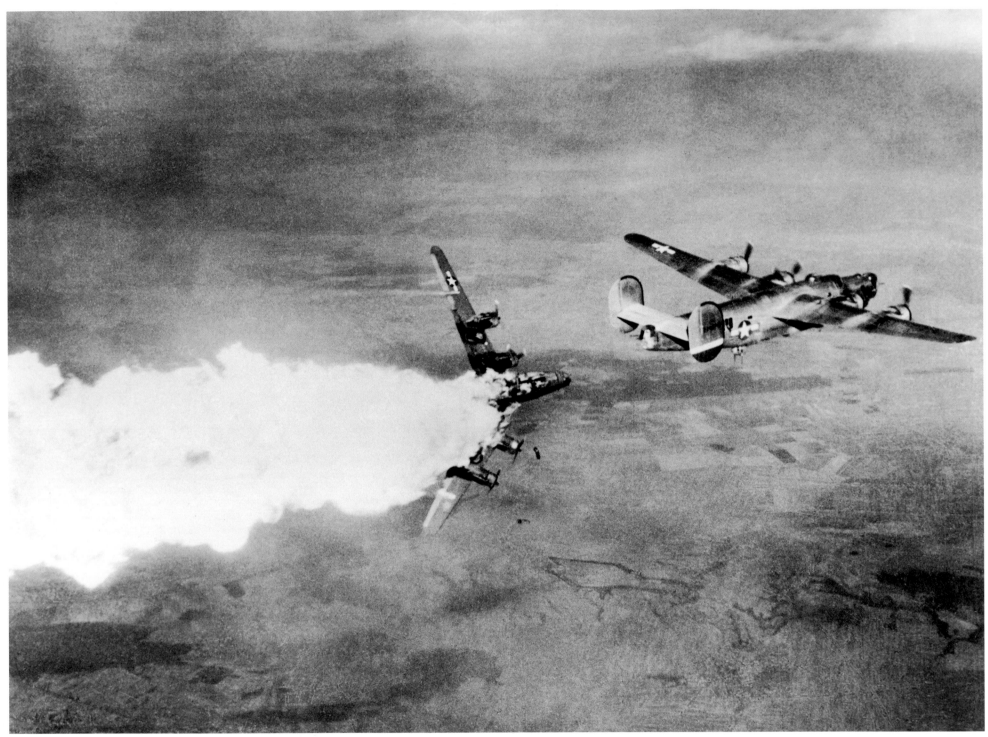

BLECHHAMMER, GERMANY, NOVEMBER 20, 1944

Blechhammer, the location of a major IG Farben chemical complex, was one of the most heavily defended German targets in Europe.
On this mission, involving more than 100 heavy bombers of the Fifteenth Air Force based in Italy, the Consolidated B-24
Liberator piloted by Lt. Col. Clarence "Jack" Lokker, with a crew of ten, exploded after being hit by heavy flak.
Some of the crew survived, including the copilot, who said Lokker parachuted to safety but was lost on the ground.

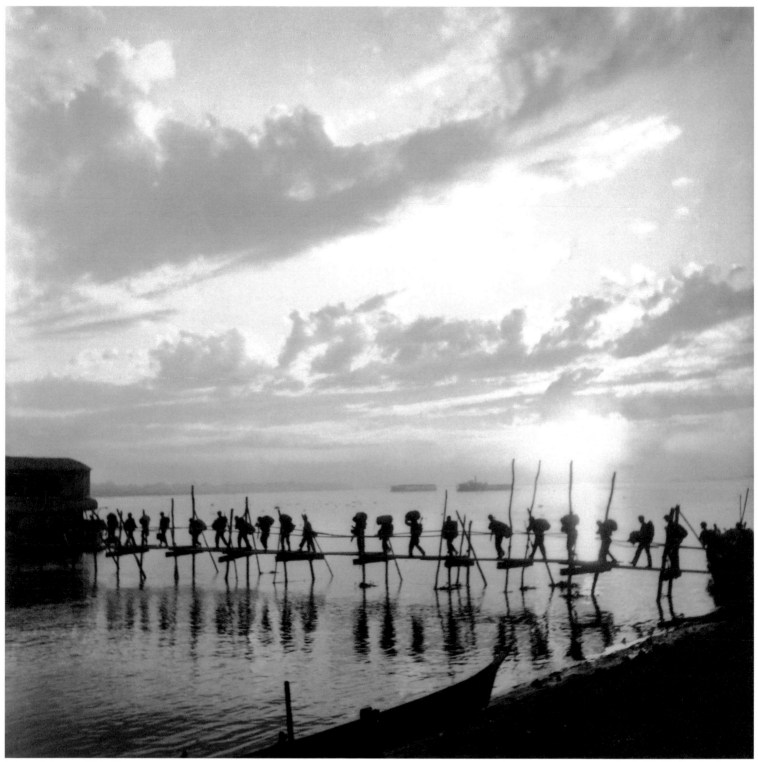

PANDU GHAT, BURMA, OCTOBER 25, 1944

The 124th Cavalry Regiment of the Texas National Guard, the last horse-mounted unit in the
United States, turned in its horses on June 10, 1944, and was posted to Burma. Here, silhouetted
against the sun, men of the regiment serve as their own beasts of burden at Pandu Ghat,
under way from the Ramgarh Training Center to Myitkyina in northern Burma.

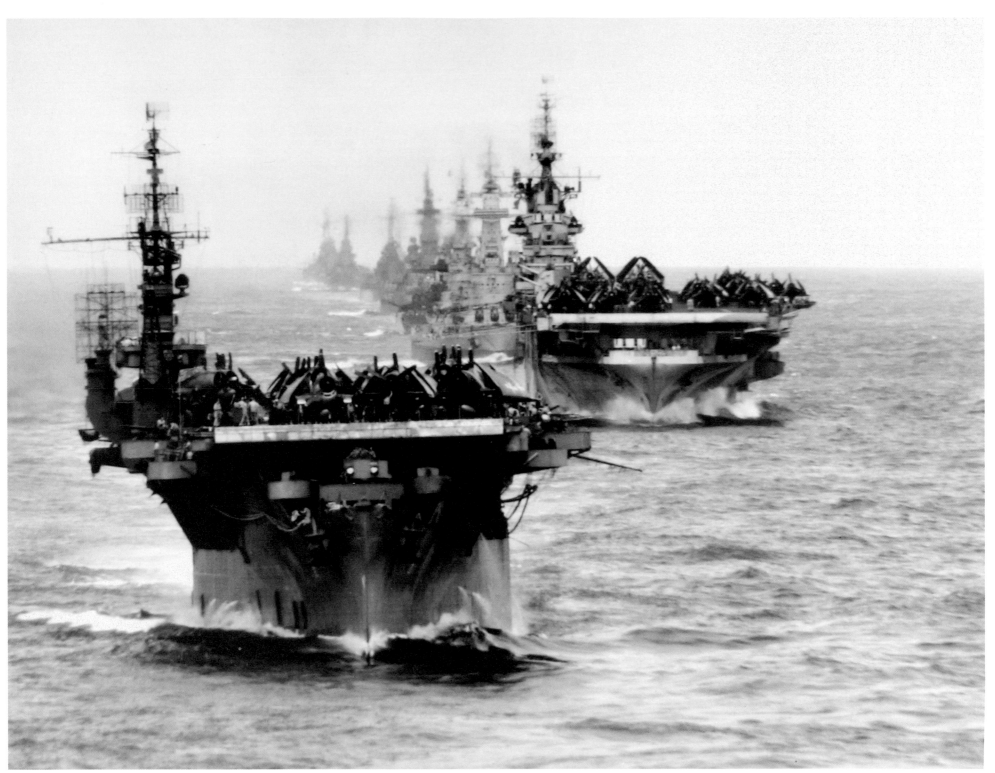

ULITHI ATOLL, CAROLINE ISLANDS, DECEMBER 12, 1944

The secret U.S. Pacific anchorage at Ulithi Atoll was for a time the largest naval facility in the world. Built from scratch in September 1944 and more or less abandoned seven months later, it served a temporary population of servicemen equal to the size of Dallas, Texas. Here, eight ships of the Third Fleet return to the anchorage after action in the Philippines. In the foreground is the USS *Langley*, an Independence-class carrier, followed by the USS *Ticonderoga*, an Essex-class carrier, three modern battleships (USS *Washington*, *North Carolina*, and *South Dakota*), and three cruisers (USS *Biloxi*, *Mobile*, and *Oakland*).

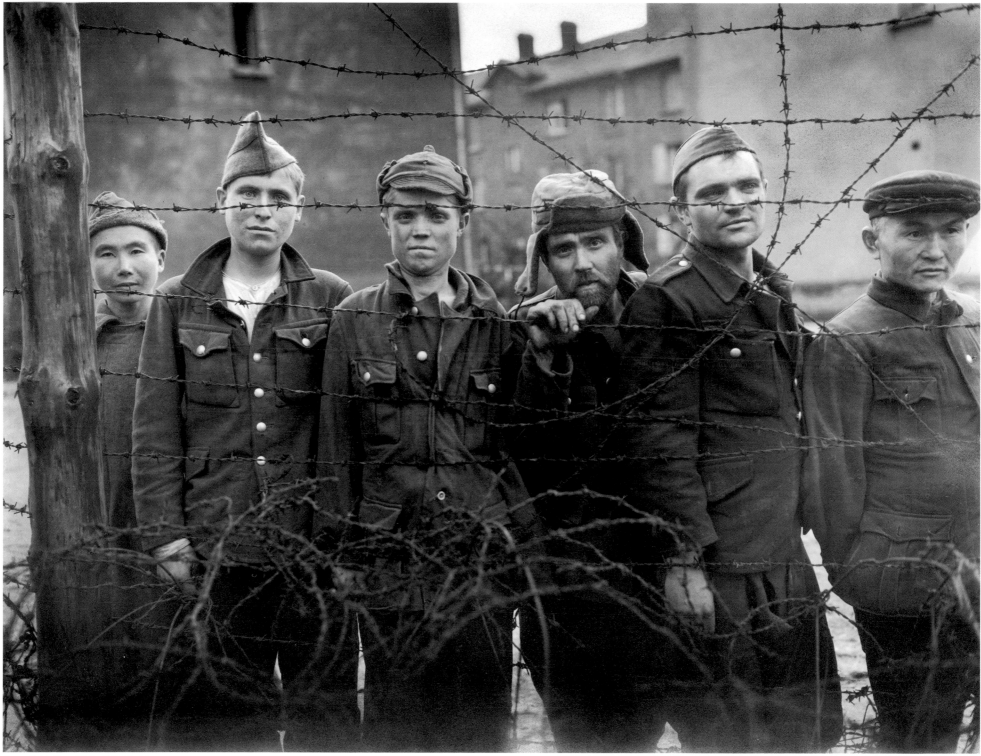

SARREGUEMINES, FRANCE, DECEMBER 1944

Six of the more than 1,000 soldiers found in a German POW camp liberated by American troops near Sarreguemines gather at the fence of their prison. The camp held Russians, Italians, Serbians, Poles, and Frenchmen.

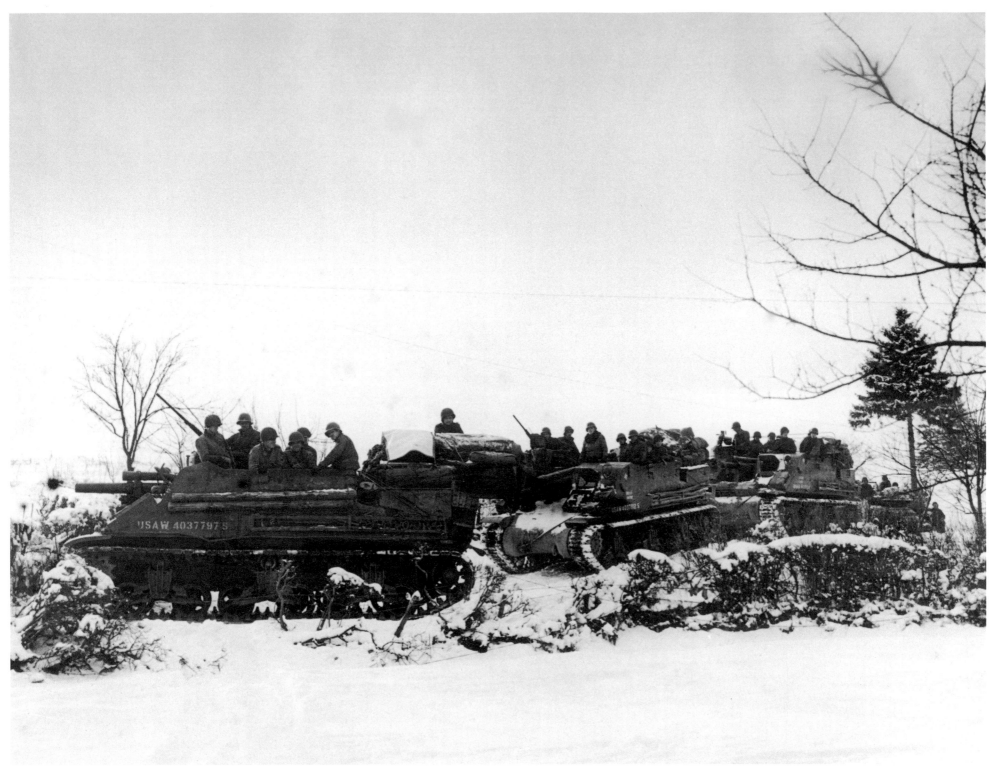

SAMREE, BELGIUM, LATE DECEMBER 1944

More than one million men fought in the Battle of the Bulge, including some 600,000 Germans, 500,000 Americans, and 55,000 Englishmen. The fight began on December 16 with a massive westward German surge through the Forest of Ardennes that caught the Allies off guard as they gathered strength for a push into Germany; it took until late January for the Allies to regain their original position. Here, American tanks and armored gun carriers drive over snow-covered terrain toward Samree, as the Allied forces regain the initiative.

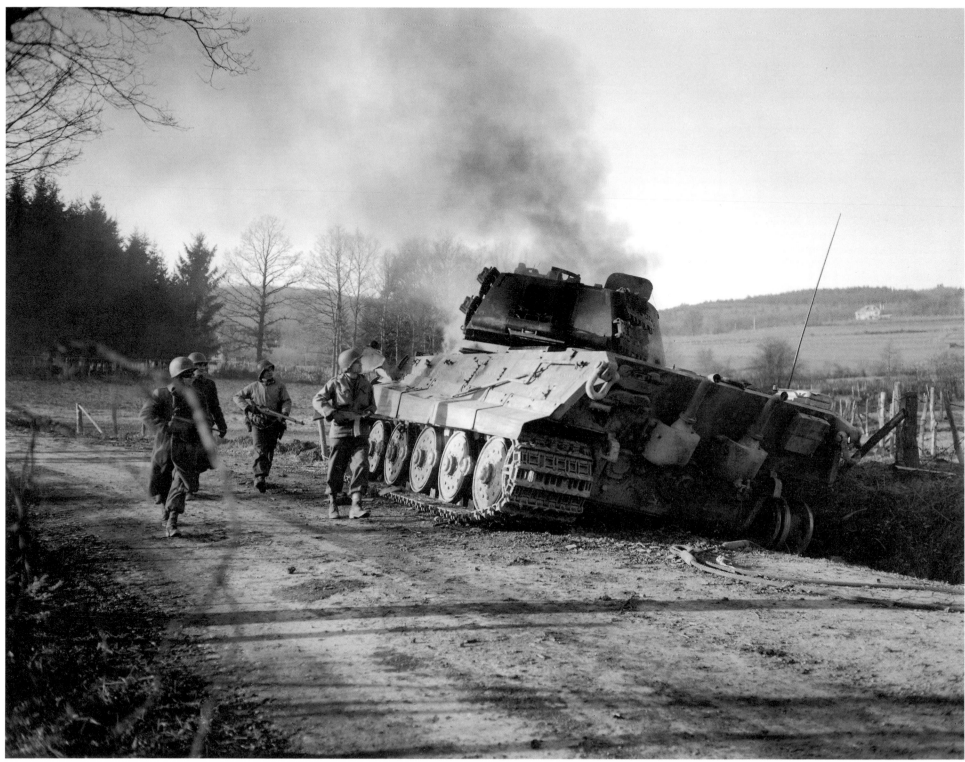

LA GLEIZE, BELGIUM, LATE DECEMBER 1944-EARLY JANUARY, 1945

The Germans lacked the supplies to capitalize on their initial advantage in
the Ardennes. Here, American soldiers patrolling outside La Gleize pass an abandoned and
burning German Tiger tank, which may have simply run out of gas before being wrecked.

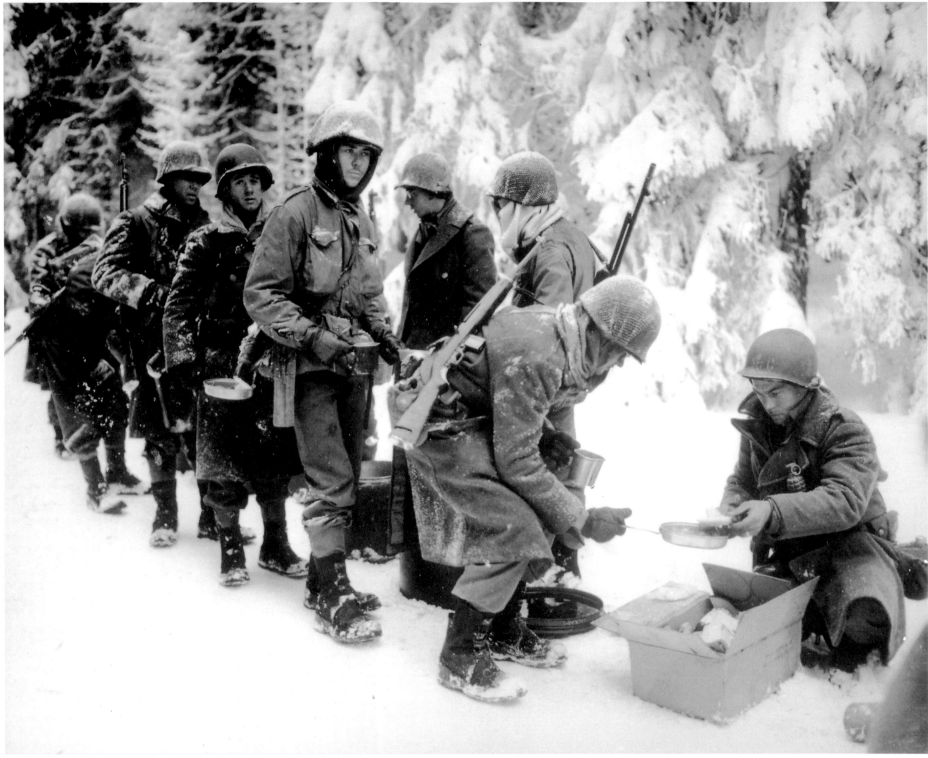

LA ROCHE, BELGIUM, JANUARY 13, 1945
The Battle of the Bulge was fought in snow and extreme cold. Here, American soldiers
of the 347th Infantry in heavy winter gear halt their advance to La Roche for a short meal.

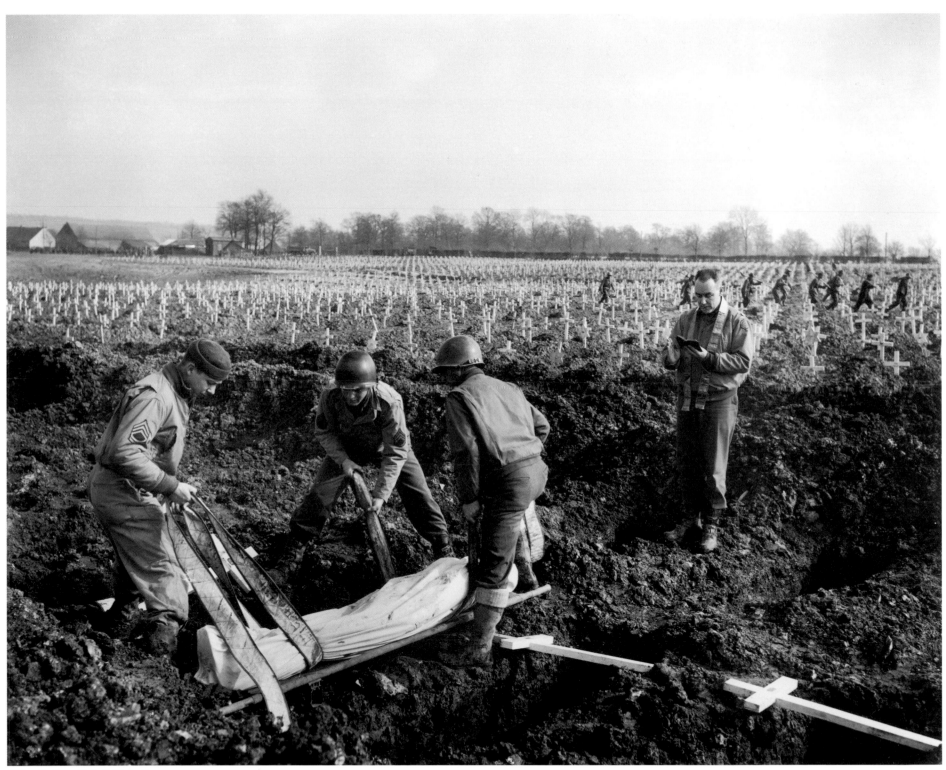

William C. Allen, AP Staff/AP Archives

HENRI-CHAPELLE, BELGIUM, MARCH 14, 1945

An American soldier, identified in the photograph's original caption as Patsy Caliendo, is laid to rest in the largest
Allied military cemetery on the Western Front. Crosses in the background mark the graves of several thousand
American dead. The Battle of the Bulge took a terrible toll on both sides: 100,000 Germans killed, wounded, or captured;
81,000 American casualties, including 19,000 killed and 23,500 captured; and 1,400 British casualties, with 200 killed.

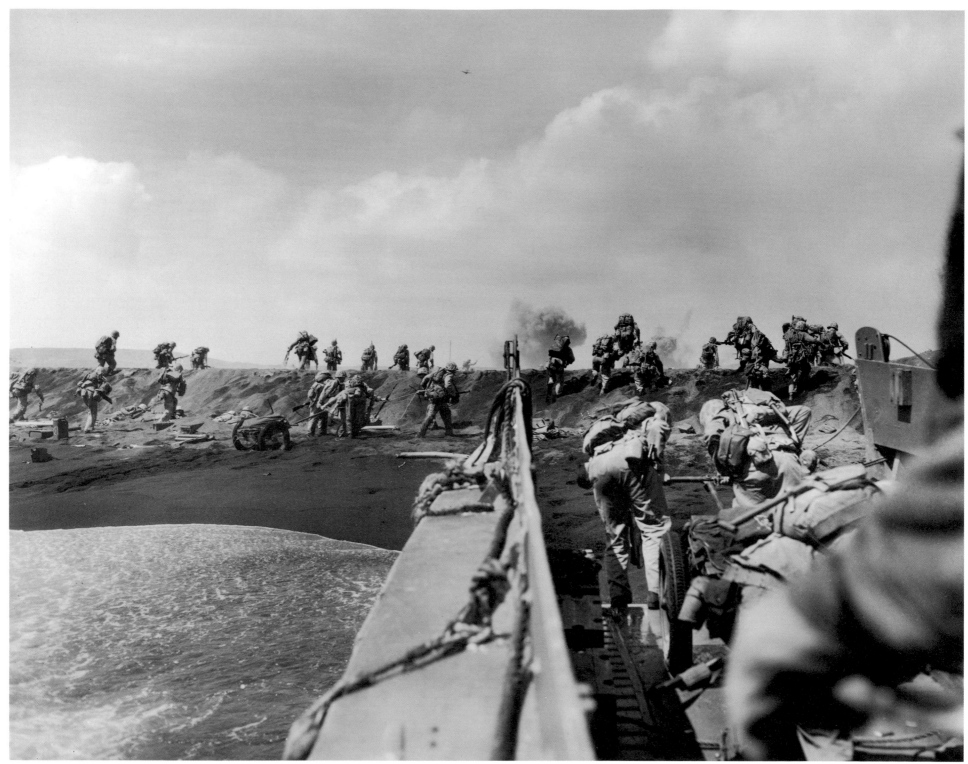

IWO JIMA, VOLCANO ISLANDS, FEBRUARY 19, 1945
After the American forces secured the Philippines, plans called for the occupation of Iwo Jima
and then Okinawa in the Ryukyu Islands, the former as an airbase for Boeing B-29 Superfortresses
and their fighter escorts. The Iwo Jima landing took place on February 19 after one of
the longest and most intense air and sea bombardments of the Pacific war.

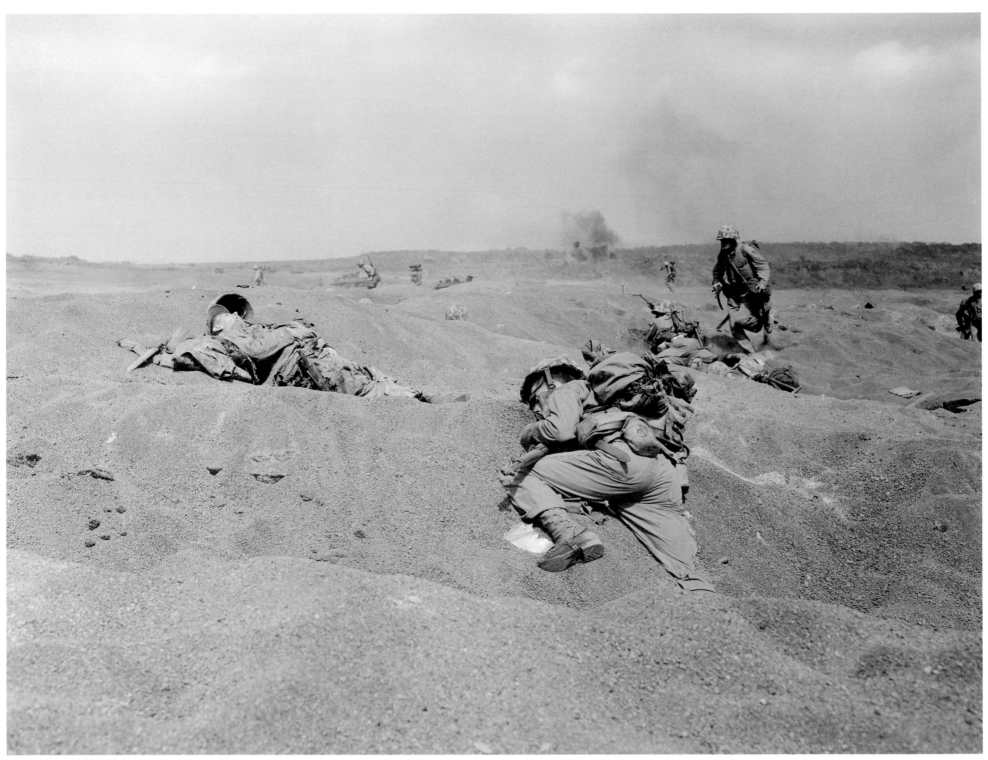

IWO JIMA, VOLCANO ISLANDS, FEBRUARY 19, 1945

Two U.S. Marines, slumped in death, are among the first losses at Iwo Jima. The bombardment of Iwo Jima, one-third
the size of Manhattan, had surprisingly little effect on the island's 25,000 Japanese defenders, who were well protected in caves
and deep tunnels. The 30,000 U.S. Marines who landed on the first day could not dig foxholes in the loose volcanic ash,
and hidden Japanese gunners shot many of them; the Americans sustained 2,500 casualties before nightfall.

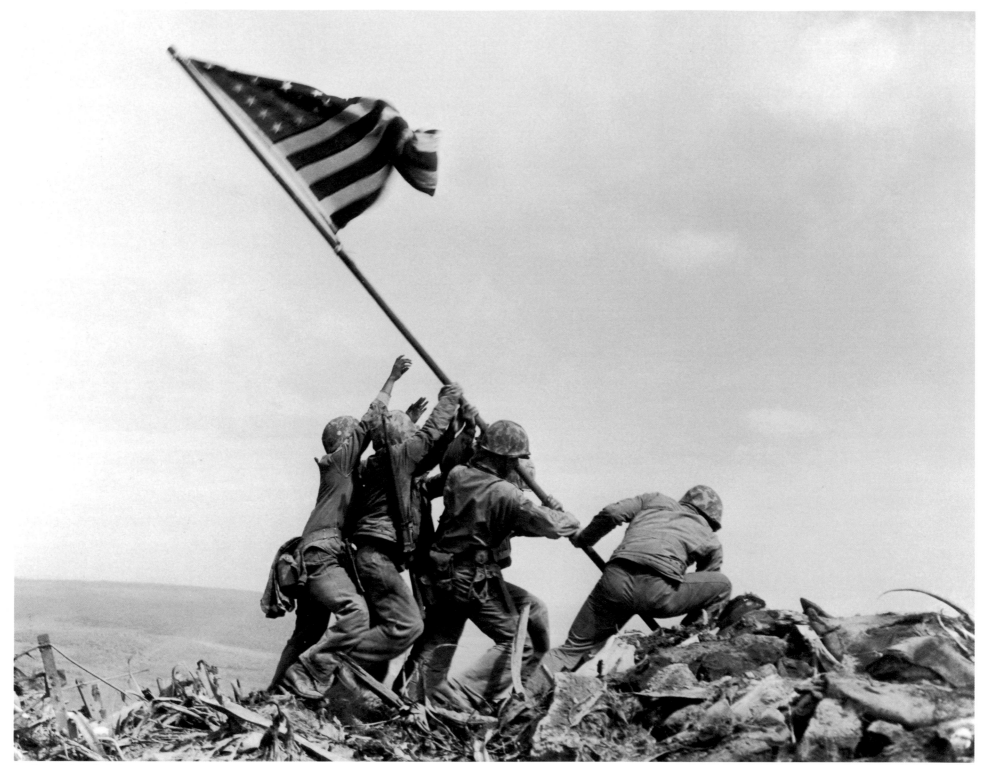

IWO JIMA, VOLCANO ISLANDS, FEBRUARY 23, 1945

The dominant landmark on Iwo Jima is a 550-foot volcanic cone at the island's southern tip called Mount Suribachi, from which the Japanese could fire at will on the Marines. On February 23, a party from Company E, Second Battalion, Twenty-eighth Marines, led by Sgt. Mike Strank, cleared the heights. AP photographer Joe Rosenthal photographed six of them raising an American flag at the summit. The picture caused a sensation in America, made heroes of the men, and won a Pulitzer Prize in 1946. Three of the flag-raisers never saw the photograph; they died in the fight for the island, the bloodiest in Marine Corps history.

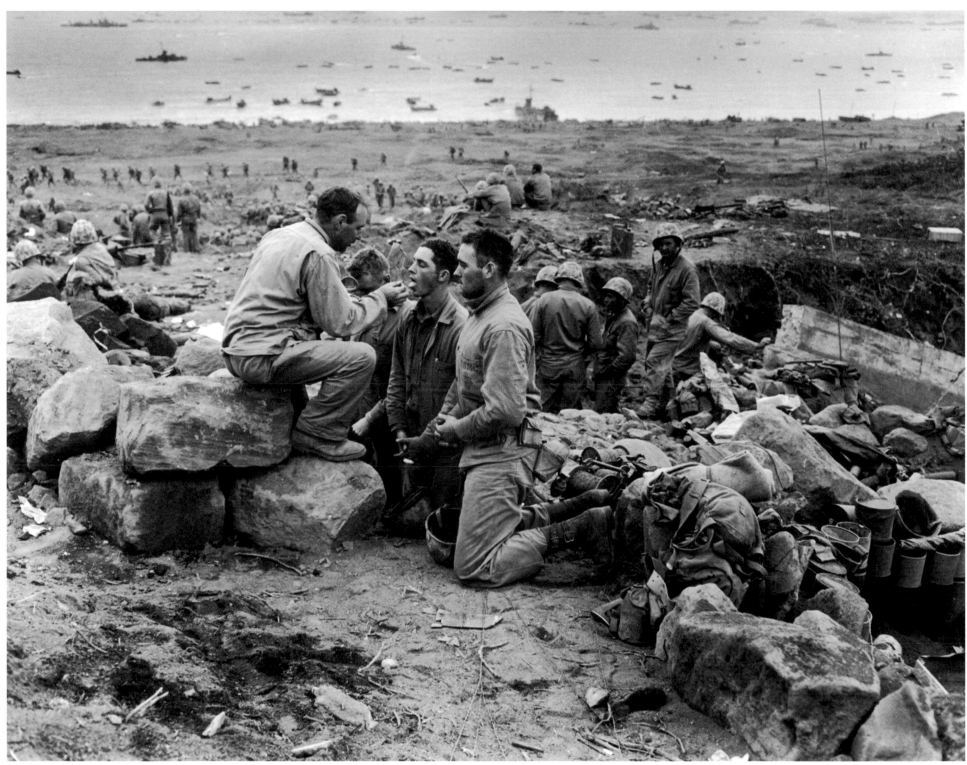

Joe Rosenthal, AP Staff/AP Archives

IWO JIMA, VOLCANO ISLANDS, MARCH 3, 1945
U.S. Marines receive Communion from a Marine chaplain on Iwo Jima. The battle for the island
was extremely costly for both sides: only about a thousand of the 25,000 Japanese defenders survived;
the Americans suffered about 26,000 casualties. The island was not fully secured by the
American forces until March 26, but the needed airfields were up and running earlier.

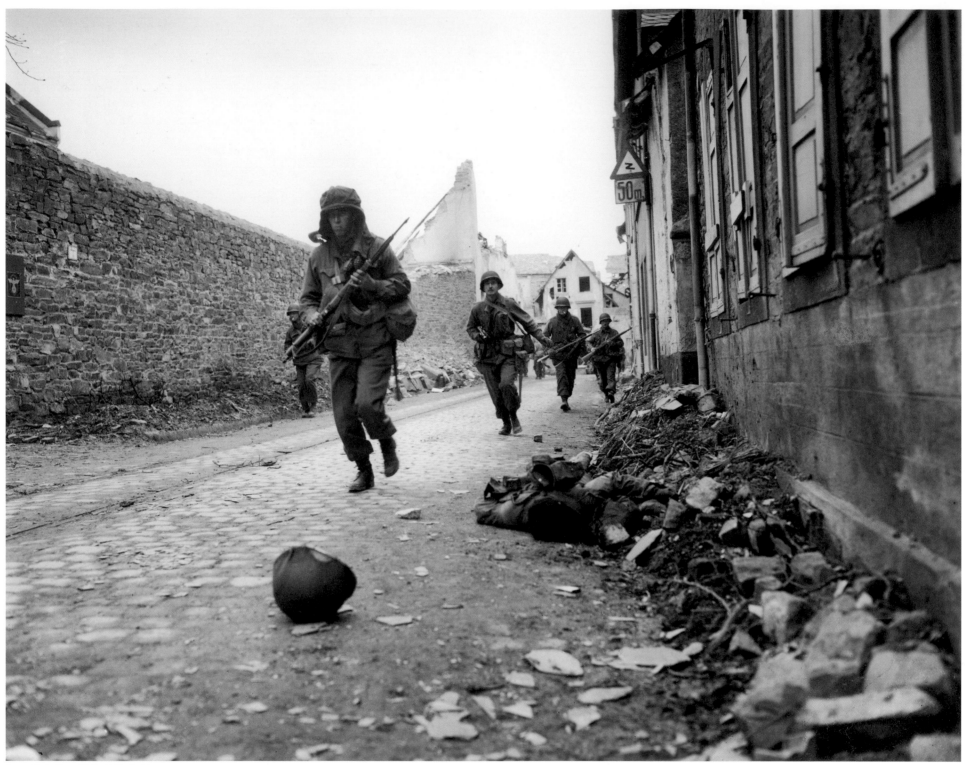

KOBLENZ, GERMANY, MARCH 18, 1945

After Ardennes, General Patton's Third Army pushed vigorously into Germany.
Mid-March found him seeking a Rhine crossing—a major strategic and symbolic goal—
and pinning down German forces to the west of the river, taking many prisoners in the process.
Here, soldiers of the Third Army storm into Koblenz; a dead comrade lies against the wall.

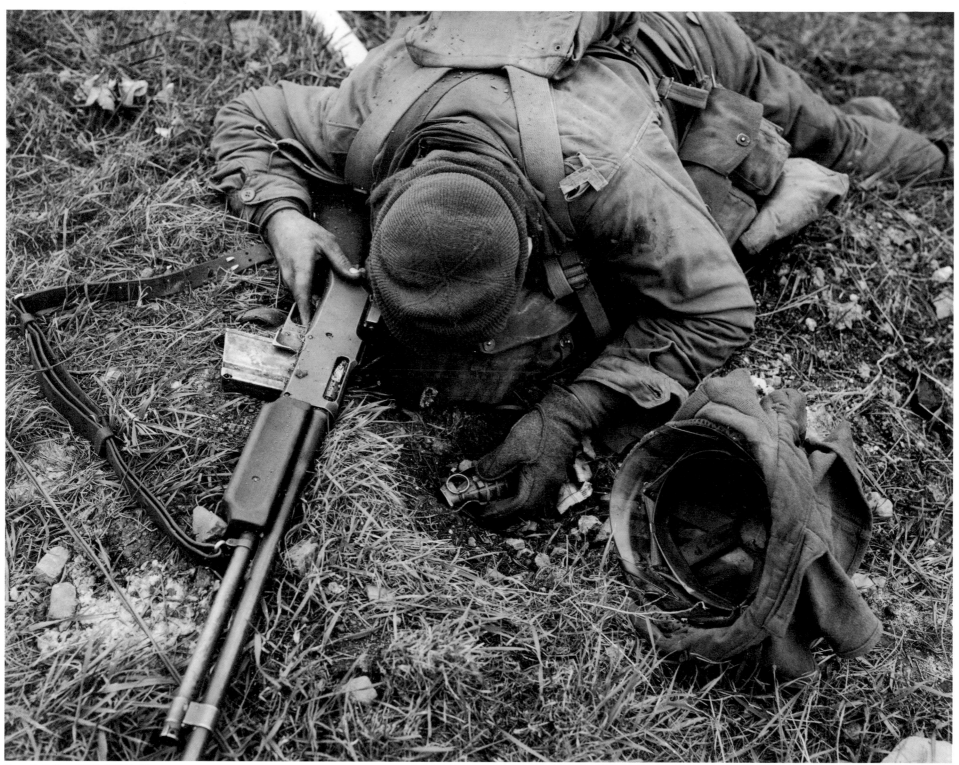

Byron H. Rollins, AP Staff/AP Archives

KOBLENZ, MARCH 1945

An American soldier, shot dead by a German sniper, clutches his rifle and hand grenade.

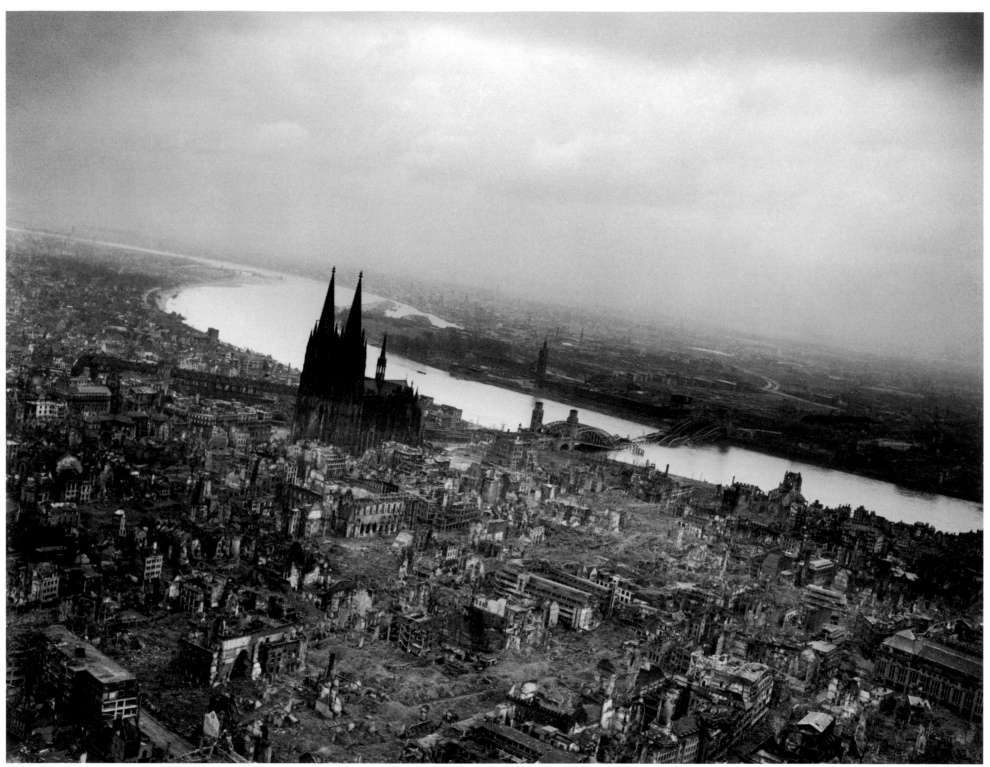

COLOGNE, GERMANY, MARCH 1945

This aerial view shows the destruction of the German city of Cologne caused by almost three years of Allied air warfare.
Air raids on German cities cost approximately 300,000 civilian lives and more than twice as many serious casualties, and not
always to great strategic advantage for the Allies. In this photograph, the Cologne Cathedral, which suffered blast and shell damage,
stands erect on the west bank of the Rhine. At right, the Hohenzollern Bridge is half submerged in the waters of the Rhine.

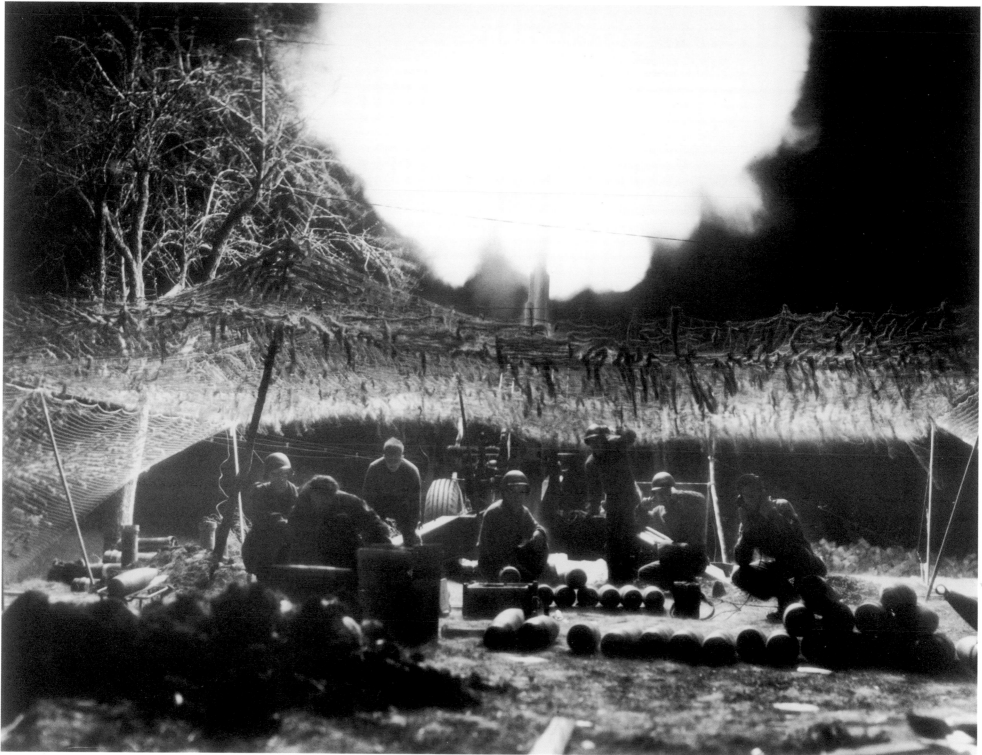

RECHTENBACH, GERMANY, MARCH 27, 1945
An American gun crew of the Seventh Army pounds the retreating German army with
heavy field artillery in the newly captured town of Rechtenbach.

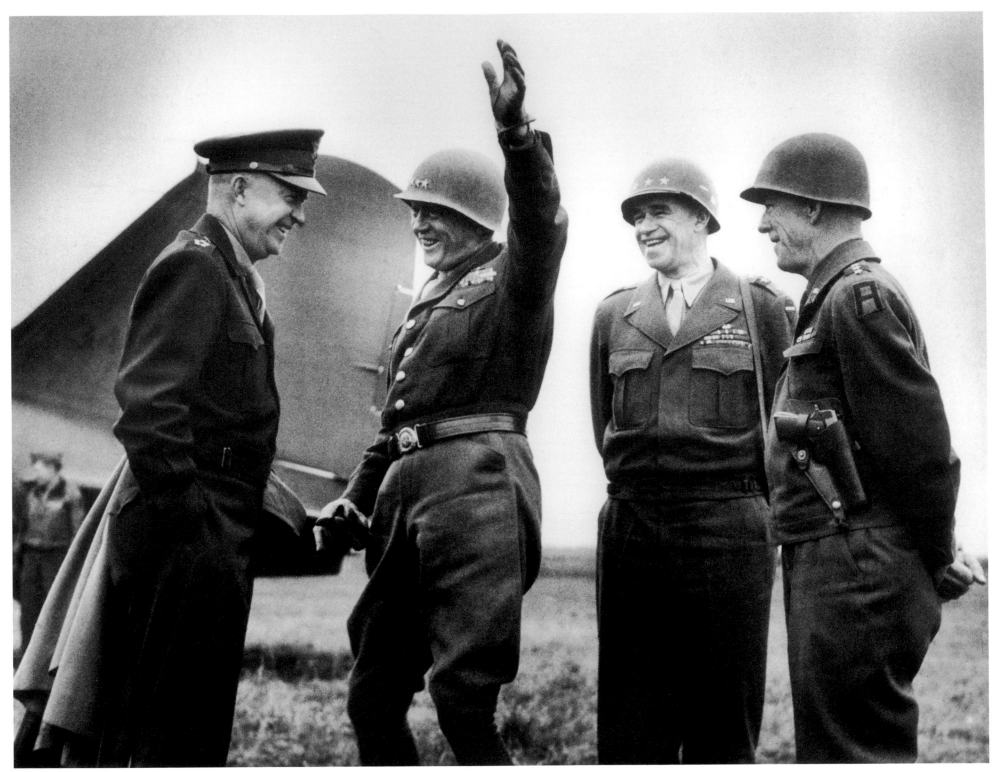

UNIDENTIFIED LOCATION, EUROPE, MARCH 28, 1945

Supreme Commander Eisenhower meets his field commanders somewhere on the Western Front: left to right, Lt. Gen. George S. Patton, Commander of the Third Army; Gen. Omar Bradley, Commanding General of the Twelfth Army Group; and Lt. Gen. Courtney Hodges, Commander of the First Army. Patton's army had crossed the Rhine six days earlier, on March 22. That delighted Bradley's officers, who resented seeing so many Allied resources committed to the more deliberate Montgomery, whose forces crossed on the night of March 23. Patton marked his achievement by urinating in the river on March 24, and wrote to Ike about it.

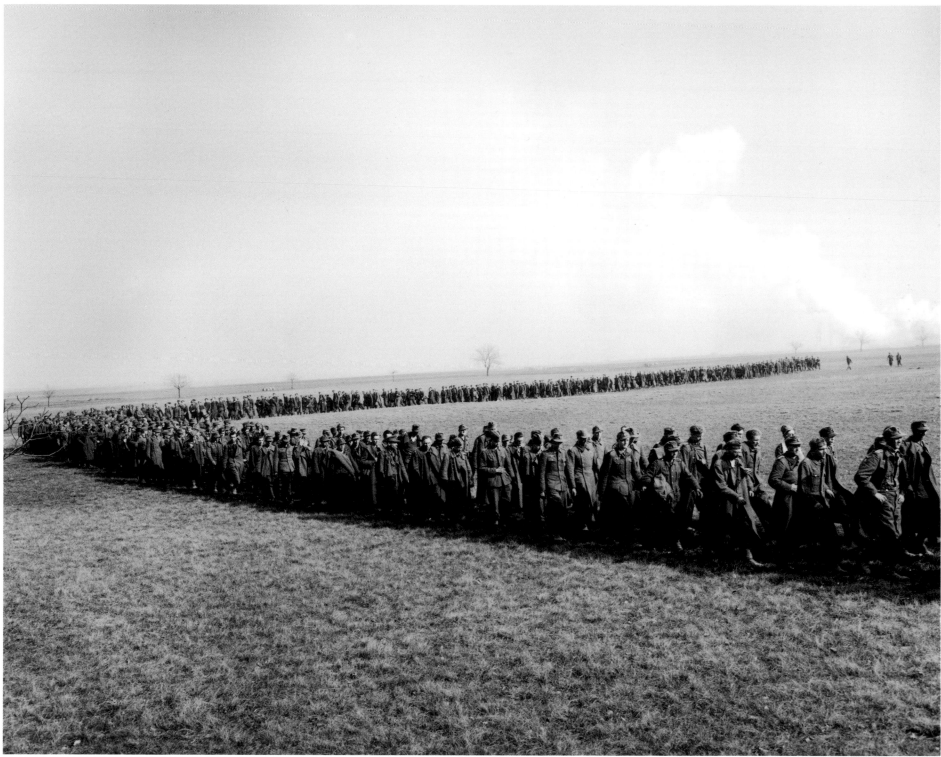

GERMANY, MARCH 26, 1945

German POWs who surrendered to Patton's Third Army march in defeat through farmland east of the Rhine.

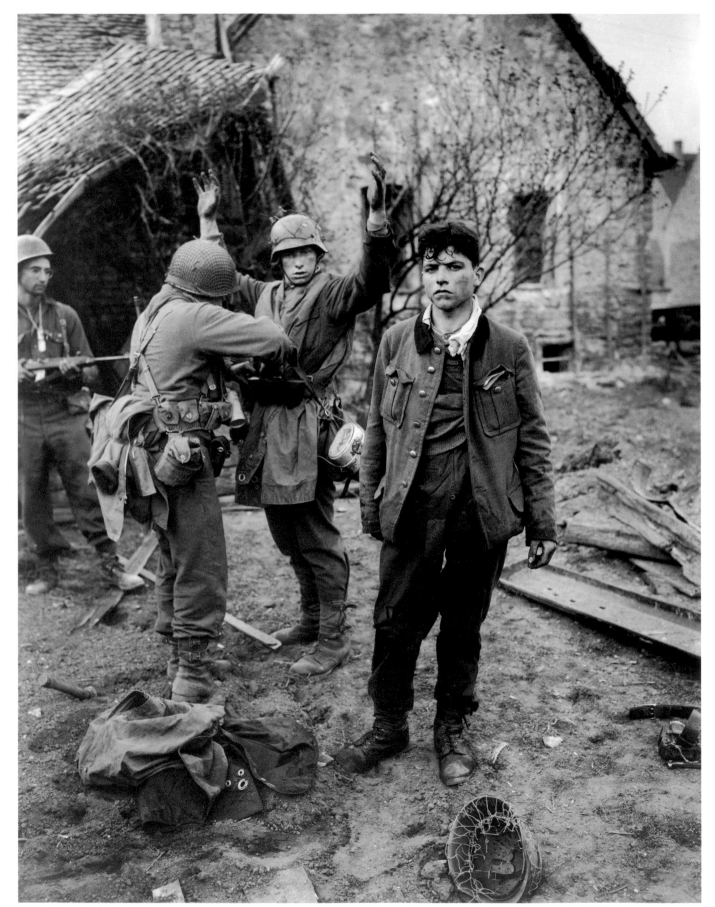

GERMANY, MARCH 26, 1945
Soldiers of the Third Army take
two German snipers prisoner. The
one in the foreground was wounded
in an exchange of rifle fire.

GERMANY, MARCH 1945
A 5-year-old boy puffs on a cigar
dropped by a soldier of the Third Army,
while en route to Frankfurt. The city
was captured on March 29.

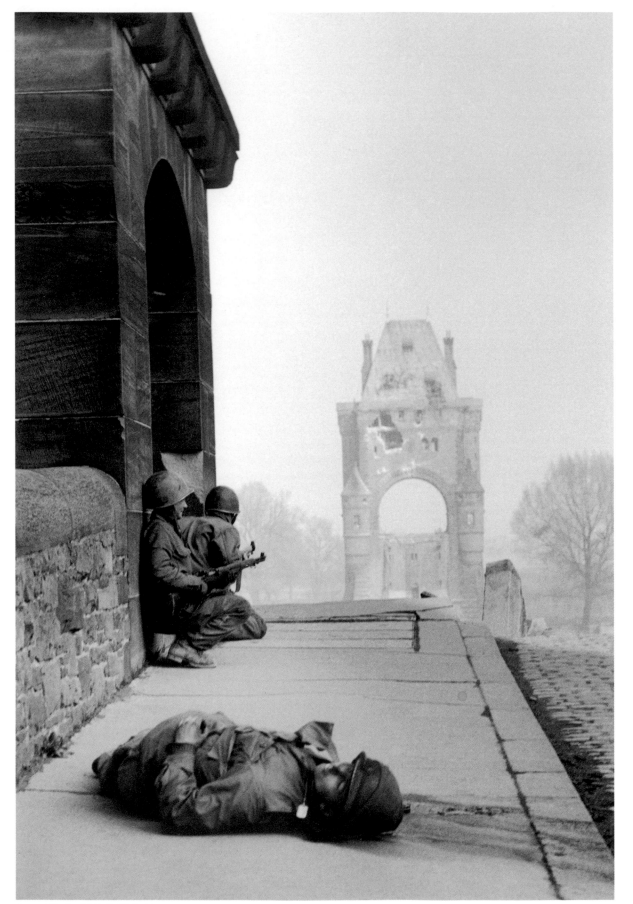

WORMS, GERMANY,
MARCH 1945

The Seventh Army crossed the Rhine at
Worms on March 28. Here, two U.S. soldiers
of the Seventh Army cover a bridge in the
distance. A comrade lies in the foreground,
hit by German snipers on the east bank.

William C. Allen, AP Staff/AP Archives

BONN, GERMANY, APRIL 1945

When the Allied armies captured a German city, hierarchies were overturned and the vanquished
became victors. The First Army captured Bonn on March 9. Here, a former Russian slave laborer, left,
who had been released by the Allies after three years of forced work in a German factory,
unleashes his anger against a German civilian policeman on a Bonn street.

Pat W. Kohl, U.S. Army/AP Archives

RENTWERTSHAUSEN, GERMANY, APRIL 10, 1945
Soldiers of the Seventh Army pose on the barrel of a mammoth German
274-mm railroad gun captured in an advance near Rentwertshausen.

JIBERT, ROMANIA, APRIL 13, 1945

A woman carries the few possessions she could salvage from her burning house, set afire by a Nazi saboteur, in Jibert, a Saxon village in the Transylvania region of Romania. Transylvania had been captured by the advancing Russian army, and in the previous January, many Saxons— of German origin—had been deported to Soviet labor camps.

Troy A Peters, Roberts Commission/AP Archives

WALDENBURG, GERMANY,
APRIL 16, 1945
Following heavy artillery raids,
American infantrymen move down
a street, looking out for snipers,
as the Seventh Army penetrates
deeper into Germany. The city,
now called Wałbrych, was soon
to be assigned to Poland by the
1945 Potsdam Conference.

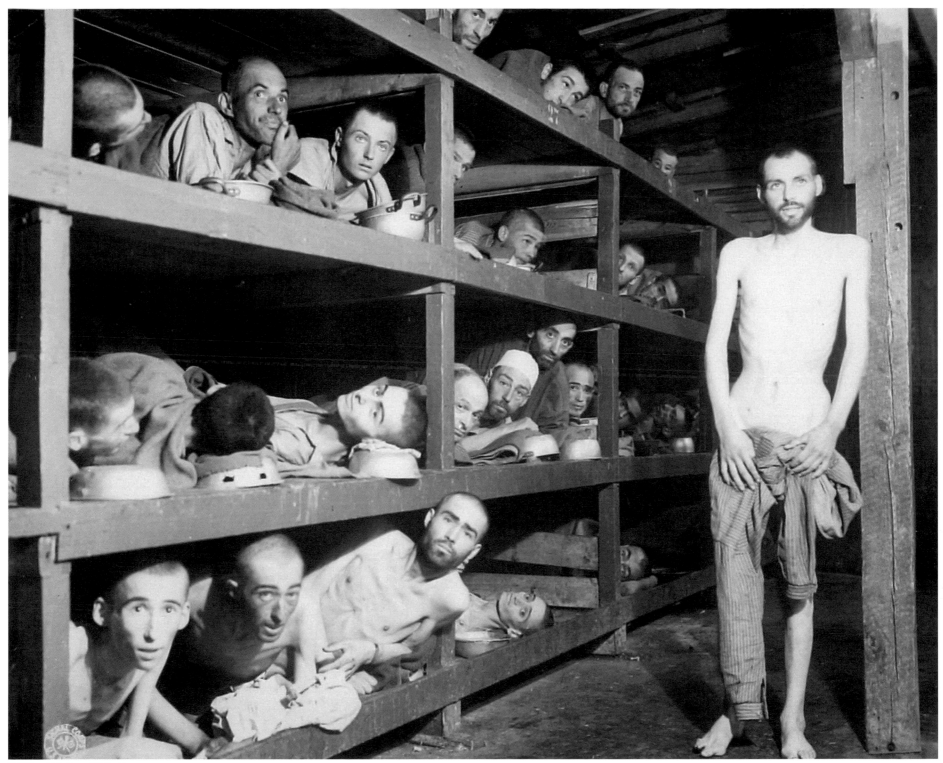

BUCHENWALD, GERMANY, APRIL 16, 1945

Allied forces discovered concentration and extermination camps as they pushed into Germany. On April 12, Eisenhower wrote, "We are constantly finding German camps . . . where unspeakable conditions exist. . . . I can state unequivocally that all written statements up to now do not paint the full horrors." This photograph shows gaunt inmates of the Buchenwald concentration camp four days after their liberation by the Third Army. The young man seventh from left in the middle row bunk is Elie Wiesel, who would later be awarded the 1986 Nobel Peace Prize.

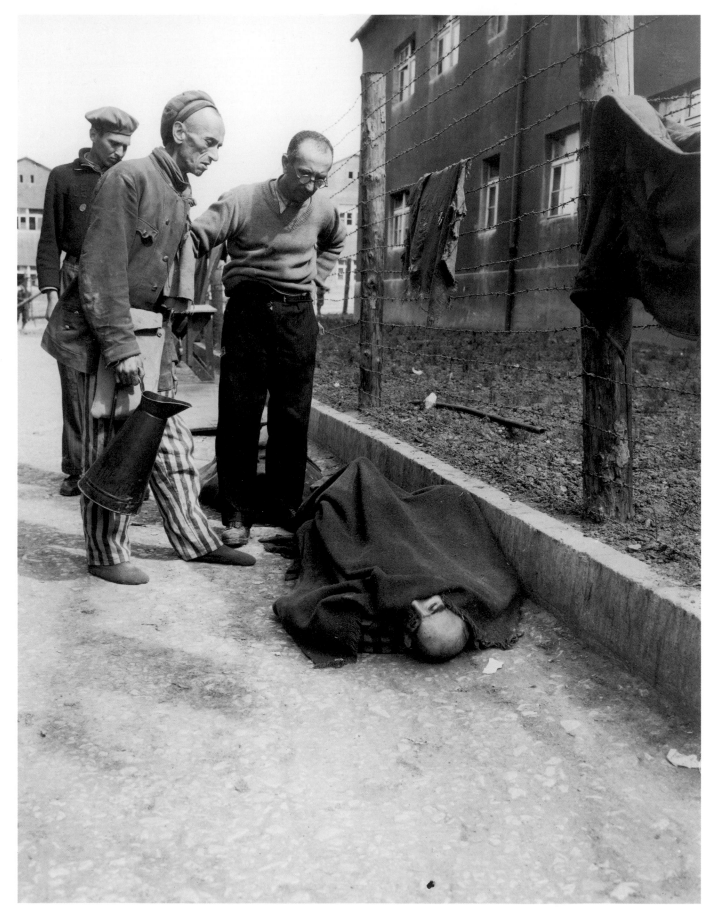

BUCHENWALD, GERMANY,
APRIL 19, 1945
A prisoner who died from Nazi
maltreatment is covered and
awaits burial as three other
prisoners look on. German SS
guards had killed hundreds
of prisoners in Buchenwald
just before it was liberated;
executions were still taking
place as the Americans
entered the gates.

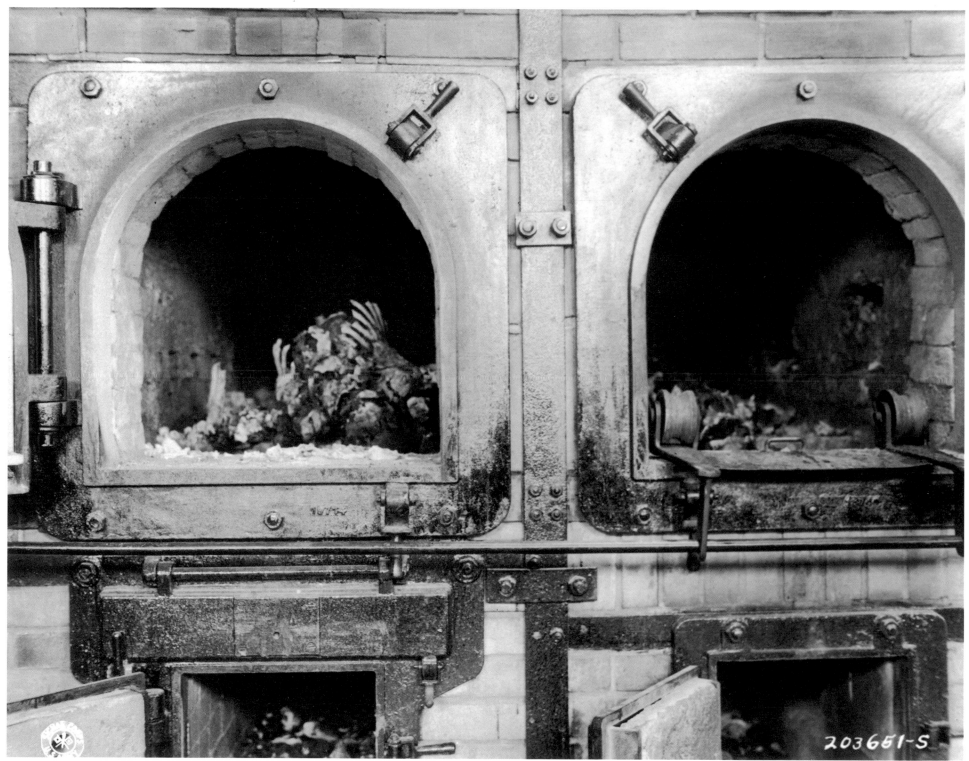

BUCHENWALD, GERMANY, APRIL 1945

U.S. troops found charred bodies in the horrific furnace chamber at Buchenwald. Established in 1937, Buchenwald, with its offshoot facilities,
became one of the largest concentration camps in Germany, with a population of more than 80,000 prisoners in late March 1945.
The Nazis killed about 6 million Jews and 4 million non-Jews in the Holocaust. Victims were exterminated by various means, including starvation,
forced labor, forced marches, organized shootings, scientific experiments, and gassing. Many thousands succumbed to typhoid in the camps.

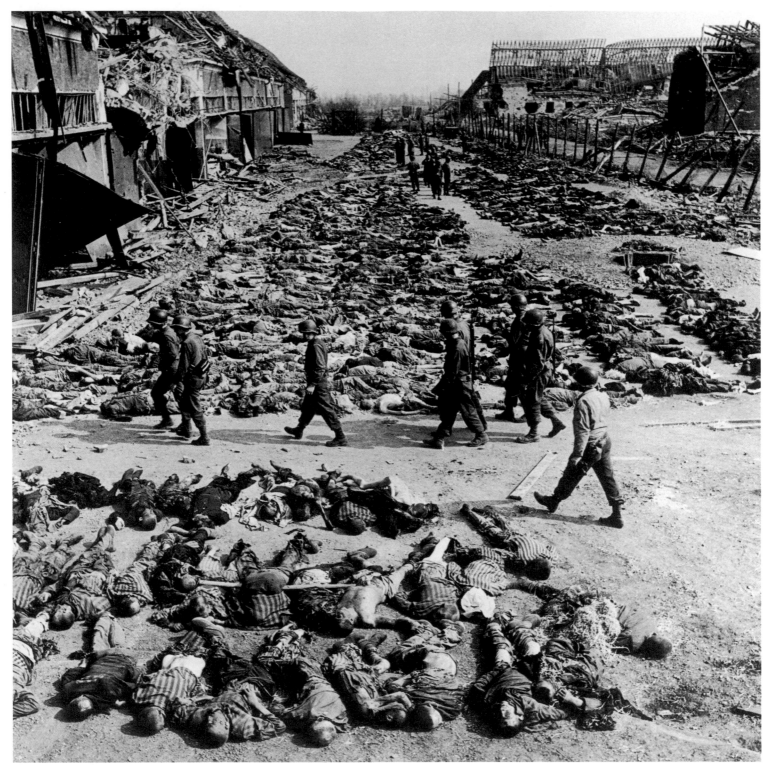

NORDHAUSEN, GERMANY, APRIL 1945

Nordhausen was a subcamp of the Dora-Mittelbau concentration camp, which had a population of about 12,000 forced laborers used to help construct facilities for the V-1 and V-2 rockets. It was essentially a holding area for sick and infirm prisoners, who were left to die of starvation and neglect (survivors had a saying: "If Dora was the hell of Buchenwald, Nordhausen was the hell of Dora"). Bombed on April 3 by the Allies, who mistook its concrete buildings for a military installation, the camp was liberated on April 12. The liberators found 3,000 corpses, which they laid out in rows, and a handful of survivors.

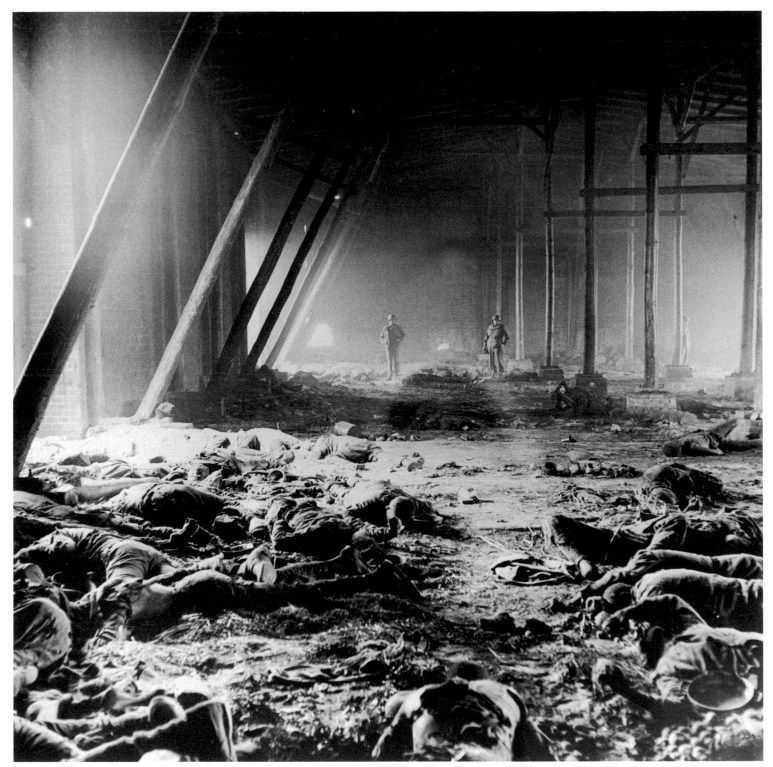

GARDELEGEN, GERMANY, APRIL 16, 1945

On April 11, a train carrying slave laborers from the Nordhausen and other concentration camps was halted near Gardelegen because the track had been destroyed. The SS guards marched their prisoners into the countryside. Two days later, SS and Luftwaffe troops filled a masonry barn with gasoline-soaked straw, drove the prisoners into it, and ignited the straw. Luftwaffe troops outside Gardelegen surrendered to the U.S. Ninth Army on April 15, and the following day the Americans—three are seen here in the distance—discovered the barn, and 1,016 corpses. Photographs of the atrocity appeared in *Life* magazine in May, 1945.

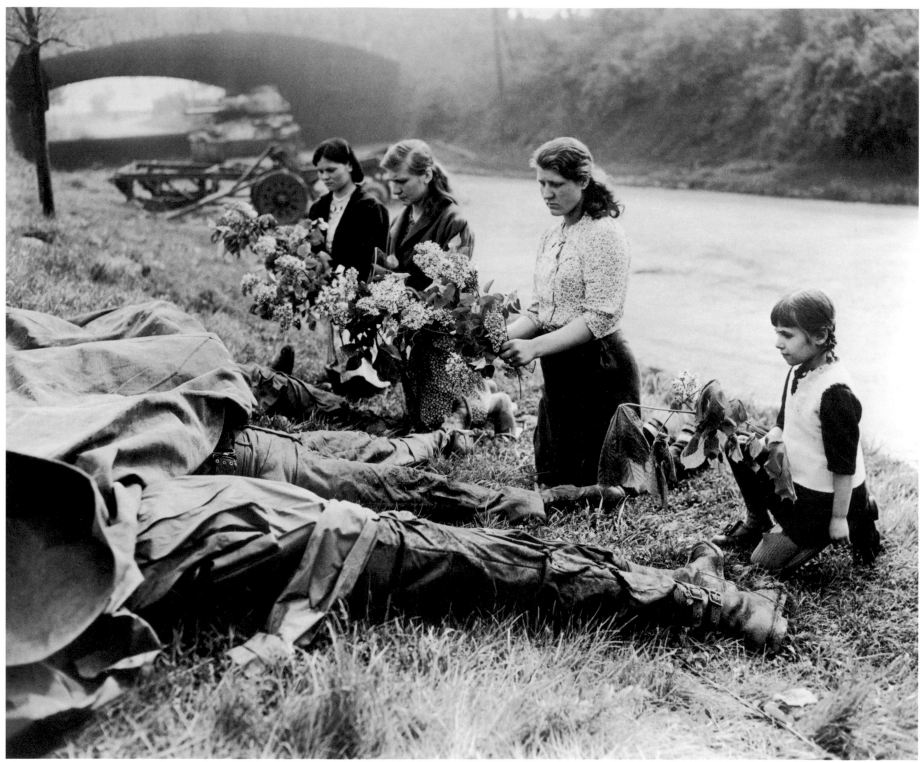

HILDEN, GERMANY, APRIL 18, 1945

Four young Russian women recently liberated from a slave-labor camp by the Thirteenth
Armored Division of the First Army lay flowers at the feet of four slain American soldiers. A Russian
witness said a German officer killed three of the Americans after they surrendered.

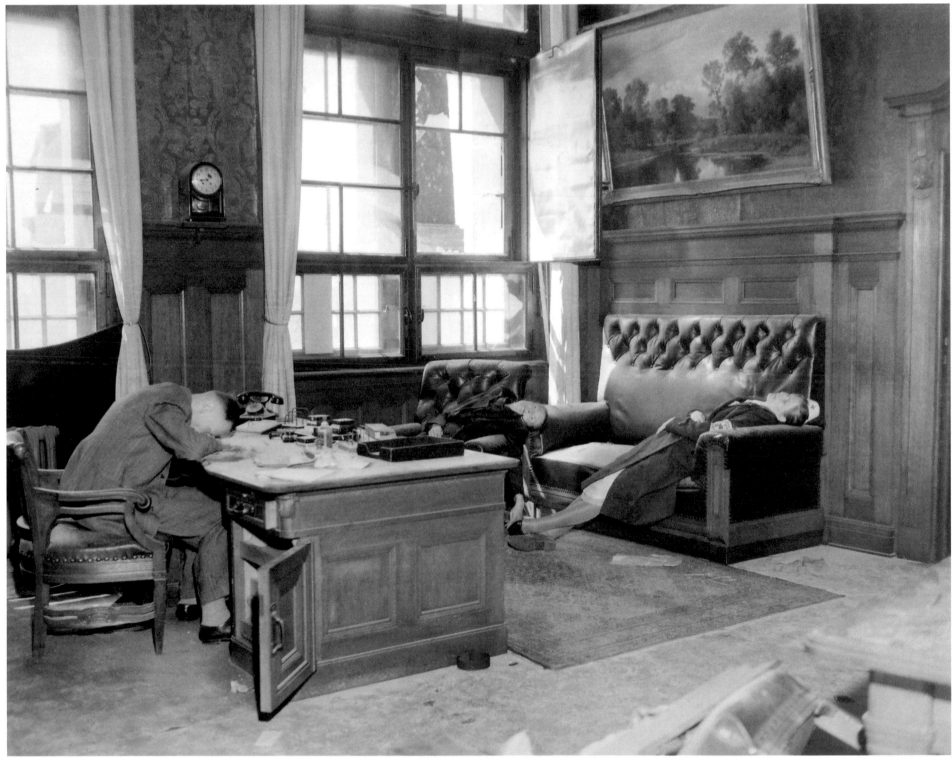

LEIPZIG, GERMANY, APRIL 20, 1945

The Third Army captured Leipzig, some seventy miles from Nordhausen, after a brief struggle
on April 19. There they found the mayor with his wife and daughter dead in his office: a triple suicide.

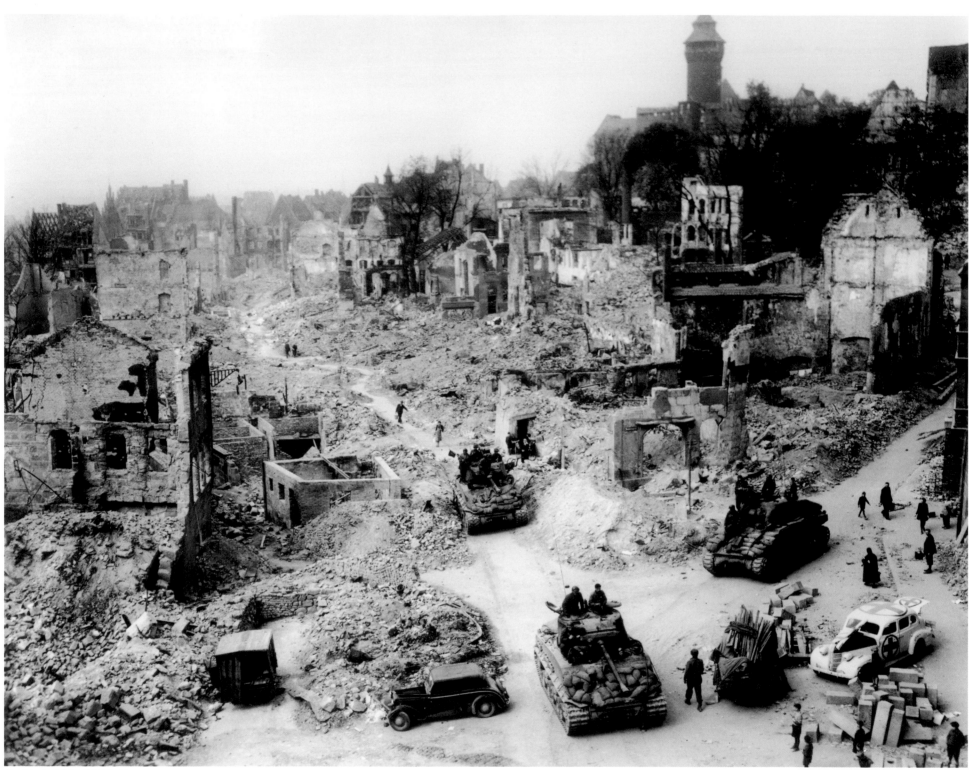

Jim Pringle, AP Staff/AP Archives

NUREMBERG, GERMANY, APRIL 23, 1945

Tanks of the Seventh Army rumble through the ruins of Nuremberg, captured April 20. About 90 percent of the city
was destroyed by bombing, but the Palace of Justice still stood, and it was there that U.S. Supreme Court Justice Robert
Jackson recommended the war crimes trials be held after the surrender. The Nuremberg Trials began on November 20, 1945, and
ended on October 1 of the following year; of the twenty-one defendants at the trial, all but three were convicted and punished.

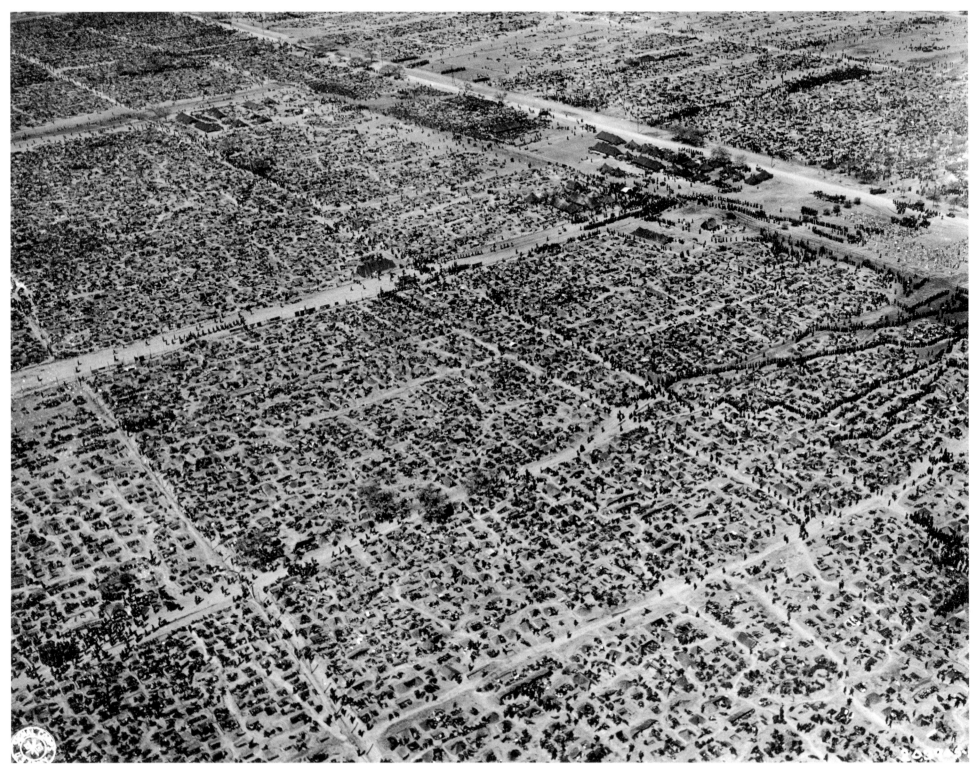

GERMANY, APRIL 25, 1945

On their advance into Germany, the Allies on both the Western and the Eastern fronts captured millions of German soldiers, many suddenly destitute with the loss of support from their government and families. Public opinion in the nations poised to achieve victory was not sympathetic to their plight, but the International Committee of the Red Cross got Allied permission to send relief. Contributions, however, were meager. This POW camp holds more than 160,000 German prisoners.

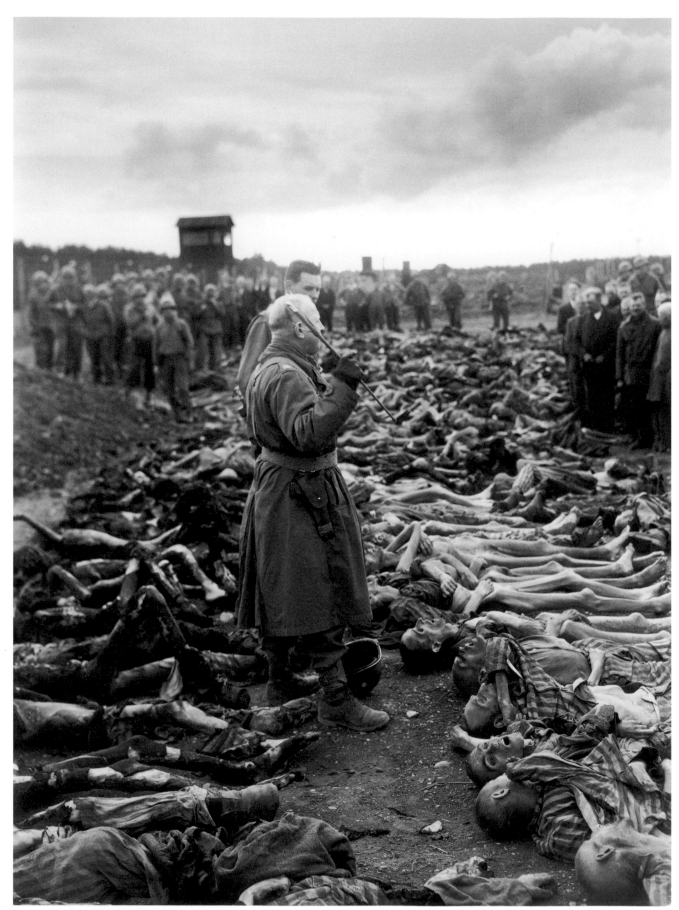

LANDSBERG, GERMANY,
APRIL 30, 1945

Landsberg was a subcamp of the Dachau
concentration camp, twelve miles away.
At Landsberg, nearly 4,000 prisoners were
burned in their barracks as the Seventh
Army approached on April 29. On the
following day, Lt. Col. Ed Seiller, head
of the military government section of the
Twelfth Armored Division, rounded up 250
German civilians and forced them to dig
graves and to tour the camp—a practice
instituted by Gen. Patton. Here, Seiller
addresses them as he stands surrounded
by the corpses of some of the victims.

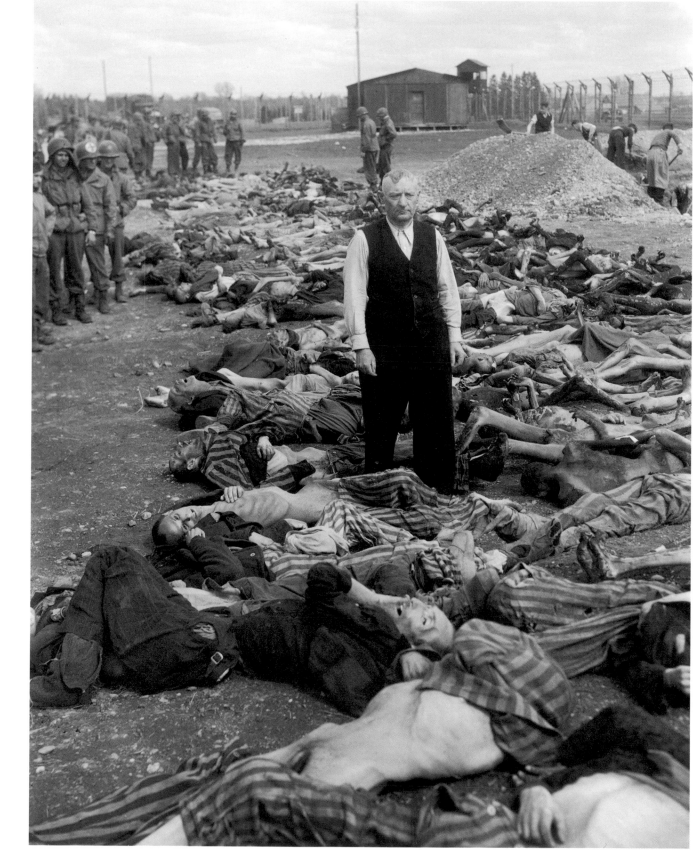

LANDSBERG, GERMANY,
APRIL 30, 1945

The former commandant of the
concentration camp at Landsberg,
SS Capt. Johann Baptist Eichelsdorfer,
stands amid the corpses after his capture
while trying to escape in civilian clothing.
A U.S. military court tried forty-two
officials of the Dachau camp system in late
1945 and sentenced Eichelsdorfer to death.
He was executed on May 29, 1946.

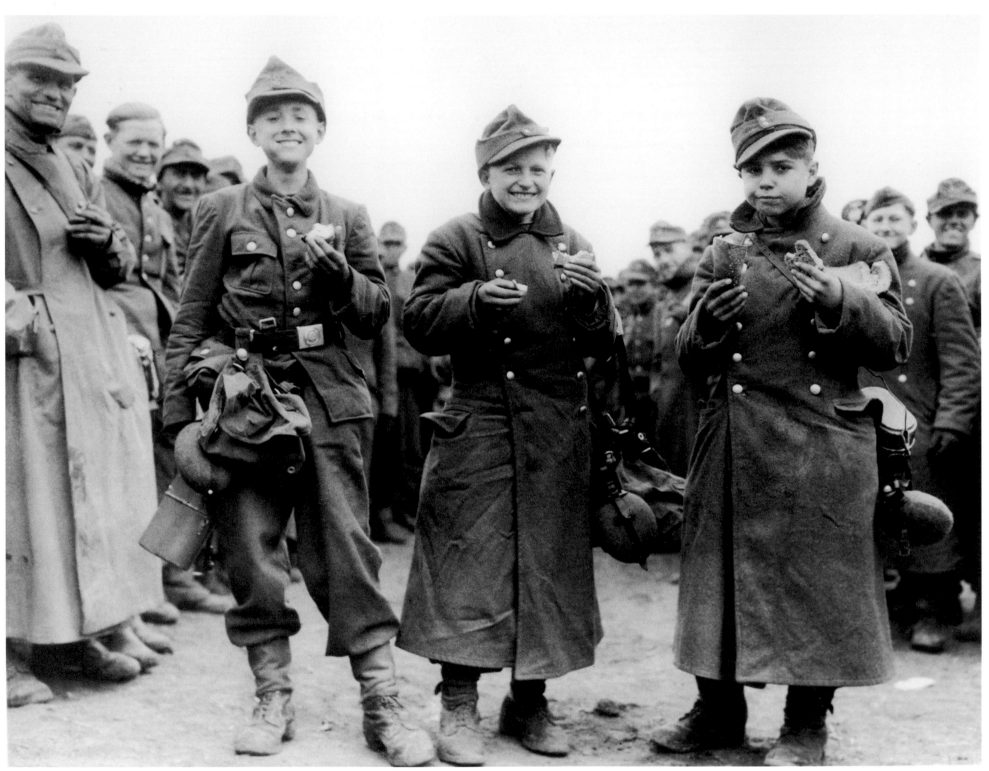

BERSTADT, GERMANY, APRIL 1945
These three 14-year-old boys fighting in the German army were taken prisoner by the Third Army.

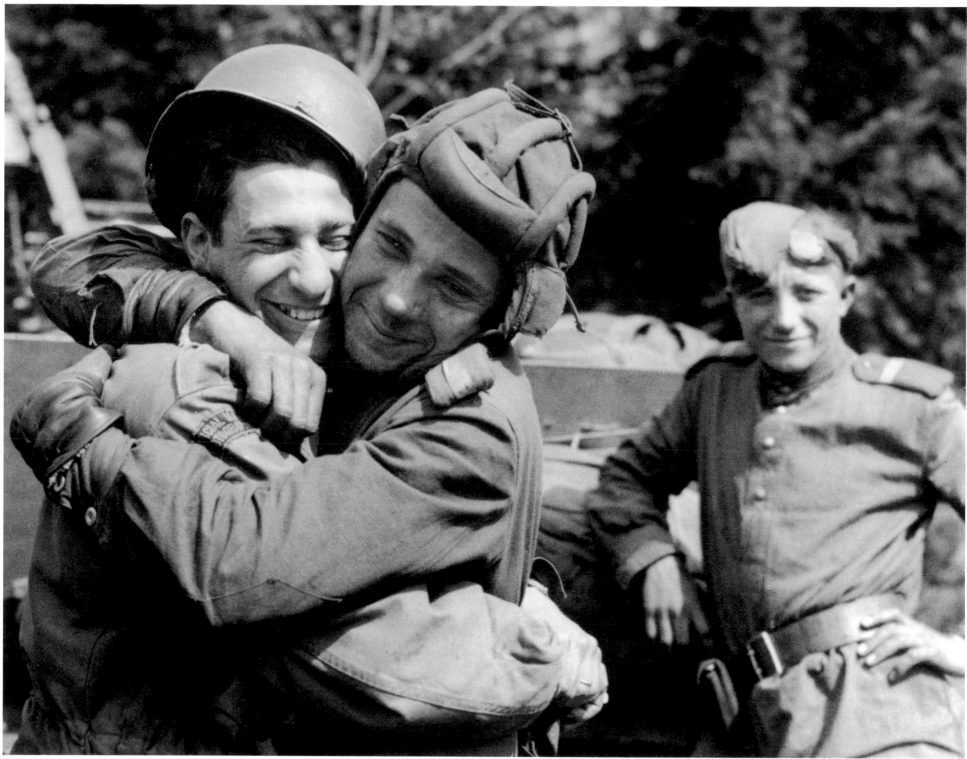

GRABOW, GERMANY, MAY 1945

The first meeting of the American army and Russian army took place on April 25
at Torgau on the Elbe River; it involved troops of the U.S. First Army. Here, about a
week later, in another meeting, a Russian soldier, right, hugs a photographer from the U.S.
Eighty-second Airborne Division, which was attached to the British Second Army.

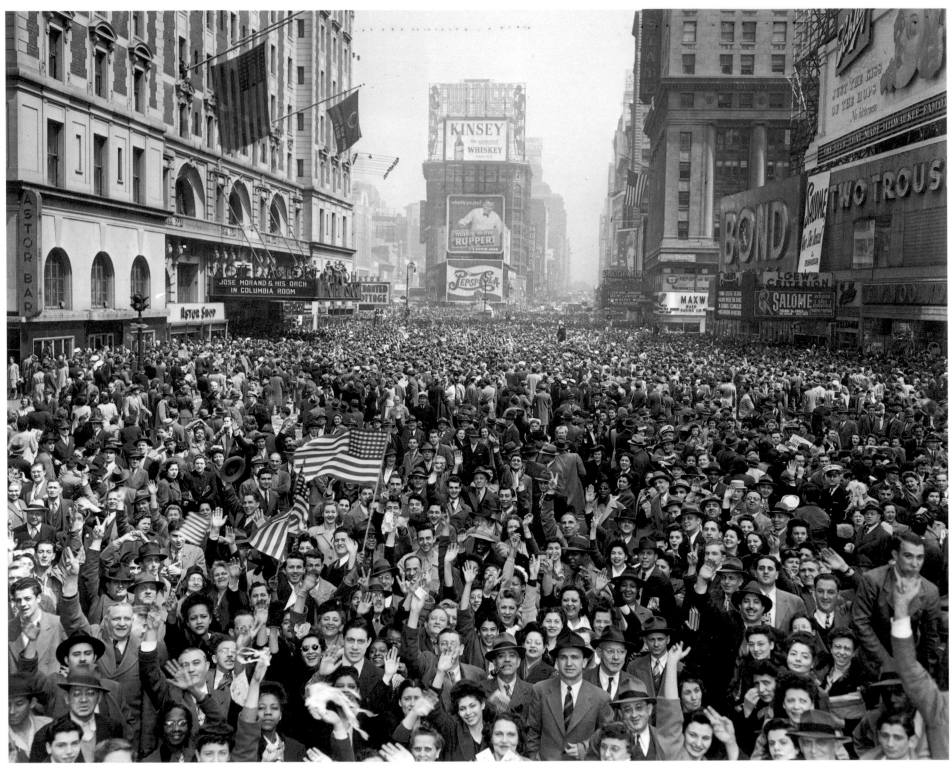

NEW YORK CITY, MAY 7, 1945

The end came rapidly. On April 30, with Russian troops on his doorstep, Hitler killed himself in his bunker in Berlin.
On May 4, German forces in Holland, Denmark, and northwest Germany surrendered to British Field Marshal Montgomery.
On May 7, Germany signed an unconditional surrender with the Allies in Reims, France. Here, looking north
from Forty-fourth Street, New York's Times Square is packed with crowds celebrating the news.

NEW YORK CITY,
MAY 7, 1945
Staff Sgt. Arthur Moore, of Buffalo,
New York, who was wounded in
Belgium, stands on Forty-second
Street near Grand Central Terminal,
as New Yorkers celebrate.

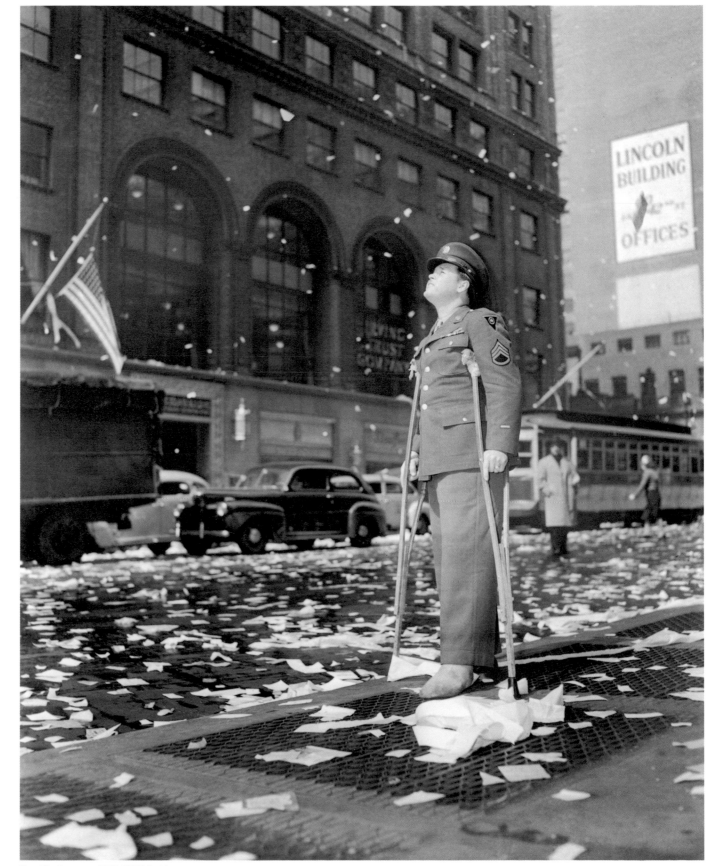

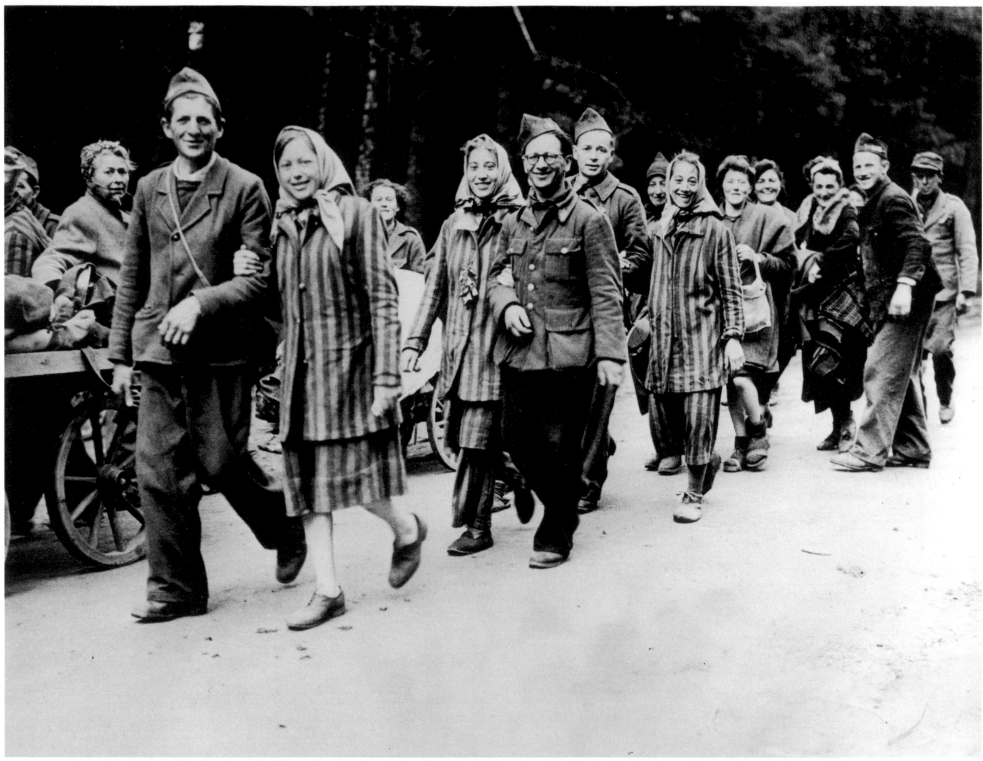

FRANCE, MAY 1945

Survivors of Nazi concentration camps, some still in their striped prison
garb, walk arm in arm as they start the long trek to their homes. The men are French
POWs, most captured when the Germans overran France in 1940.

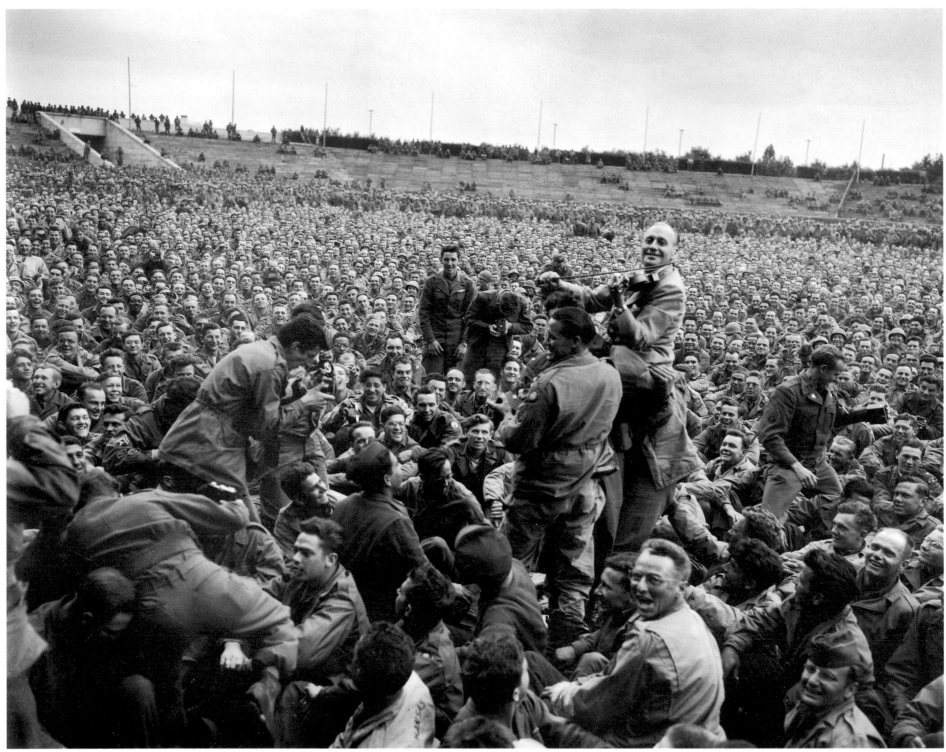

William C. Allen, AP Staff/AP Archives

NUREMBERG, GERMANY, JULY 4, 1945

Jack Benny, comedian and violinist, is carried on the shoulders of a group of soldiers through a crowd of 40,000 GIs at a USO show on the Fourth of July. The venue appears to be the Zeppelinfeld, the enormous stadium that Albert Speer built for Hitler's Nazi Party rallies. On April 22, the U.S. Army had held a ceremony there to commemorate the capture of the city, carefully covering up the swastika on the pediment of the Tribune Building (located behind the photographer in this picture) with an equally enormous American flag. A few days later, the Americans blasted the swastika off the building.

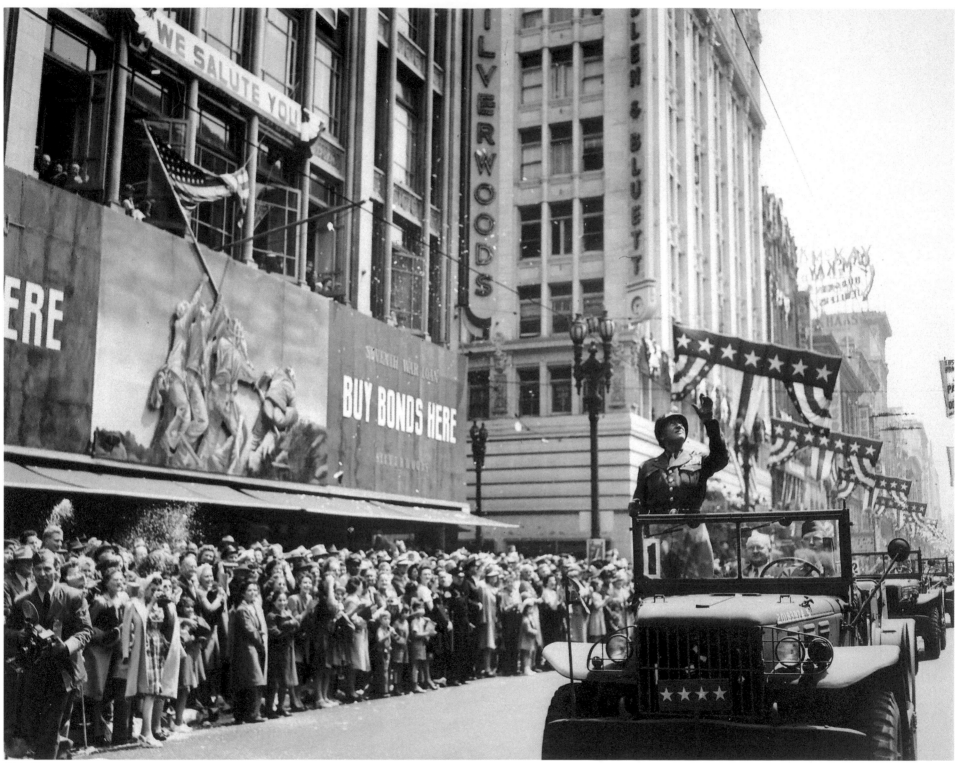

AP Archives

LOS ANGELES, JUNE 9, 1945

Gen. George S. Patton acknowledges the cheers of thousands during a parade through downtown Los Angeles, upon his return to his native California with Lt. Gen. James H. Doolittle, who is in another jeep farther back in the parade. Shortly thereafter, Patton returned to Germany and controversy, as he advocated the employment of ex-Nazis in administrative positions in Bavaria; he was relieved of command of the Third Army and died of injuries from a traffic accident in December, after his return home. Note the use of the Iwo Jima flag-raising photograph on the war bonds billboard.

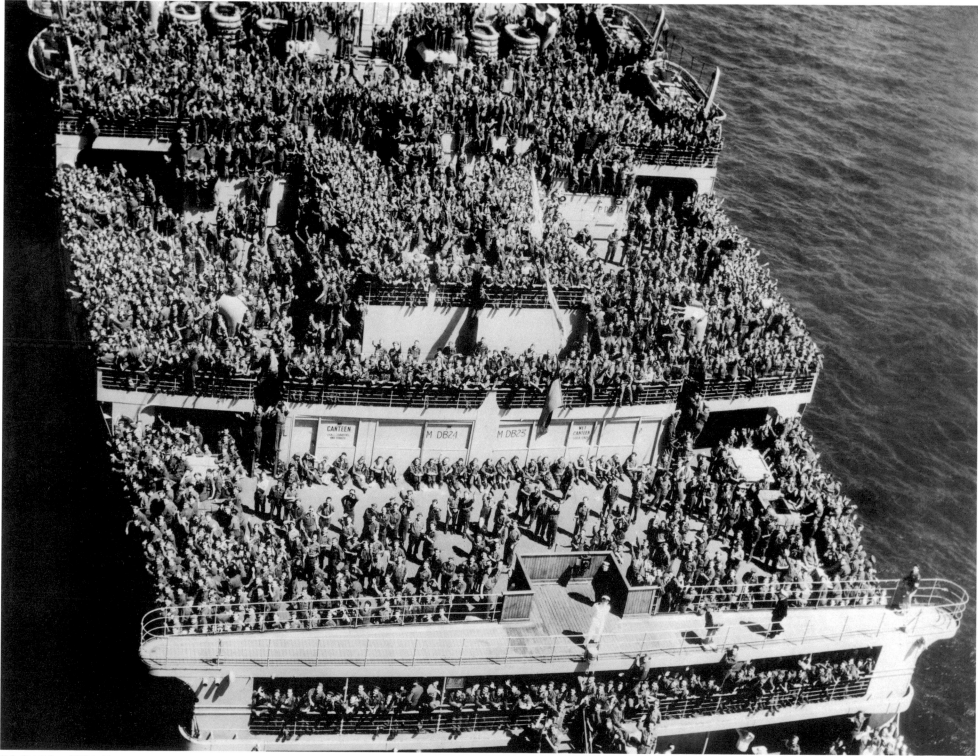

NEW YORK CITY, JUNE 20, 1945
U.S. troops returning from Europe pack the decks of the British luxury liner-turned-troopship
HMS *Queen Mary* as she steams into New York Harbor with some 14,000 aboard.
This was the ship's first voyage to America since V-E Day.

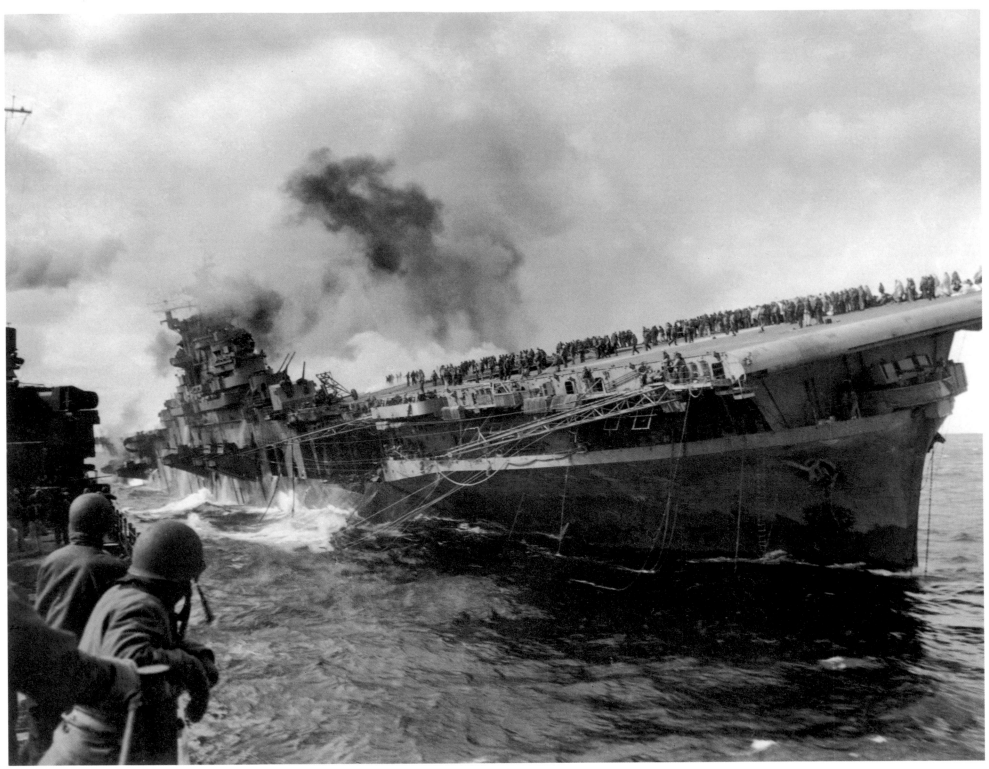

U.S. Navy/AP Archives

RYUKYU ISLANDS, JAPAN, MARCH 19, 1945

Anticipating stiff resistance to the impending invasion of Okinawa, Pacific command ordered carrier-based
raids on Japanese airfields in the weeks before the landing. The raids were successful, but at a price. The carriers USS *Wasp*,
USS *Yorktown*, and USS *Franklin* (seen here, from the USS *Santa Fe*) were badly damaged by kamikaze attacks.

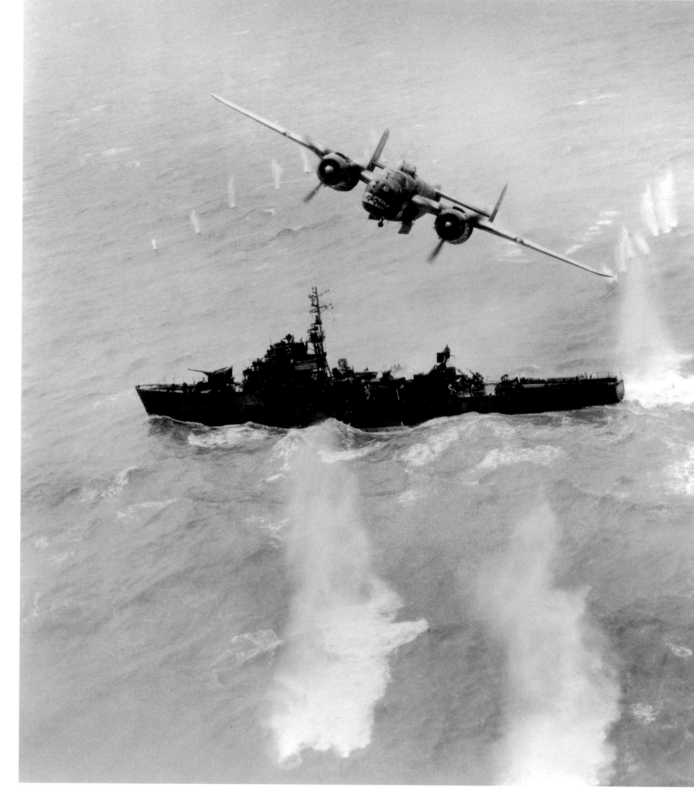

CHINA SEA, APRIL 6, 1945
The grotesque face painted on the nose of this North American B-25 Mitchell bomber appears to leer at a Japanese destroyer escort in the China Sea, near the Ryukyu Islands. The ship was one of two sunk that day by B-25s. The bomb bays of the plane are still open.

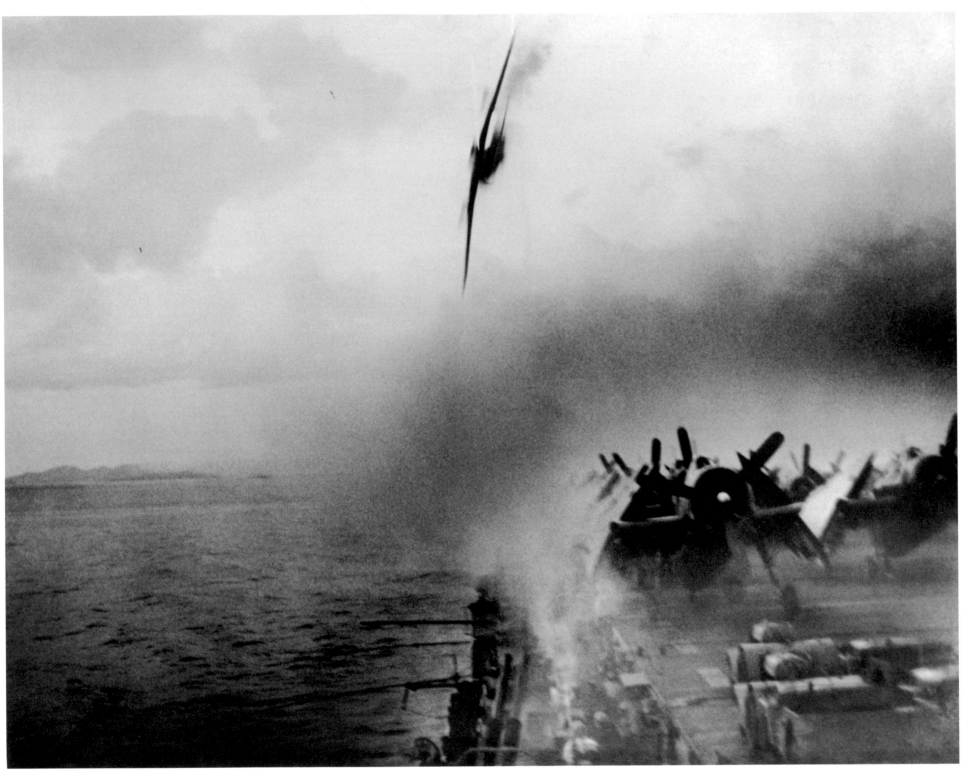

RYUKYU ISLANDS, MAY 4, 1945

Antiaircraft gunners, center foreground, pour a deadly stream of fire into an already-burning Japanese kamikaze
plane plumeting toward the flight deck of the USS *Sangamon*, a Navy escort carrier, during action in the Ryukyus.
This suicide plane landed in the sea close to the carrier. Another Japanese aircraft later succeeded in hitting the ship's
deck, inflicting heavy damage. Casualties were eleven dead, twenty-five missing, and twenty-one seriously wounded.

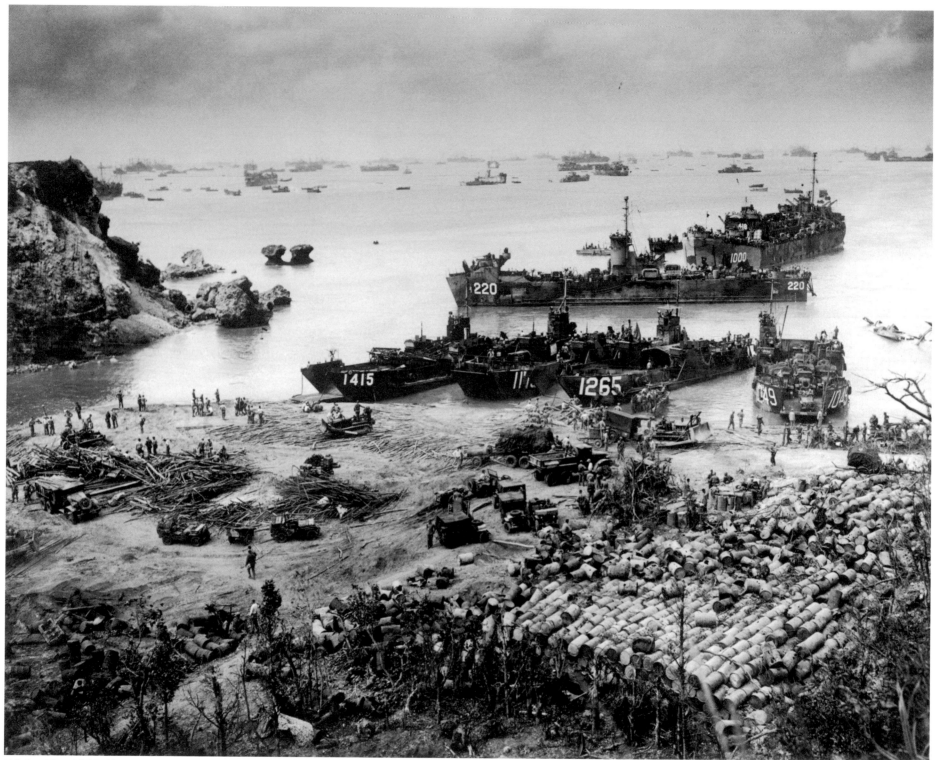

OKINAWA, JAPAN, APRIL 13, 1945

Iwo Jima provided a base for operations against Okinawa; Okinawa was to be the last island stepping-stone to an invasion of mainland Japan. Operation Iceberg, the amphibious assault on Okinawa, began on April 1. This photograph shows the beachhead two weeks later.

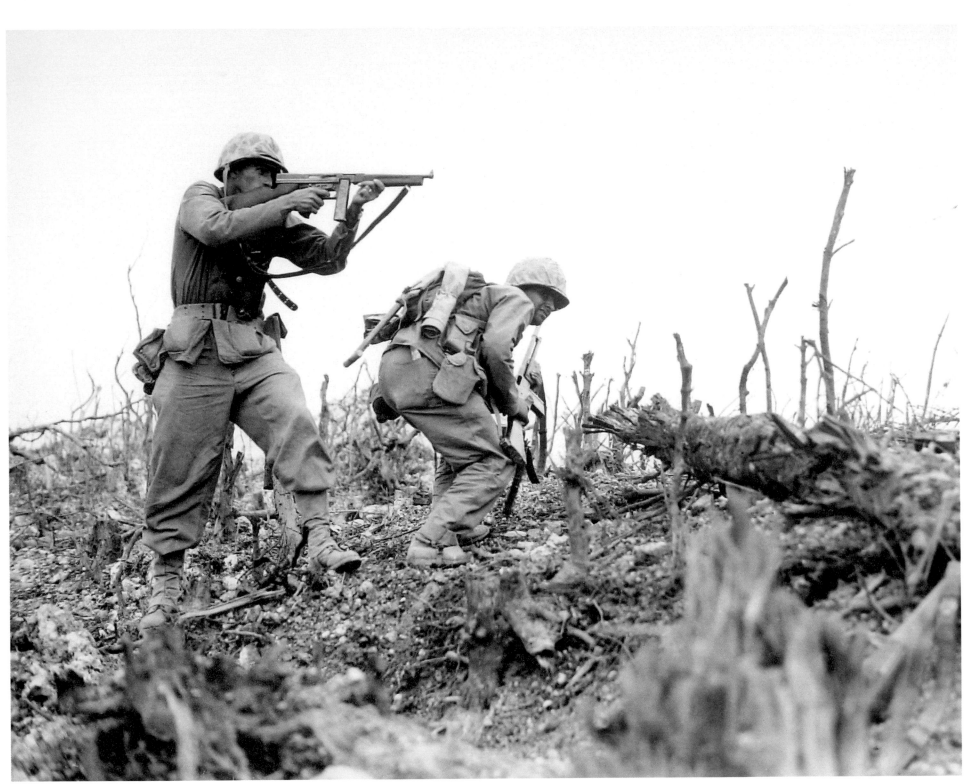

OKINAWA, MAY 1945

Okinawa was extremely well garrisoned, and the Japanese High Command was determined to hold it at all costs. As on Iwo Jima, intense bombardment of the Japanese positions had little effect, thanks to a secure system of cave defenses. Marine assaults on protected positions in April were terribly costly, but when the Japanese counterattacked in May, their losses were enormous. Here, a U.S. Marine fires at a Japanese sniper as his comrade ducks for cover, during the advance to take Wana Ridge near the town of Shuri.

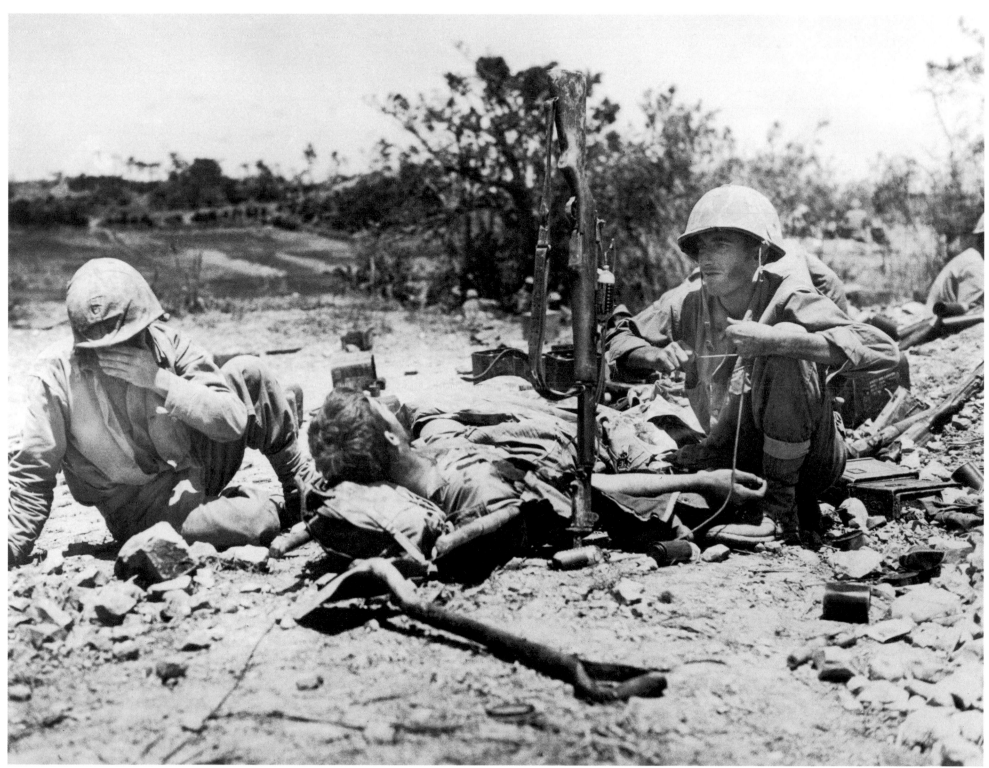

OKINAWA, MAY 14, 1945

The total Japanese loss in the Battle of Okinawa was estimated at 110,000 men. American casualties numbered 49,000, including 12,500 killed, their heaviest campaign loss in the Pacific war. Here, a wounded U.S. Marine lies on a stretcher with his head on his pack while a Navy hospital corpsman, right, administers blood plasma. The blood plasma container is suspended from a rifle thrust in the ground.

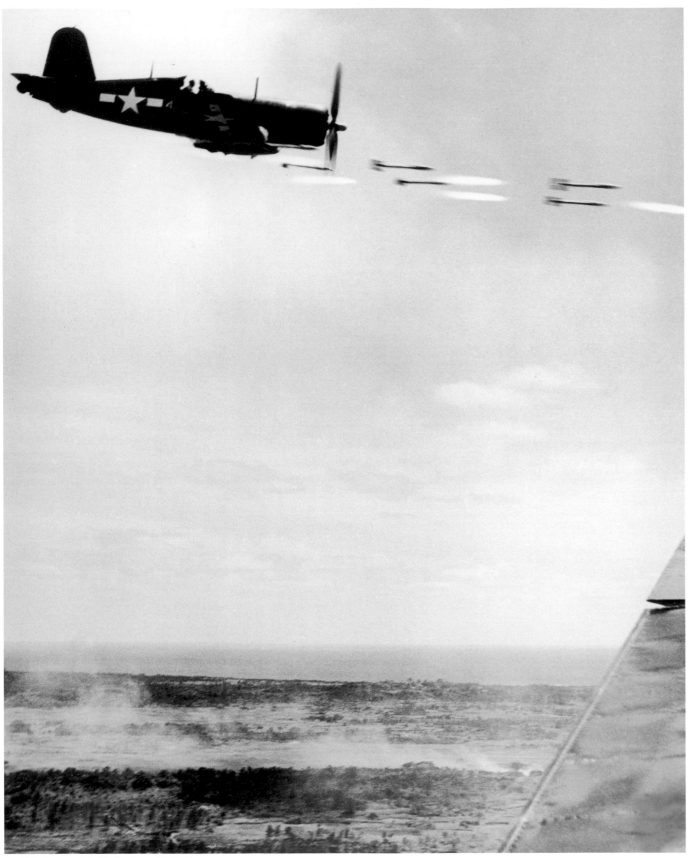

OKINAWA, JUNE 1945
With the pilot visible, a U.S. Navy
Chance-Vought F4U Corsair fighter
plane is firing its load of rocket
projectiles on the run against a
Japanese stronghold on Okinawa.
Battle smoke is seen rising in
the lower background.

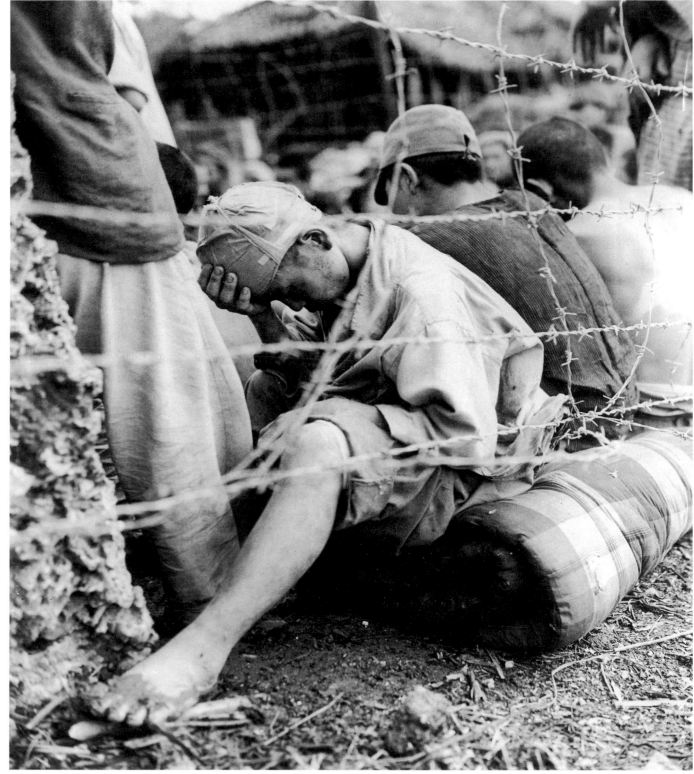

OKINAWA, JUNE 1945
In mid-June, the battle was over.
While the Japanese officers committed
suicide, thousands of Japanese soldiers
surrendered for the first time in the
Pacific war. Here, a Japanese POW sits
behind barbed wire after he and some
300 others were captured within the last
twenty-four hours of the battle.

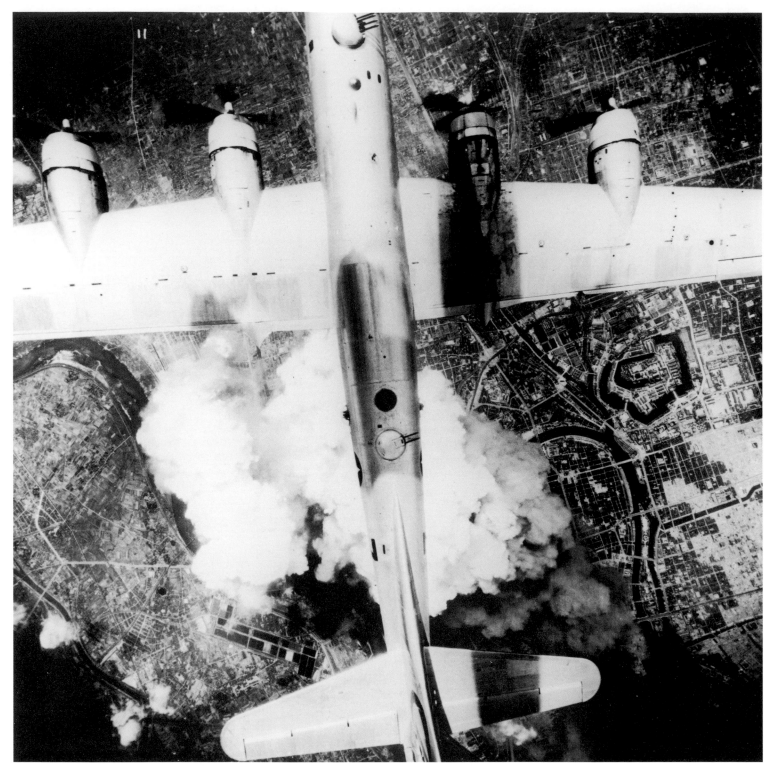

OSAKA, JAPAN, JUNE 1, 1945

In 1945, the United States began its air offensive against mainland Japan in earnest. On March 9, more than 270 Boeing B-29 Superfortress bombers destroyed nearly a quarter of Tokyo with incendiary bombs. Here, with its No. 3 engine out, one of 458 Tinian-based B-29s takes part in the second of at least four massive firebombing raids on Osaka. Between February and June, the Twentieth Air Force launched almost 7,000 B-29 flights on seventeen incendiary raids on Japanese cities. Approximately 500,000 Japanese civilians died in the war, many in these raids, and that many again were seriously injured.

NAGASAKI, JAPAN, AUGUST 9, 1945
On August 6, the United States dropped
an atomic bomb on the Japanese city of
Hiroshima, destroying most of the city.
Three days later, a second atomic bomb
exploded over the Japanese port and city of
Nagasaki. The initial death toll in Hiroshima
was estimated at 66,000, with 69,000 injured;
Nagasaki at 39,000, with 25,000 injured. Tens
of thousands more died later of bomb-related
causes. Here, a giant column of dark smoke
rises more than 60,000 feet into the air
from the Nagasaki explosion.

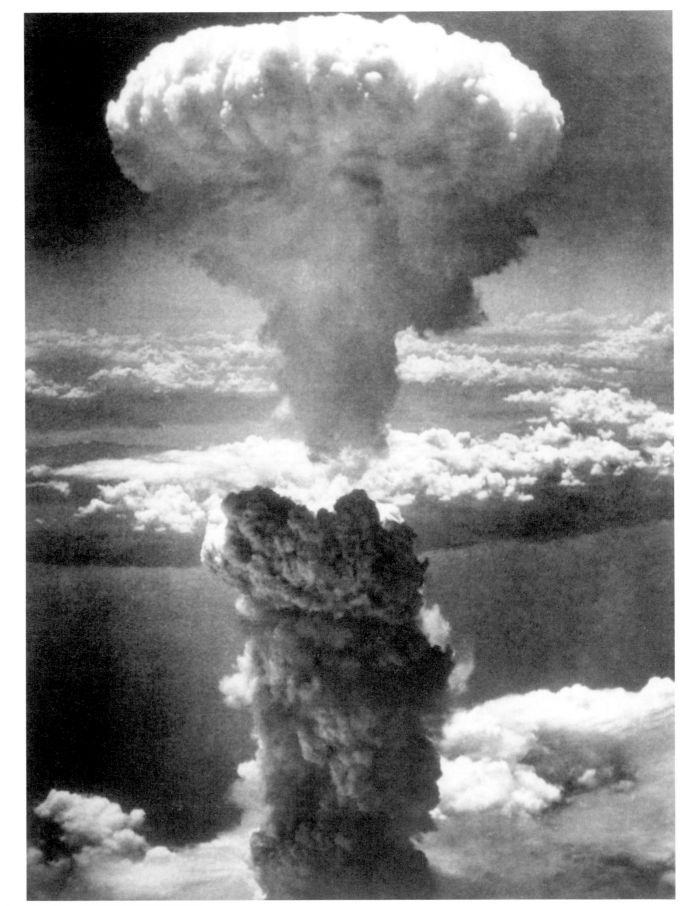

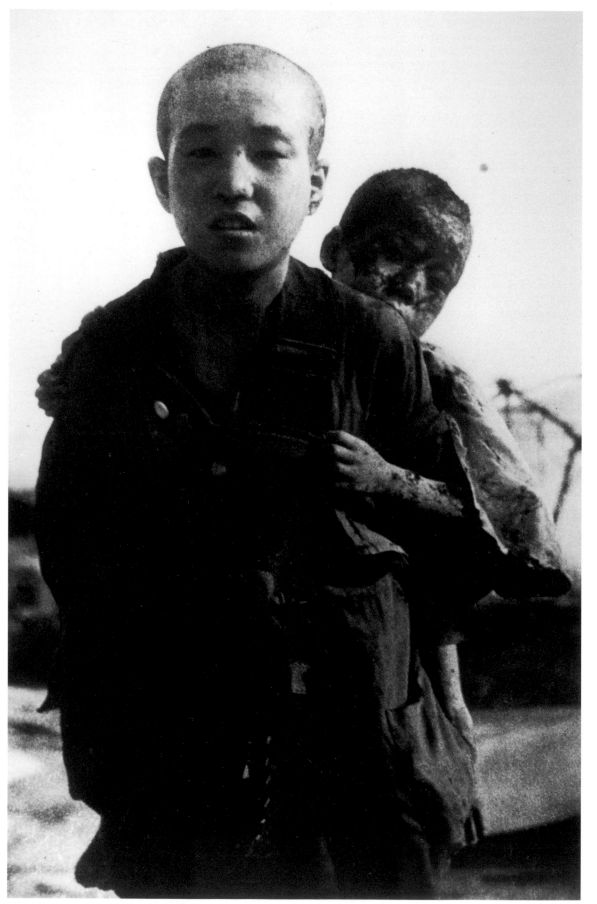

Yosuke Yamahata, United Nations/AP Archives

NAGASAKI, JAPAN, AUGUST 10, 1945
Twenty-eight-year-old Yosuke Yamahata was a photographer on assignment with the Western Army Corps near Nagasaki when news of a second "new-style bombing" was received, and he was sent immediately to photograph its aftereffects. He arrived before dawn on August 10, accompanied by a writer and a painter, and took approximately 120 images before leaving the city in midafternoon. The photographs were not released to the public by the Japanese military. Some, including this one—of a young boy carrying his burned brother on his back—were disseminated to the world press by the United Nations after the war.

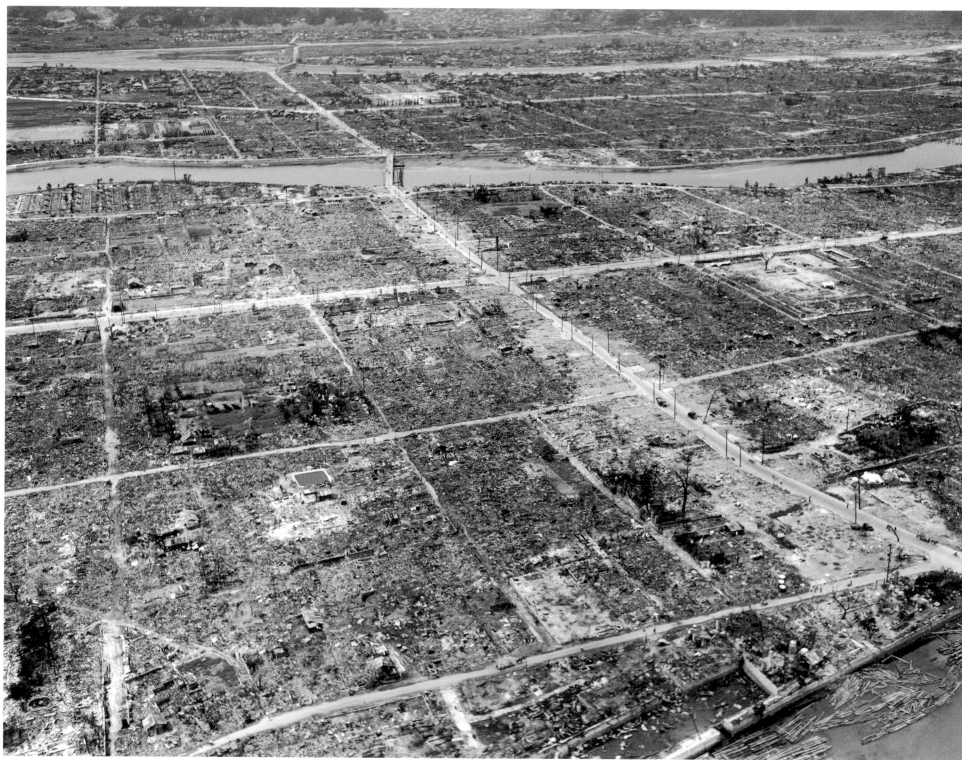

HIROSHIMA, JAPAN, SEPTEMBER 5, 1945

The landscape of Hiroshima shows widespread rubble and debris in an
aerial view made one month after the atomic bomb was dropped.

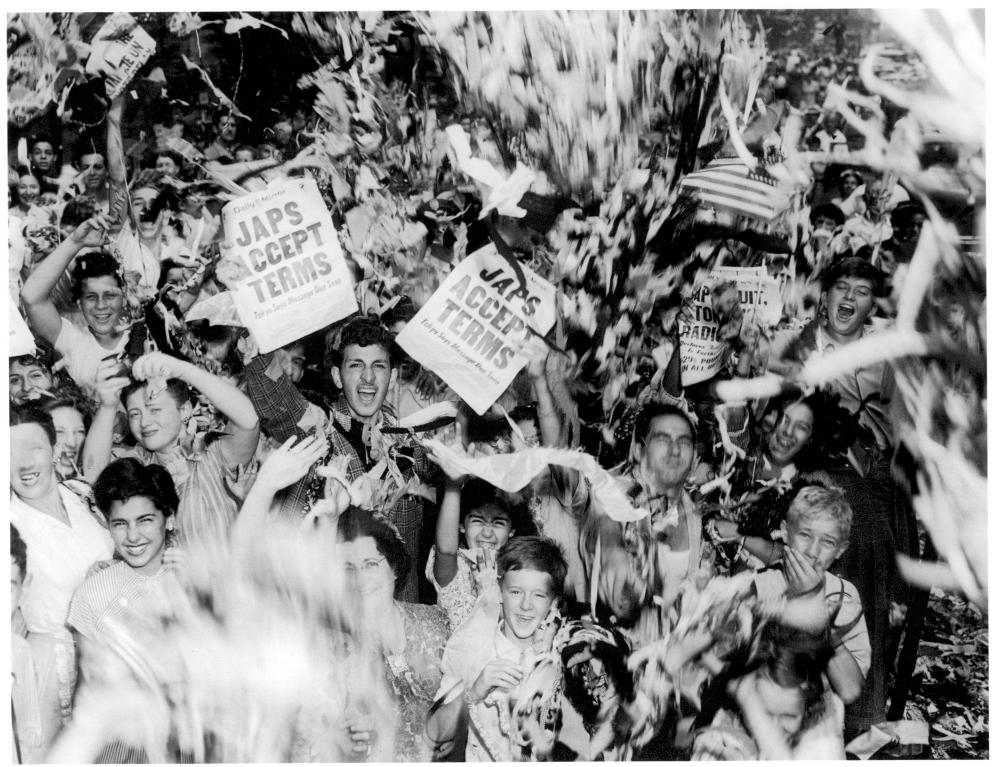

NEW YORK CITY, AUGUST 14, 1945

On August 14, the emperor of Japan decided in favor of surrender,
and the announcement was made via radio. Here, civilians and
service personnel wave flags and shout with joy in New York's Times
Square after receiving the news that World War II was ended.

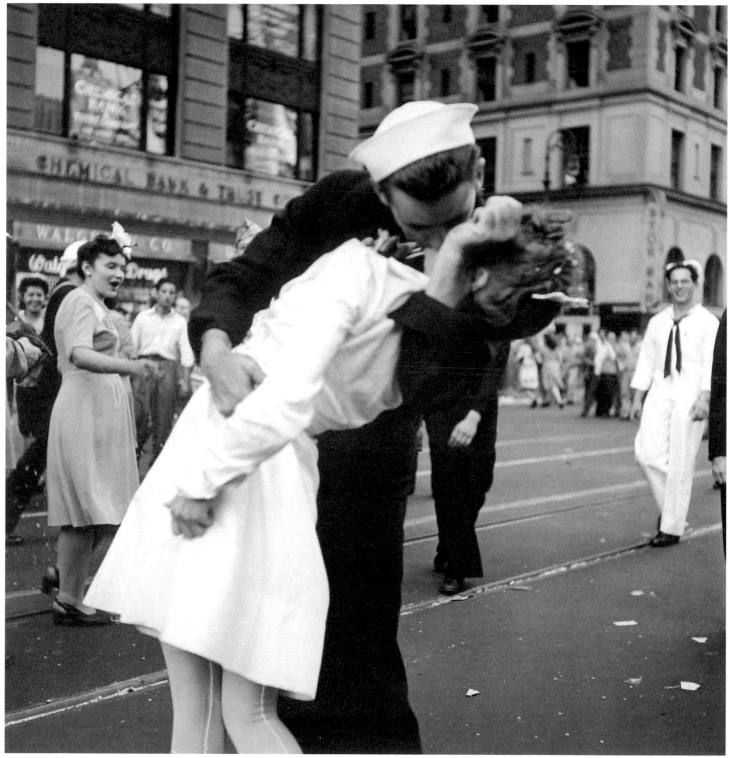

NEW YORK CITY, AUGUST 14, 1945
A sailor and a nurse embrace in Times Square.

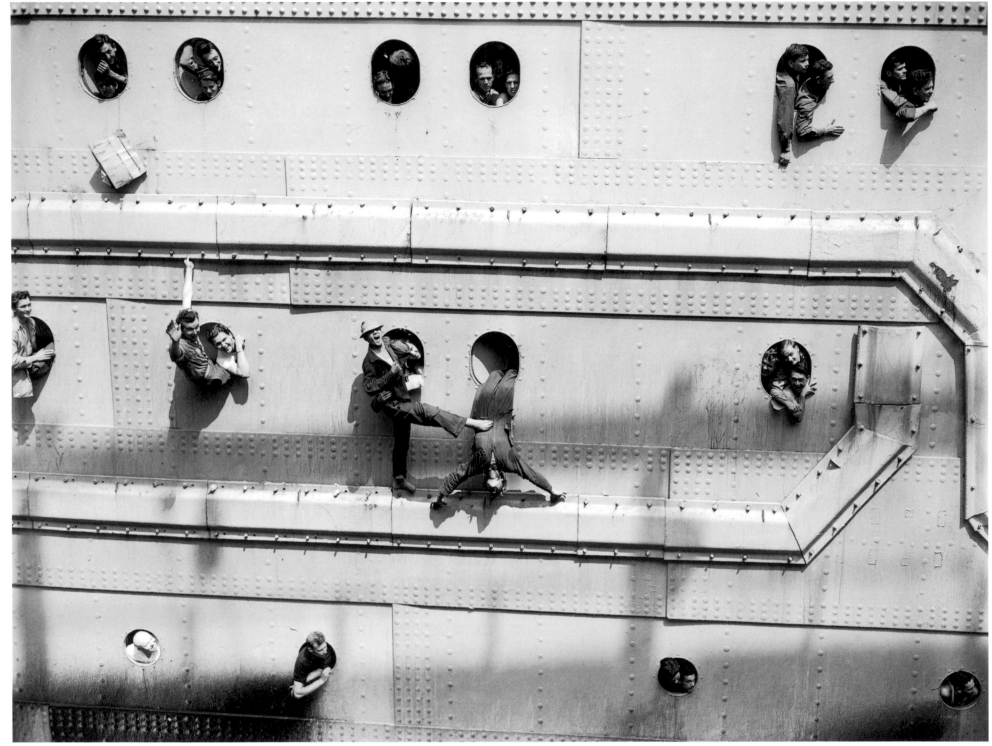

NEW YORK CITY, AUGUST 31, 1945
U.S. troops returning from Europe fill every porthole
as the HMS *Queen Elizabeth* pulls into a pier in New York Harbor.

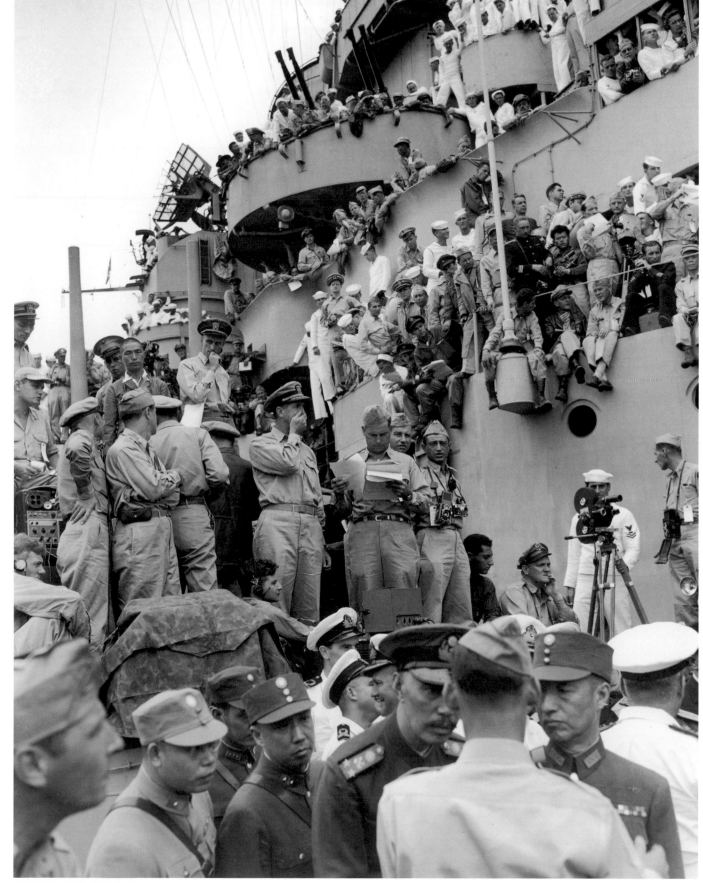

TOKYO BAY, SEPTEMBER 2, 1945
On the morning of September 2, more
than two weeks after accepting the
Allies' terms, Japan formally
surrendered. The ceremony, less than
half an hour long, took place under
overcast skies onboard the battleship
USS *Missouri*, anchored with
other United States' and British
ships in Tokyo Bay. Here,
correspondents from all over
the world observe the ceremony.

Frank Filan, AP Staff/AP Archives

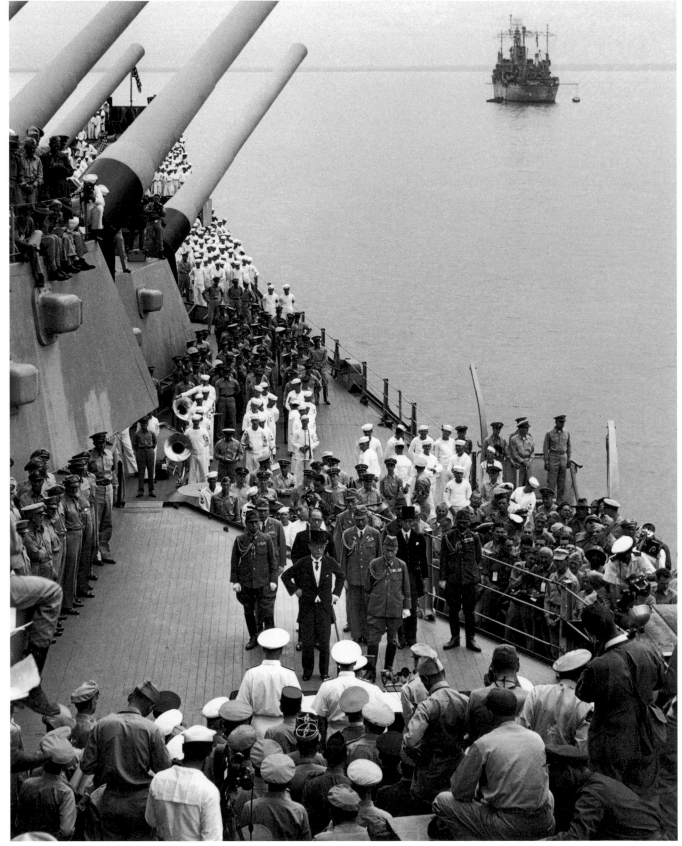

TOKYO BAY, SEPTEMBER 2, 1945
Japanese officials stand in a group
facing representatives of the Allied
armed forces prior to signing the
surrender agreement on the deck of
the USS *Missouri*: in front, Foreign
Minister Mamoru Shigemitsu
(wearing top hat) and Gen. Yoshijiro
Umezu, Chief of the Army General
Staff; behind them are three
representatives each of the Foreign
Ministry, the Army, and the Navy.
Among the officers in the foreground
are Fleet Adm. Chester W. Nimitz
and Gen. of the Army Douglas
MacArthur.

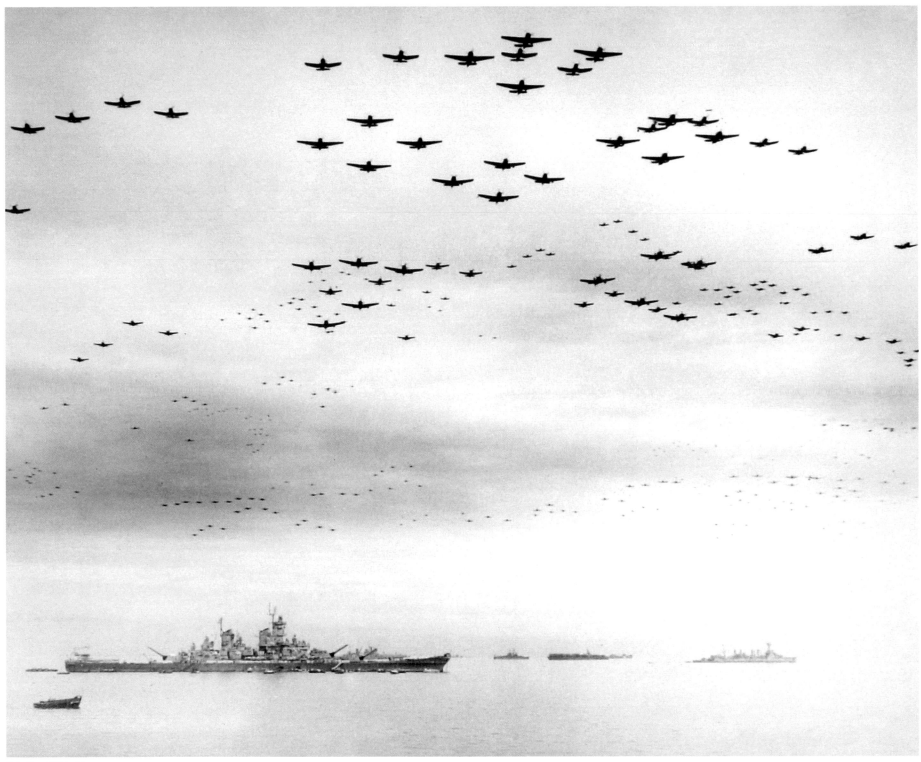

U.S. Navy/AP Archives

TOKYO BAY, SEPTEMBER 2, 1945

F4U Corsairs and F6F Hellcat fighter planes fly in formation over the USS *Missouri* during surrender ceremonies ending World War II. In World War II, the United States military officially recorded 292,131 battle deaths, 115,187 deaths from other causes, 671,801 wounded, and 139,709 captured or missing. After seven years of war, Britain had sustained approximately 245,000 battle deaths; Russia, 2.2 million; France, 211,000; Germany, 3.5 million; Japan, 1.2 million; and Italy, 77,000. Battle deaths in other nations drawn into the conflict are estimated at 3.6 million, including 2.2 million Chinese soldiers killed since 1937.

ACKNOWLEDGMENTS

DESIGNERS: Eric Himmel and Arlene Lee
PRODUCTION MANAGER: Jane Searle

Photo librarian *Greg Murphy*, curator of the New York AP World War II collection, played a major role in researching the content for this book. His tireless research uncovered many rarely seen photos. *Mike Hollingshead* did the same in AP's London Photo Library, contributing significant research to find original photos in that collection. Grateful thanks to retired AP Executive Photo Editor *Hal Buell* for sharing his own extensive World War II research.

AP staffers in bureaus around the world contributed further research and assistance. These included Germany's Chief of Bureau *Steve Miller*, and Frankfurt Photo Library staffers *Veronika Daubner*, *Mile Penava*, and *Madeleine Kaul*. London assistance came from Senior Photo Editor *Horst Faas* and Head of Photo Archiving *Jane Gowman*. Tokyo's Director for AP Wide World Photos *Rikio Imajo* researched photos from the Pacific, and Photo Editor *Guy Kopelowicz* researched the Paris archives.

Others contributed significantly to the editorial process, including Washington Enterprise Editor *Cal Woodward*, retired Vice President *Walter Mears*, and Corporate Archives Director *Valerie Komor*.

Special thanks also for the assistance of *Samantha Topol* of Harry N. Abrams, Inc., *Peter Himler* of Burson Marstellar, *Marlene Adler* of Walter Cronkite's office, and *Joyce McCluney* of Bob Dole's office.

The Bildarchiv Preußischer Kulturbesitz in Berlin graciously provided the photograph on page 63, as the original print belongs to its collection.

The following photos in the AP Photo Archives are part of the War & Conflict collection maintained by the Still Picture Branch of the National Archives and Records Administration. Photos are listed with the War & Conflict reference number and the National Archives negative number.

page 2: WC1229: 127-N-120562	page 68: WC1033: 111-SC-188691	page 136: WC1098: 111-SC-203308
page 7: WC1025: 111-SC-178198	page 75: WC915: 026-G-3122	page 137: WC1092: 239-PA-70-4
page 20: WC995: 208-PP-10A-1	page 77: WC926: 026-G-3345	page 138: WC1095: 111-SC-205778
page 28: WC997: 208-PP-10A-3	page 78: WC1185: 111-SC-189099	page 139: WC1105: 208-AA-206K-31
page 32: WC1249: 208-AA-132N-4	page 81: WC1173: 111-SC-190968	page 145: WC1345: 111-SC-204462
page 38: WC1132: 080-G-30549	page 87: WC1041: 026-G-2343	page 156: WC753: 208-PU-154F-5
page 39: WC1135: 080-G-16871	page 89: WC1042: 111-SC-190366	page 158: WC979: 080-G-273880
page 40: WC1134: 080-G-19948	page 96: WC1050: 111-SC-193970	page 161: WC1226: 026-G-4426
page 46: WC1145: 208-AA-288BB-2	page 100: WC975: 080-G-238363	page 162: WC1228: 127-N-123170
page 49: WC1315: 080-G-418331	page 102: WC1047: 111-SC-191933	page 164: WC1224: 127-GR-97-126420
page 52: WC976: 080-G-17489	page 113: WC1207: 111-SC-407101	page 165: WC1307: 127-N-125719
page 53: WC788: 208-PU-91B-5	page 115: WC1159: 111-SC-197483	page 167: WC1242: 208-N-43888
page 56: WC802: 208-AA-352QQ-5	page 116: WC956: 080-G-301351	page 171: WC1358: 080-G-377094
page 64: WC1176: 080-G-52573	page 120: WC1075: 111-SC-198849	page 175: WC1370: 080-G-421

Prints of many of the images in this book are available at www.memoriesofww2.com.

Library of Congress Cataloging-in-Publication Data

Memories of World War II : Photographs from the Archives of The Associated Press / foreward by Bob Dole ; introduction by Walter Cronkite.

 p. cm.

 Includes bibliographical references and index.

 ISBN 0-8109-5013-8

 1. World War, 1939-1945—Pictorial works.

I. Associated Press.

D743.2.M46 2004

940.53'022'2—dc22

 2004003066

Printed and bound in Mexico

10 9 8 7 6 5 4 3 2 1

Harry N. Abrams, Inc.
100 Fifth Avenue
New York, NY 10011
www.abramsbooks.com

Abrams is a subsidiary of LA MARTINIÈRE